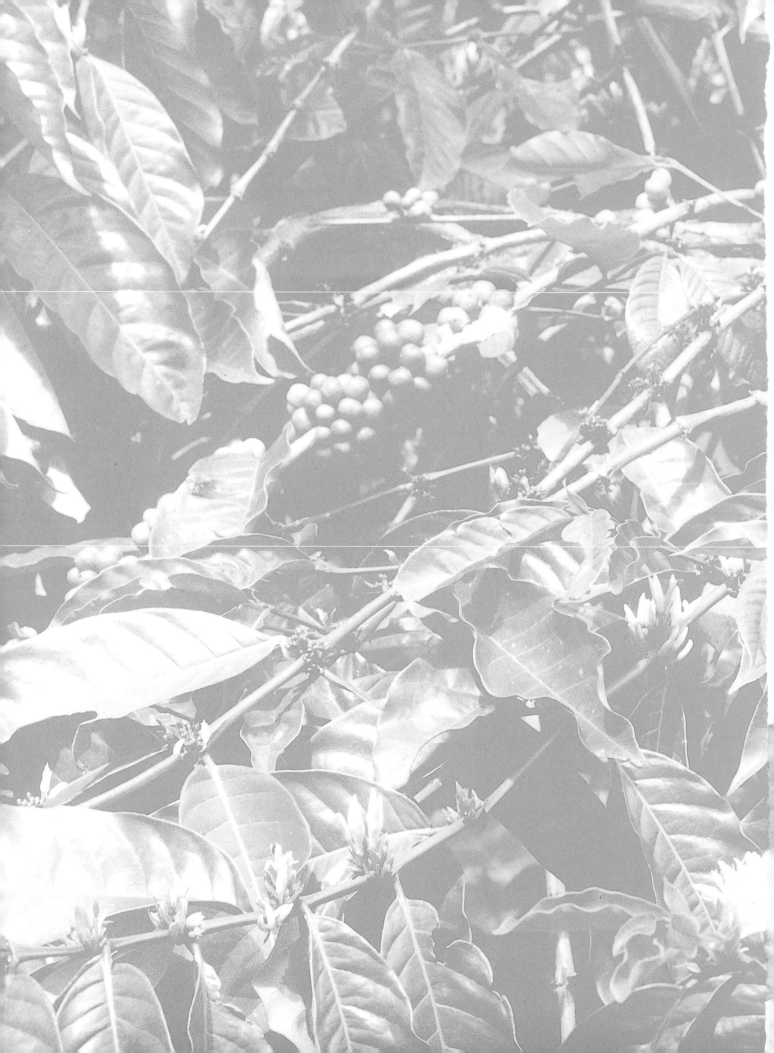

THE BIRTH OF
COFFEE

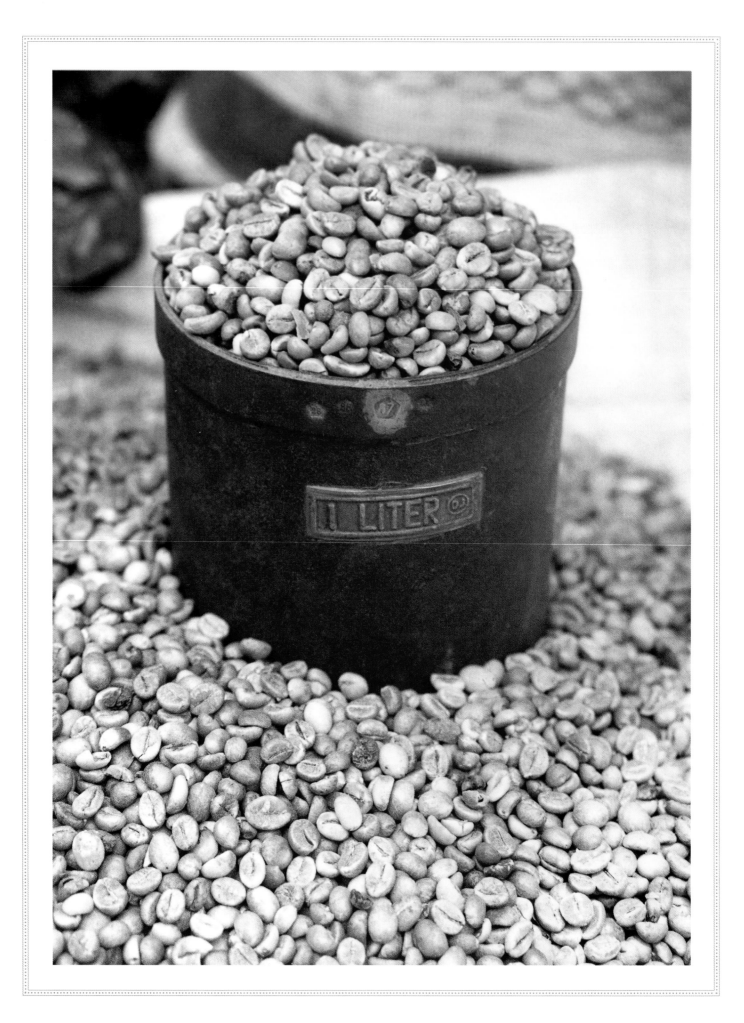

THE BIRTH OF
COFFEE

PHOTOGRAPHS BY

Daniel Lorenzetti

TEXT BY

Linda Rice Lorenzetti

CLARKSON POTTER/PUBLISHERS

NEW YORK

Grateful acknowledgment is made to Random House, Inc. for permission to
reprint material from *Out of Africa* by Isak Dinesen. Copyright © 1937 by
Random House, Inc. Copyright renewed 1965 by Rungstedlundfonden.
Reprinted by permission of Random House, Inc.

The Birth of Coffee (www.birthofcoffee.com)
is a special project of
The Image Expedition (www.imageexpedition.com)

Published by Clarkson Potter/Publishers, New York, New York.
Member of the Crown Publishing Group.

Random House, Inc. New York, Toronto, London, Sydney, Auckland
www.randomhouse.com

CLARKSON N. POTTER, POTTER, and colophon are trademarks
of Random House, Inc.

Printed in China

Design by Marysarah Quinn

Library of Congress Cataloging-in-Publication Data
Lorenzetti, Daniel.
The birth of coffee / by Daniel Lorenzetti and Linda Rice Lorenzetti.
1. Coffee. 2. Cookery (Coffee). I. Lorenzetti, Daniel. II. Title.
TX415.L67 2000
641.3'373—dc21 00-020334

ISBN 0-609-60678-6

10 9 8 7 6 5 4 3 2 1

First Edition

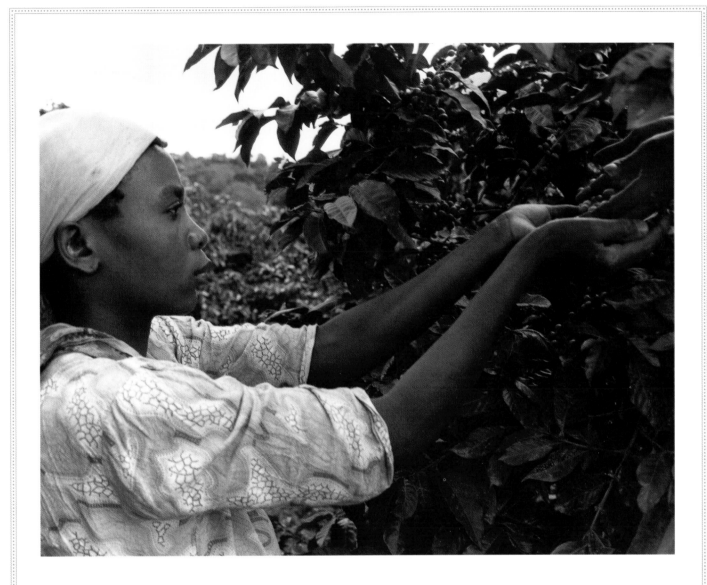

It is impossible to imagine how many hands hold a

single coffee bean from the moment it has been

harvested to the time it comes to the end

of its journey.

This book is dedicated to the men and women worldwide

whose hard work and dedication

brings coffee from the seed to the cup.

ACKNOWLEDGMENTS

WE WOULD LIKE TO THANK OUR FAMILIES, especially our parents, Leland and Bettye Rice and Dan and Pam Lorenzetti, for their love and support. Many thanks as well to all of our Montana family and Florida friends who encouraged us throughout the project.

The Birth of Coffee project sponsors include:

Community Coffee Company, L.L.C.
The Folger Coffee Company
Java Trading Co.

Many organizations and people around the world have assisted with this book, including:

Ted Lingle—Specialty Coffee Association
 of America
Robert Nelson—The National Coffee Association
 of the U.S.A.
Jorge Cardenas—National Federation of Coffee
 Growers of Colombia
Nathan Herskowicz—SINDCAFE and the members
 of ABIC, Brazil
Aguinaldo and Nanci Jóse de Lima—Cerrado
 Coffee Growers Association, Brazil
Jeremy Block—C. Dorman, Ltd., Kenya
Omar, Abdullah, Samira, and Sonia Bagersh—S. A.
 Bagersh, Ethiopia
Kaid A. Yahya—Yemen Café
Surya Dharma—Indonesian National Tourist
 Promotion Board
Manfred Töpke—ANACAFE, Guatemala
Bill and Carole McAlpin—LaMinita, Costa Rica
Francisco Zamora Fernández—COOCAFE,
 Costa Rica

In many ways, others inside the coffee industry supported this project: Norman and Donna Saurage, Pat Pettijohn, Chris Hood, Jane McCabe, Wesley Dehn, Mary Williams, Santiago Echavarria, Donald Schoenholt, Enrique Calvo, Carlos Vargas, Luis Samper, Carlos Brando, Christian Wolthers, R. C. Beall, Theodros Berhanu, Mohamed Abdullahi Ogsadey, Gamal Tarmoom, Carolina Carvalho, Ismael Andrade, Francisco and Evelyn Pascoli, Maurício Miarelli, and Ambassador and Mrs. Ovidio de Andrade Melo.

We would like to thank Laura Blinton, Zoe Higgins, Dolores Sanches, Denise Zadina, Harris Chan, Jad Shor, David Brewster, Dr. David Stern, John Paul and Alexandra Caponigro, Andy Chang, Ferry Joy, Bonnie and Jim Clearwater, Hugh Leavell, Marcia Phillips, William Ray, Brad Lovette and Ikuyo Ohigashi, Robert and Janice Laff, Benny Wei, Nancy Ruby, Doyle Cochran, Julie Gilbert, Beverly Coyle, Addie Rice, and the Deer family.

Special appreciation goes to Tom McCartney, teacher and friend, as well as to Steve Jackson, curator of art and photography at the Museum of the Rockies in Bozeman, Montana, for his invaluable assistance. At Random House we want to thank John Groton, Andrea Rosen, Lauren Shakley; our editors, Katie Workman and Chris Pavone; Julia Coblentz and Marysarah Quinn—each of them devoted long hours and added their unique talents to the success of the project.

The Birth of Coffee is a special project of *The Image Expedition* and its sponsors include:

Olympus America
Imacon
Ilford Imaging
Continental Airlines
Starwood Hotels
Royal Robbins
PrintFile

These organizations have contributed products and services to our efforts: Ethiopian Airlines, Mamiya America, Hitachi, Lonely Planet Publications, America OnLine, Nurre Caxton, Light Impressions, and Eagle Creek.

CONTENTS

PREFACE 8

THE BEAN, ITS JOURNEY 11

ETHIOPIA 16

YEMEN 38

INDONESIA 60

BRAZIL 80

COLOMBIA 106

COSTA RICA 128

GUATEMALA 146

KENYA 170

FROM SEED TO BEAN 190

INDEX 192

PREFACE

COFFEE GROWS IN DANGEROUS PLACES. WORLD NEWS FOCUSES ON the disturbing details—kidnappings, financial upheaval, border disputes, bombings, hijackings, civil war, plane crashes, drought, and earthquakes. All are frighteningly recurrent events in the countries where coffee grows best.

Coffee also grows in the temperate and volatile climates spanning the globe between the Tropics of Cancer and Capricorn. In the majority of these rugged growing regions, fertile soils are primarily volcanic in composition, the volcanoes themselves often very active. Consequently, exploring the land where coffee grows best can be remarkably challenging. We frequently laughed—sometimes out of joy, other times out of fear—about how our travels were punishing us. But a good-natured guide in Sulawesi corrected us, optimistically asserting that rough roads were "romantic" roads. By the book's culmination, we had experienced some extremely intense "romantic" adventures.

This pervasive ruggedness is our most vivid memory. Only now do we realize how absolutely it touches the lives of the people who live in these countries in a complex diversity of ways. They often live under the constant threat of volcanic eruption and frequently sit atop fault lines that can cause devastating earthquakes. Others wait helplessly in the path of destructive hurricanes and typhoons. Climatic conditions caused by El Niño drench some of the growing regions with debilitating rains while others scorch and wilt as if the rain will never come. We never made it to several of the locations on our original itinerary precisely because of such events.

There are a lot of books about coffee. So, you might ask, after all this, what motivated us to choose coffee as a subject in light of all the potential difficulties and discomfort. Part of the answer is actually quite simple. When we first considered the subject of coffee for a photographic essay, and began to research the many books on the subject, it struck us that something was noticeably missing from all of them. There are volumes written on the history of coffee, the cultivation of coffee, and of coffee as a beverage—most filled with colorful pages and sumptuous images of tantalizing coffee concoctions, contemporary and old-world coffeehouses, and coffee paraphernalia of intriguing design and function. The pages of these books overflow with coffee recipes, facts, opinions, and trivia. But, it seemed to us, the thing oddly missing was the people who pick, plant, and produce coffee. Aside from the occasional smiling face of Juan Valdez staring at us from the pages of our favorite magazine, what do we know of the millions of people around the world whose lives are dedicated to growing and producing the world's second-largest traded commodity? These are the people for whom coffee is not merely a beverage but, more important, a livelihood. Are they as passionate about coffee as the people

who drink it? What is their relationship with this intriguing bean that has traveled around the world?

The concept of *The Birth of Coffee* was born in Indonesia. We had known little about coffee before planning a two-month expedition to that amazing island nation. We knew colonial Java had been an important location for early coffee plantations and we conjured up romantic images of old-world plantations, the Dutch East India Company, and wooden sailing ships journeying to Europe laden with sacks of coffee. But even as we added a coffee plantation to our itinerary, we had little idea where that adventure would lead.

We visited our first coffee plantation high on a volcanic hillside not very far from Mount Bromo on the island of Java. It was there that we saw coffee trees for the first time and were encouraged to savor the ripe, sweet taste of a just-picked coffee cherry. We had not realized it yet, but we were hooked. Immediately, we decided to seek coffee on the islands of Sumatra and Sulawesi. Several days later, over dinner in the beautiful Art Deco city of Bandung, Java, the entire concept of *The Birth of Coffee* was fully developed. We already knew that there was much more to tell about the rich story of coffee and the people who bring it to the cup.

And so our coffee journey began. Before its completion, we would travel more than a quarter of a million miles around the world, visiting eight countries to learn more than we ever dreamed about coffee. In meeting the people who grow coffee, we often had the feeling that we were touching the heart and soul of the countries we were documenting. And long before the end of our project, we developed an appreciation for the beverage that far exceeds the taste of a fine cup of coffee.

The people we met in the individual growing regions inspired and educated us. Many touched our hearts. There is something indefatigable about people who work with coffee, no matter where in the world they are. There is, too, an almost universal feeling of commitment in what they do. One cannot help but feel the close affinity that the people who grow and produce coffee around the world have for the product itself. One senses it as a farmer lovingly inspects coffee trees, looking for signs of bloom or infestation, or pops a ripe cherry into his mouth. And one cannot help but notice the almost worldwide need to touch coffee. Whether it has just been picked and is sitting in a basket, or has been dried, processed, and stored, if there is coffee nearby, someone is nearly always dipping a hand into it. If you have walked into a coffee store where they roast on the premises and bags of coffee beans are stored within reach, you know the impulse.

Throughout our travels, as we met the people who plant, pick, and grow coffee, the answers to our original questions were responded to again and again. It was communicated in the many outstretched hands welcoming us worldwide, in countless cups of coffee offered in hospitality, and in the explanations and time taken to show us around coffee plantations, large and small. We hope that we have answered some of these questions with our words and images.

In our opinion, coffee lovers the world over owe all of these people respect and gratitude. They

work long and hard for a small amount of money. Still, they, like those of us who passionately love to drink coffee, are motivated by an intense connection that borders on addiction. Sometimes the connection is not to coffee at all, but strongly to family, culture, or survival. But more often than not, the connection lies strongly with coffee as well. We observed it, again and again, in the coffee workers we met throughout the world. Their faces lit up as they introduced us to their families, showed us their land, and shared their coffee with us. It is all of these factors that ultimately make a cup of coffee possible.

In the end, we knew that no cup of coffee would ever taste the same. To pour a handful of beans into our grinder at the break of day is to envision the many people we have met and places we have traveled. Their faces will always be reflected on the dark surface of every cup of coffee we drink.

—Daniel Lorenzetti
Linda Rice Lorenzetti
The Image Expedition

THE BEAN, ITS JOURNEY

CONSIDER A SINGLE COFFEE BEAN.

Hold a roasted specimen in your hand, and you will find it to be a nearly weightless oblate, split cleanly in half. One side, convex, is smooth perfection. The other, flat, is creased its length from top to bottom. It is from this side that the bean is often photographed or drawn and is most easily recognized.

Take a second bean, place it crease to crease against the first, and envision them encased together. This will take a bit of imagination, since now, after roasting, they have changed form and do not fit together smoothly. Still, this will give you some idea how two beans emerge from a single fruit harvested from the coffee tree.

The fruit itself is called the coffee cherry. What becomes known as the coffee bean is actually the seed of that cherry. The two seeds, lying side by side inside the fruit, are completely separate forms, which have shared the environment inside the fruit since the flowering of the coffee tree and their subsequent formation. Depending upon the variety of the coffee plant itself and the climate where it is grown, the two beans will have spent nearly a year side by side within that cherry sharing a coffee tree branch with many others.

So it is that when we refer to coffee being harvested, it is the coffee cherries that are being gathered from the tree. Under ideal conditions, at the time it is picked, the cherry will have reached its peak of ripeness, turning either bright red or bright yellow, depending on the variety of coffee tree on which it has grown.

The journey of a single bean from the time the cherry is picked until it is roasted, ground, and brewed is a journey that is richly steeped in history and tradition. It consists of many processes, involving a great number of people, over months or even years. The processes themselves may vary in technique and sophistication from farm to farm, country to country, factory to factory, or roaster to roaster. Still, whether in a remote village on the island of Sumatra in Indonesia or at a large, modern processing facility in Brazil, the coffee process is essentially similar. At the same time, around the world such processes are constantly being analyzed, evaluated, and updated based on new theory and experimentation. But even as the processes themselves are being modernized, to visit a contemporary coffee plantation is to find much unchanged. In the midst of state-of-the-art equipment one still finds handmade rakes, baskets, and fiber bags being used exactly as they have been for centuries. From country to country these tools are remarkably similar. Coffee is a crop that, with few exceptions, is still tended and harvested by hand, supporting an industry that employs an estimated 25 million people

worldwide. During centuries of coffee cultivation, generations of coffee workers have come and gone—yet their faces, and often their lives, stay remarkably the same.

THOUGH THERE ARE MANY SPECIES OF COFFEE, IN THE COMMERCIAL COFFEE industry two are predominant: arabica and robusta. Indigenous to Ethiopia, the arabica tree was named for the Arabs, who were the first to cultivate it commercially. Grown at higher altitudes because it prefers cooler temperatures, arabica trees supply 70 percent of the world's coffee. Robusta, on the other hand, differs genetically and is a heartier, more disease resistant plant. Less expensive to cultivate because it can be grown at lower, warmer altitudes, it suffers the disadvantage of having a poorer cup quality than arabica. Both are grown for different markets, though the cherries produced from either species have the same components and follow the same processes.

FROM OUTSIDE TO INSIDE—FROM THE SKIN TO THE BEAN—THE COFFEE CHERRY contains a number of layers. First, there is the outer skin, inside of which rests the white pulp of the fruit. When hulled, the pulp does not come cleanly away from the two seeds lying inside the cherry but adheres to them as a sticky mucilage. Because in some countries this mucilage is removed, it is considered a layer. Next is a thin skin, commonly called the parchment, which encases each seed individually, rather like an envelope. Resting inside the parchment envelope, each seed is sheathed in a tight, tissuelike covering, referred to as the silver skin. Once harvested, each cherry will pass through a variety of procedures, each designed to remove one of the layers.

Coffee cherry is processed in one of two ways. The older, more traditional method is often referred to as dry, or "natural," processing. Soon after harvest, the cherries are simply spread outside to dry, and only after drying is the fruit removed from the beans. Still used in Yemen, as well as in other countries where water is a limited and precious resource, natural processing is often said to impart a certain sweetness to the bean because the fruit stays in contact with it while the cherry dries.

"Wet" processing, on the other hand, is thought to impart a cleaner, more vibrant taste. With wet-processed coffee the outer skin and most of the fruit are removed immediately after harvesting. The fruit can be pulped mechanically, as is done in very industrialized countries, like Brazil and Colombia, or manually. The manual method of pulping is a centuries-old, labor-intensive process that usually involves a heavy pestle or hand-turned grinder. Either way, the point is to remove as much of the skin and pulp as possible. But even when pulped by sophisticated machinery, a portion of the fruit's mucilage will stick tenaciously to the bean.

The next step, fermentation, is integral to wet processing. After the beans have been pulped, they are transferred to a water bath, where they will rest for a period of time, usually overnight. Soaking the beans in water initiates a chemical change that softens the clinging mucilage just enough

for it to be easily removed. It is important that the process last only long enough to loosen the mucilage but not so long as to affect the taste of the beans. The amount of time depends on the beans themselves and the ambient temperature, requiring a watchful and practiced eye. Only when the mucilage has been loosened to just the right degree are the beans removed from the water and rinsed.

In some countries modified versions of the wet or natural processes take place. The fruit might be pulped but not fermented, or washed to remove the pulp but not soaked to remove all the mucilage, so that the bean dries with some of the fruit still attached. Such variations depend on prevailing practices and the availability of technology or water.

However they have been processed to this point, the coffee beans, still soft and green, must now be carefully dried so that they do not spoil. For this to happen the coffee is spread in a thin layer on a large, flat, dry surface. Even in fully mechanized countries, this process almost universally takes place outdoors, under the sun. Since coffee is generally harvested in the dry months, there is an unlimited amount of relatively constant sunshine to assist. Still, it requires undivided attention because there is always the chance of rain; if rain comes the coffee will have to be covered or moved. Also, the beans have to be protected from damp night air. From farm to farm and country to country, processes differ slightly. But the goal is always the same—to dry the coffee beans slowly and continuously until they reach just the right stage of dryness. They must be protected from getting wet at any cost.

We saw the ceaseless process of drying coffee everywhere we traveled. In Indonesia beans were often spread to dry on beautiful wool rugs, while in Yemen they rested atop flat-roofed houses. African coffee dried on seemingly endless rows of aboveground racks, continually turned by hand, while in Colombia buildings with giant racks that could be moved into the sun each held layers of beans. In Brazil we saw unbelievable quantities of coffee spread out on great *terreiros*, turned by tractor and sometimes even by horse. Central American coffee dried on smaller terraces, turned by men and women who walked across the smoothly spread beans with rakes, row by row. Watching them was like watching a Japanese master rake a Zen garden. There was the restful sound of the beans turning and the continually changing visual pattern as the rows were raked at right angles to one another. Filling the air was the unmistakable scent of green coffee.

But drying is not simply a lovely, tactile process; it is a long and demanding labor because the drying beans have to be turned or raked every several hours. If they sit untouched, they will dry unevenly, causing spoilage. Every batch of coffee needs to be rotated regularly until the beans have dried to approximately 11 percent humidity. Depending on weather, it takes from seven to fifteen days for a single batch of beans to reach this point. Every day's harvest must be kept separate, since each is at a different stage of drying. In some countries, because of sheer quantity of beans or inclement weather, the process is frequently completed in mechanical dryers. Still, the intent is for as much of the drying to take place outside as conditions allow.

Once dried the coffee beans, still encased in their parchment envelopes, are stable and can be stored. In most countries the beans will remain bagged and warehoused this way until processed for

export. At this point coffee is usually referred to as *coffee in parchment,* or by the Spanish, *pergamino.* Coffee is stable in this environment and can remain warehoused over many months.

To be readied for export, the coffee beans enter the next stage of processing, in which the parchment skin is removed and the beans are separated by weight, color, and size. While the first process is generally mechanized, the latter is sometimes accomplished by sophisticated machinery, sometimes by human eye and hand. Often it is a combination of both. Expensive high-tech machinery is accurate enough to shoot a single bean into the air, evaluate it by color, then send it to the appropriate batch with a blast of air. But even with equipment that can perform with such exactitude, the beans must still pass the final and most critical test—the human eye. Almost universally, this is the work of women. Watching them remove damaged or poor-quality beans from a rapidly moving conveyor belt, one thinks again of the pneumatic sorting machine and wonders if the women do not work almost as quickly.

Processed and sorted, the beans are now referred to as *green coffee*—and are ready to leave the producing country for destinations around the world.

THERE IS SOMETHING ENDLESSLY FASCINATING ABOUT COFFEE. IT IS ALMOST magical in its lore, dynamic in its history, and rich in countless traditions. To tell the story of coffee is to tell much about the nature of humankind. It is a complex and dynamic tale that involves ceremony and religious custom. It includes voyages of discovery, wars and civil strife, as well as battles for land and control of governments. It incorporates migrations of people throughout the world—the indifferent repression of some, the good fortune of others. There are small stories highlighting unimaginable triumphs of accomplishment and great ones of fortunes lost. Some include reverent consideration for the ecological use of land, while others are of blatant indifference and disregard. Coffee is at the heart of them all—along with the emergence of world economies, the founding of prosperous cities, and the formation of entire countries.

But the narration of coffee goes far beyond markets and commodities. Most important, it is a story, composed again and again around the world, of people, all doing their small parts to make possible the cup of coffee you drink. Without them coffee would have neither history nor tradition and we would simply cease to know the pleasure found in a steaming cup of fragrant brew. The story of coffee rests in the faces of these people—in their labor, in their lives, in their hands.

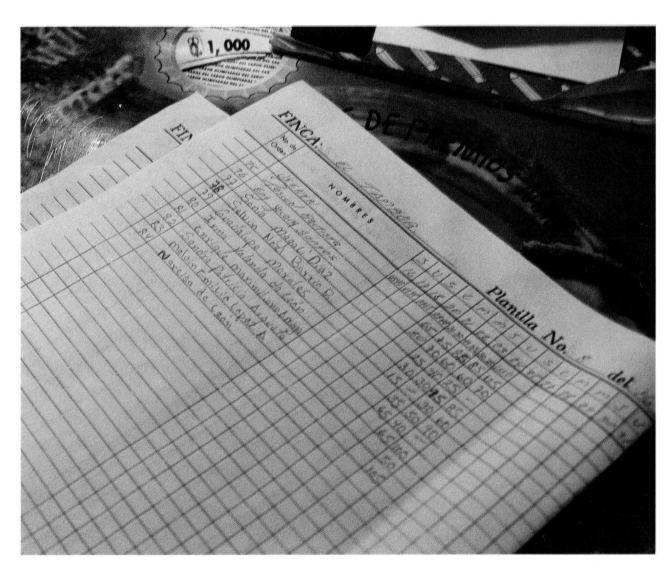

PLANILLA NO. 8

*Too often they are nameless, faceless people, largely
forgotten by those who drink the coffee they labor so hard
to provide. But this ledger shows the real names of the
people who picked coffee this day at Finca El Tambor in
Guatemala—Pascual, Gay, Sonia, Selvin, Guadalupe,
Irma, Enrique, Sandra, Melvin, Narcisa.*

ETHIOPIA

ETHIOPIA—WHERE THE STORY OF COFFEE BEGINS. According to legend, goatherds in ancient Abyssinia observed that their flocks became playful after eating the red fruit of a particular tree. One among them, named Kaldi, was particularly interested in the peculiar reaction it caused.

In Kaldi's day the coffee tree grew wild only in a small region of the Abyssinian upland forests. Gathering the fruit he had watched his flock eat, Kaldi not only sampled the berries but shared his "discovery" with priests at a local monastery. They noticed that eating the unknown fruit lifted their spirits. And, more important, the holy men found that it gave them strength and endurance through long hours of praying and chanting. It is easy to imagine coffee's place in history beginning at this point, as word and bean were passed excitedly from monastery to monastery.

Whether merely legend or actual history, the tale of Kaldi's discovery and the history of Ethiopia have been complexly woven together with time and telling. But one thing is sure: Kaldi could scarcely have comprehended the significance of his observation. After all, how could a simple herder tending his flock so many years ago foretell the enthusiasm and ardor with which the coffee bean was destined to become known throughout the world?

Sometime after its discovery, ancient Abyssinian travelers began to use the coffee cherry to make a pemmicanlike food. Grinding the dried fruit, they combined it with animal fat or butter, spices, and other grains. Shaped into small loaves, it provided a food able to withstand long overland journeys and ocean voyages. This practical and nourishing combination is still used today by some African cultures.

Eventually, coffee would make its way from Abyssinia to Arabia, a mere fifty miles across the narrow Red Sea. Circumstances of that travel remain unknown, though coffee might have traveled as food with Sudanese captives taken over the slave route to Arabia, or even been taken by the Ethiopians themselves when they drove into Arabia in the sixth century to capture land. Then again, coffee may have been carried by merchants along trade routes between Arabia and the interior of Africa. By whatever means it first made its way across the Red Sea, it moved beyond its indigenous borders and began a journey that would take it around the world.

· · ·

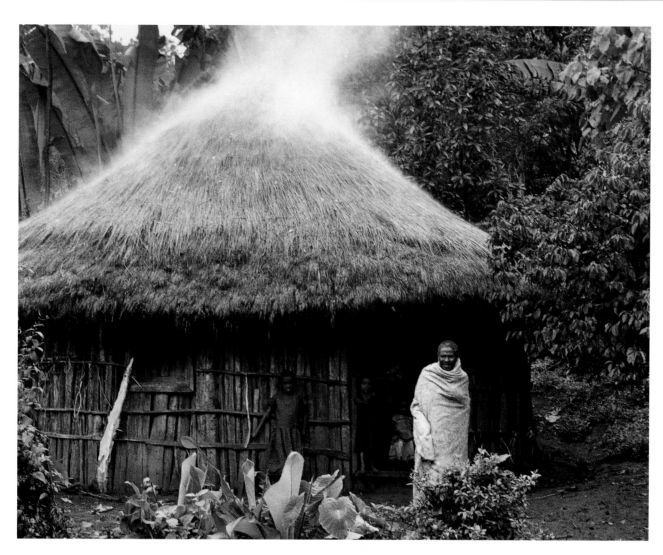

YIRGACHAFFE

The small Ethiopian town of Yirgachaffe, in the Sidamo growing region, is well known for its coffee. In the cool dampness of a rainy morning, a subsistence farmer stands outside his house while his wife and children view the day from indoors. Warmth from the cooking fire creates the combination of steam and smoke, which rise from their thatched roof.

Down the road and up the hillside, one sees a landscape of similar houses, each surrounded—like this one—by coffee trees. From every house a plume of smoke rises skyward, merging into the morning's gray fog, softly blanketing the town.

Our travels took us to coffee-growing regions and countries worldwide. In each we found a dynamic history intertwined with coffee, the history itself often brought to the country's shores with coffee's arrival. But in Ethiopia coffee is simply a way of life. It is taken for granted in a way that exists in no other country we visited. There are no dynamic upheavals in the history of coffee here because in Ethiopia coffee merely continues to be. Today it is a path to Ethiopia's future. At the same time it is a connection to the past in a land with a very long history.

To visit Ethiopia is to sense the meaning of *ancient*. The land itself seems worn beyond time. One can sense the soil's antiquity, and merely by standing on the land know that it has existed for millennia. Indeed, the thick but time-worn volcanic lava that covers much of the country has lain there for more than 40 million years. Located on the Horn of Africa, this country has a volcanic layer that forms the rugged mountains and high plateau that make up more than two-thirds of its geography. Lake Tana in the heart of these mountains is the source of the Blue Nile, which provides more than 60 percent of the water in Egypt's Nile River. Bisecting these mountains from north to south is the Great Rift Valley, which tears through the heart of Ethiopia south to Mozambique. The rift was caused by the shearing of the earth's surface when the Arabian Peninsula broke away from the rest of Africa.

Ethiopia's ancient character extends beyond its geology. The discovery of Lucy, the remains of a female hominid who lived on these lands more than 3 million years ago, suggests evidence that humankind's earliest ancestors lived here. It is possible that this land was not only the birthplace of coffee but the cradle of all humanity. One cannot help but wonder if even Lucy ate the berries of the not yet "discovered" coffee tree.

In its ancient history, this land is equally rich. Early Egyptians knew the region as the Land of Punt and attempted to conquer it in order to control the source of the Nile River. Ancient Greeks too traveled here. Ethiopia is believed to have been the home of the Queen of Sheba, from whom Menelik I, Ethiopia's first emperor, was descended, and the elusive Ark of the Convenant is said to reside in a monastery in Axum. Once part of a thriving and populous capital city, the eleven hand-hewn stone churches of Lalibela so dazzled travelers that they came to be known as the Eighth Wonder of the World.

The Arabs first crossed the Red Sea into Abyssinia in 1000 B.C.E., and Muslims are said to have lived here since the time of the Prophet Muhammad. Christianity arrived here about 300 C.E., becoming the Ethiopian Orthodox Church. Occupied briefly by the Italians in the 1930s, Ethiopia has the distinction of being one of only two African countries never to have been colonized by Europeans.

Ethiopia's people remain largely subsistence farmers, with more than 60 percent of the domestic economy based on crops. Coffee makes up more than half of the country's export earnings. Coming from a diversity of ethnic backgrounds, former kingdoms, cultures, and ways of life, Ethiopia's people speak more than eighty languages. Although predominantly Christian, the country also has a large Islamic population. Landlocked, Ethiopia exports its coffee through the port of Djibouti, connected by railroad to Addis Ababa, the country's capital.

Although mountain peaks rise to heights of 13,000 feet, coffee is grown on Ethiopia's highland plateau, or *wayna dega*. There are three distinct growing regions in Ethiopia—Kaffa to the west, Sidamo to the south, and Harar to the east.

The Kaffa region is often credited as the place that gave coffee its name. Both wet and naturally processed coffees come from here, though all of the region's coffee is dried in the traditional African style—on racks above the ground. Driving through this region, one can see miles and miles of these drying tables spread over the hillsides, and the whiteness of washed coffee set against the lush vegetation is a beautiful sight. Here too one can still find a *buna tchaka*, or forest of wild coffee trees, where workers must climb high into the branches to harvest cherry. Walking through the quiet shade of such a forest, with coffee trees reaching overhead in dense cover, is like walking through no other coffee grove. Compared to the pruned and ordered rows in which most modern-day coffee is cultivated, Ethiopian coffee forests grow with spontaneous abandon. When a seedling sprouts where a new tree is needed, it is simply left to grow.

Ethiopia's largest and most fertile growing region is Sidamo, supplying more than 30 percent of the country's coffee. Growing altitudes vary between 5,700 and 7,800 feet. The Sidamo town of Yirgachaffe is perhaps best known in the West, and some of the Ethiopian coffee that reaches the United States is sold under this origin name. The name of the town is derived from the words *yirga*, which means "stable," and *chaffe*, which means "municipality." The people here are of the Gedegna culture, and it is their tradition to place clay pots atop the conical thatched roofs of their round, wood-frame houses, or *gojjos*. The pots cover the apex of the roof, protecting the interior of the house from rain. In addition to coffee, Gedegna farmers produce numerous small crops such as false and real bananas, castor beans, sunflowers, peaches, and pineapples.

The Harar growing region lies in the highlands, near Ethiopia's border with Somalia. Predominantly Muslim, the region is dominated by two cities—the modern city of Dire Dawa and the ancient one of Harar. The former came into being at the turn of the twentieth century with the building of a railroad connecting Addis Ababa and Djibouti, a difficult five-hundred-mile stretch that took twenty years to build and consists of twenty-nine tunnels. Originally the line was to have passed directly through Harar, but bypassing the mountain city was a less costly plan. Even after following an alternative route through the lowlands, financiers ran out of money and the railroad terminated at a place called New Harar. Eventually the line was completed and New Harar came to be known as Dire Dawa. Today the train continues to make regular runs between Addis Ababa and the port of Djibouti, frequently transporting coffee for foreign sale. Not far from the modern-day rails, age-old camel trails along dry riverbeds are still hubs of activity, even as they were centuries ago.

With ninety-nine mosques, the walled, medieval town of Harar is one of the Islamic world's holy places. It remained unvisited by non-Muslims until penetrated by the British explorer Sir Richard Burton in the nineteenth century. Even today the city seems very much a part of the past. Harar's narrow, twisting streets are lined with whitewashed, two-story, flat-roofed houses while

vibrant markets scattered both inside and outside the town's ancient walls attract people from every walk of life.

Coffee from this region is processed the way it has been for centuries—strictly sun-dried. "To wash it would be to wash away its flavor," we were told over and over again. In markets worldwide, coffee from Harar is often sold as mocha, and while they tend to be slightly larger, the Ethiopian beans have a very similar flavor to Yemeni mocha. Considering the fact that the trees in both countries come from the same rootstock and are grown in comparable climate and soil, there is little doubt as to why the two coffees share attributes.

SIMPLE ELEGANCE MANIFESTS ITSELF IN MANY WAYS IN THE ETHIOPIAN CULTURE. But perhaps in no way is it more pronounced than in the process of making coffee. The method of preparation, so unlike any other, is often designated a ceremony. Whether it is served in a contemporary home or a simple village house, there is nothing quite as rewarding as watching and waiting for a traditionally brewed cup of Ethiopian coffee. One's senses come alive while inhaling the aroma of coffee beans slowly roasting over a wood fire, while waiting for the beans to cool and be ground, while watching the grounds be placed in a *jebena* with sugar and water, and while waiting—yet again—as the coffee slowly brews. Cups are warmed in the meantime, and, to tantalize the senses even more, *itan,* an incense made of myrrh, is lit. Corn is often popped and passed to those who have gathered, but it is for the coffee that everyone waits. When served it is sweet, hot, and fresh on the tongue, like no other coffee beverage. The first cup is savored while more water is added to the grounds in the *jebena* and a second pot is brewed. Likewise, there is a traditional third brewing. Conversation may continue long into the afternoon or evening, for serving coffee this way is social artistry. In the manner of its slow preparation, coffee itself is honored as a presence in the lives and history of the Ethiopian people.

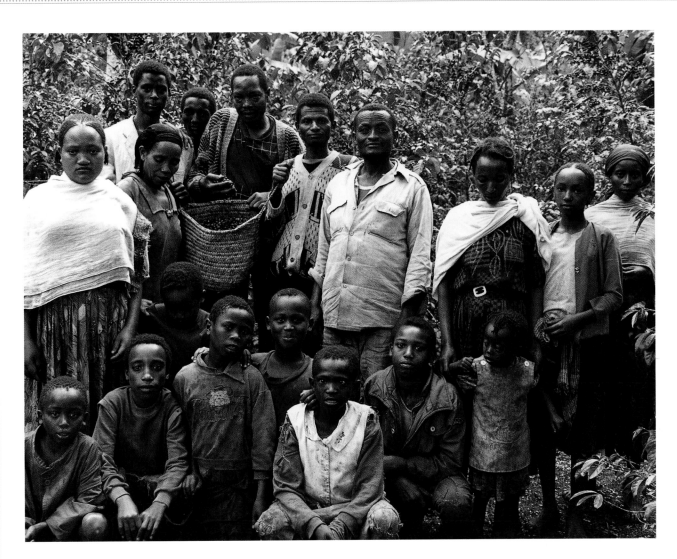

WORKERS GATHERING

*More than a day's work, picking coffee is often a social
activity in the small towns and villages of the Ethiopian
countryside. It is not uncommon to find a large coffee field
filled with many people—male and female, young and
old—working, playing, or watching. Laughter and loud
conversation are punctuated by the sounds of children
running in their games. From a great distance these workers
could be heard conversing noisily to the rhythm of their
harvesting in a stand of very old coffee trees.*

THE WHITE HORSE

In coffee fields the world over, there is always an air of urgency about getting the day's harvest in to be weighed and processed. Horses are an essential means of transportation in Ethiopia. In contrast to the commotion around it, this horse stands patiently while heavy loads of coffee are removed from its back to be placed on a nearby scale. As a long day of work draws to a close, excitement and relief culminate with the bustle of noisy activity.

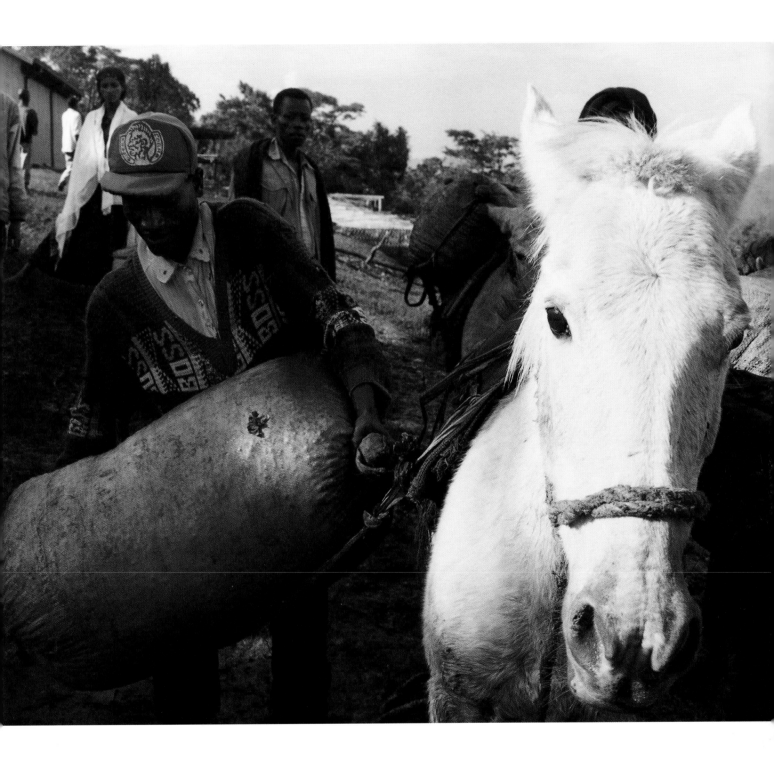

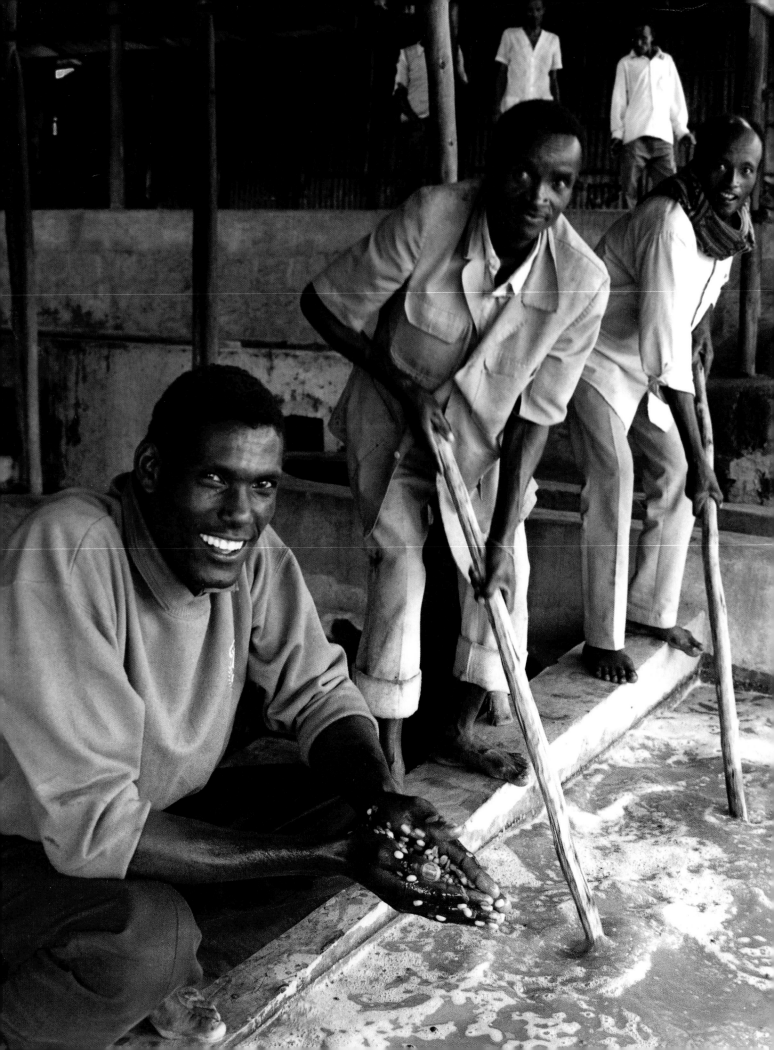

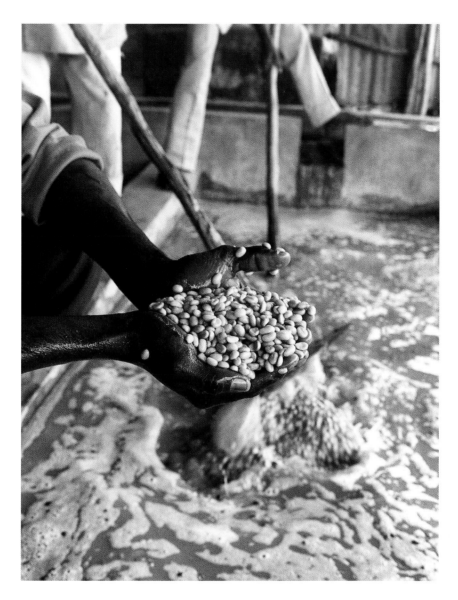

WASHING COFFEE

Washed coffee is hulled immediately after picking. Then the beans are soaked in tanks of water to loosen the fruit's mucilage remaining on the bean. Afterward, still in the white parchment skin, the beans go through a final rinse before being taken outside to dry.

Laughing and joking with one another, these men share responsibility for soaking and washing coffee beans, using simple wooden rakes to assist their work. The tart aroma of ripe fruit permeates the air, as does the sound of the beans being stirred in the huge tanks of water.

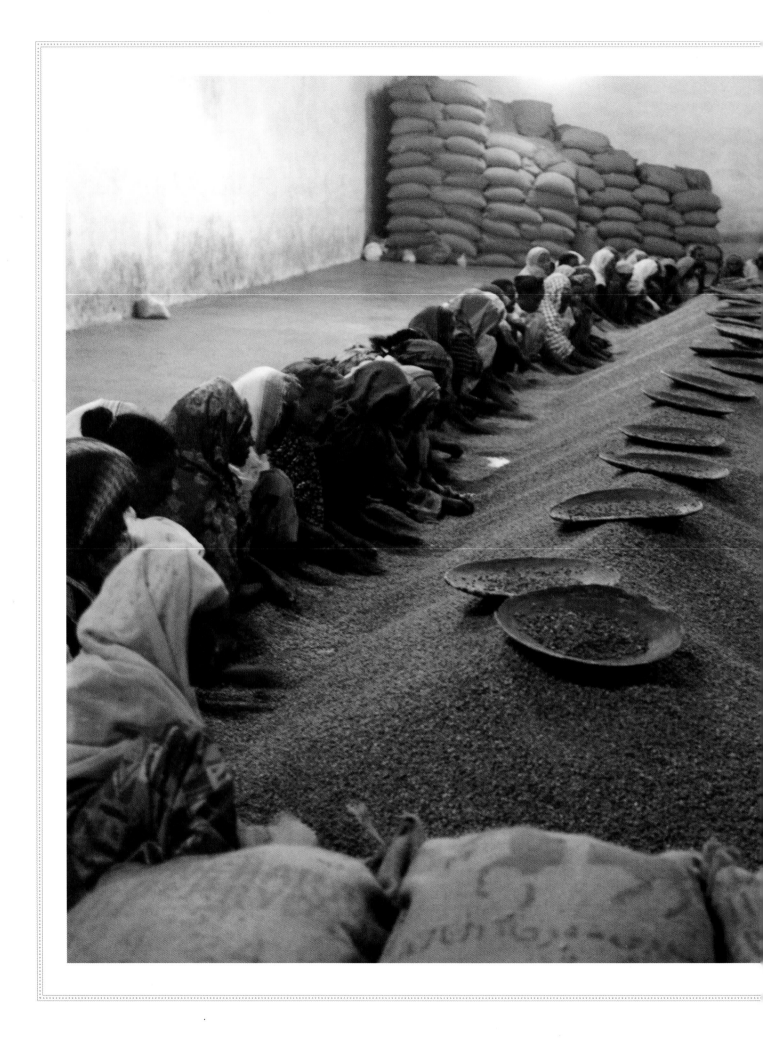

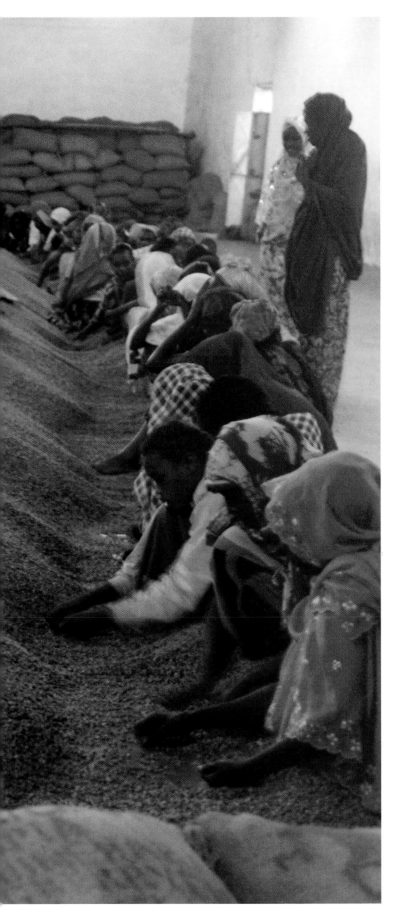

LADIES OF HARAR

Sitting on the floor of a modern coffee warehouse in the city of Dire Dawa, these women face a seemingly endless mountain of coffee. Their workday is spent sorting beans by hand—as has been done in this region for centuries. Pulling a small handful toward them, they sort—bean by bean—discarding those of lesser quality into the metal trays in the center of the mound. As the women continue their work, the accumulation of sorted beans begins to encircle the diminishing mound of those unsorted, eventually forcing the women to sit on the growing pile they create.

Despite the placid order of this scene, this is by no means somber or silent work. Singing in unison, the women's voices fill the vast warehouse with a joyful sound. Repeated over and over, their chantlike song imbues their work with energy and momentum. At the song's end the women burst into elilta, *a rapid trilling that is a sign of happiness. The chaotic sound fills the room, then gradually fades into silence—until the next song begins.*

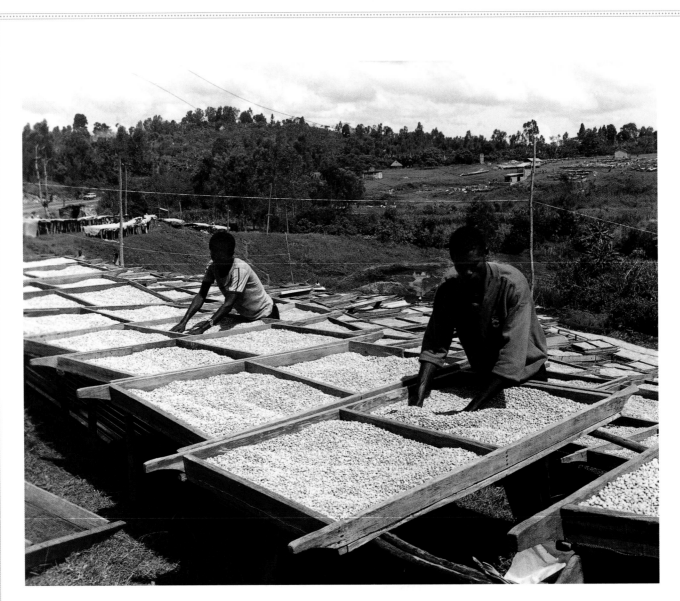

SIDAMO DRYING RACKS

African coffee is traditionally sun-dried on aboveground racks, which allow air to circulate both over and under the coffee. These men turn just-washed beans by hand, moving from rack to rack. The process continues until the harvest is over. Until then, each rack of beans will have to be turned many times a day for the many days it takes the beans to dry. And when this batch of coffee has finished drying, a new one, just washed, will arrive to take its place.

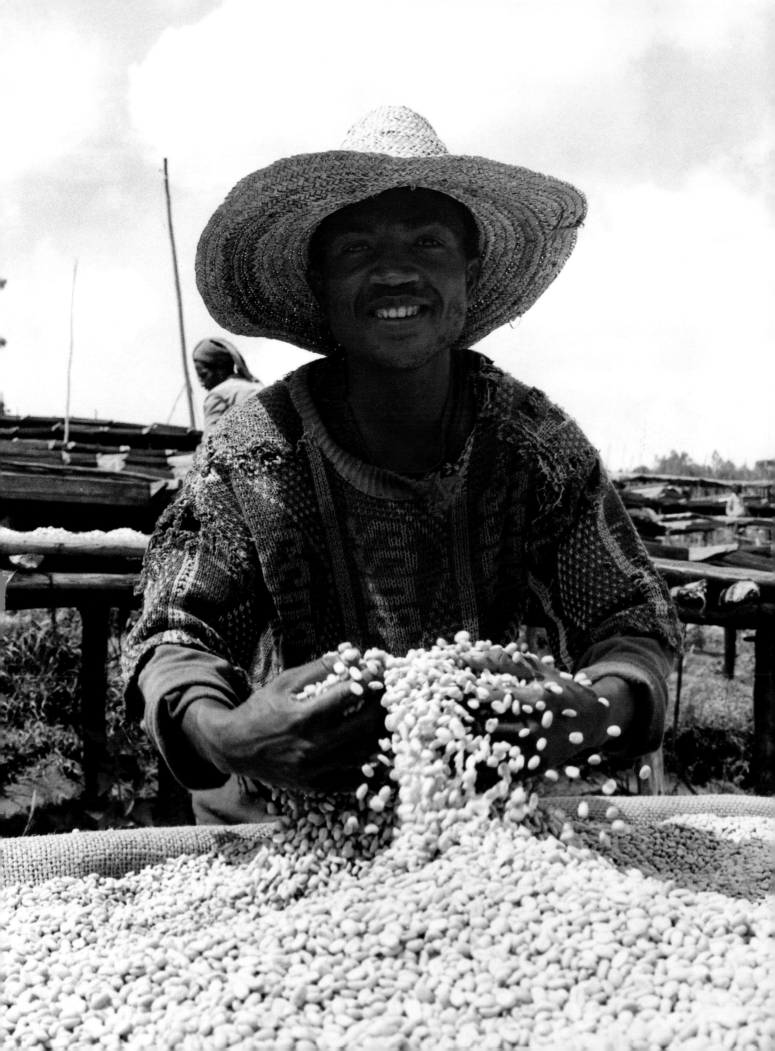

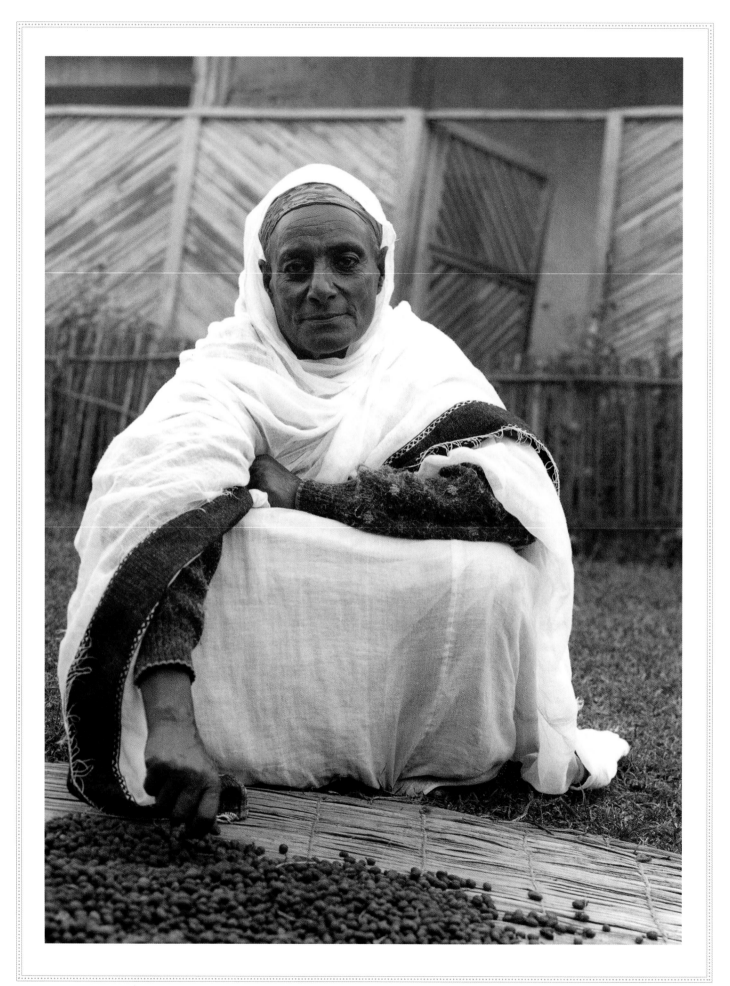

MAN IN WHITE

In Ethiopia major roadways are ancient lifelines, little changed by the years. Villages grew up alongside them centuries ago and people built their lives in close proximity. Even today nearly all of Ethiopian life seems to take place on or near these historic byways.

If you happen to be traveling through a small village, such as this one in the Kaffa region, you will catch engaging glimpses into the lives of its inhabitants. Villagers continually traverse the road, frequently by foot, herding their animals and carrying water to their homes; young children play nearby while old people watch over them. Everywhere men and women spontaneously gather to converse.

Outside his home this man sits near the side of the road, where he can observe the activity. Protected from the cool temperatures of the evening by a traditional, white cotton shema, *he turns coffee.*

JEBENAS

The traditional container for preparing coffee in Ethiopia is the jebena, *a round clay vessel. To brew the beverage, freshly roasted and ground coffee, sugar, and water are placed inside and steeped, often over a wood fire.*

In a small roadside village in the Sidamo region, this young woman works in a family-owned factory, crafting jebenas *in their simple, wood-frame house. Alongside her mother, she sits on the dirt floor in the cool, dark room, which has no electricity, fashioning these beautifully symmetrical pots freehand out of wet clay. When finished, the still-soft vessel will be placed in the sun to dry. Later, the* jebena *will be glazed and fired in a wood-burning kiln.*

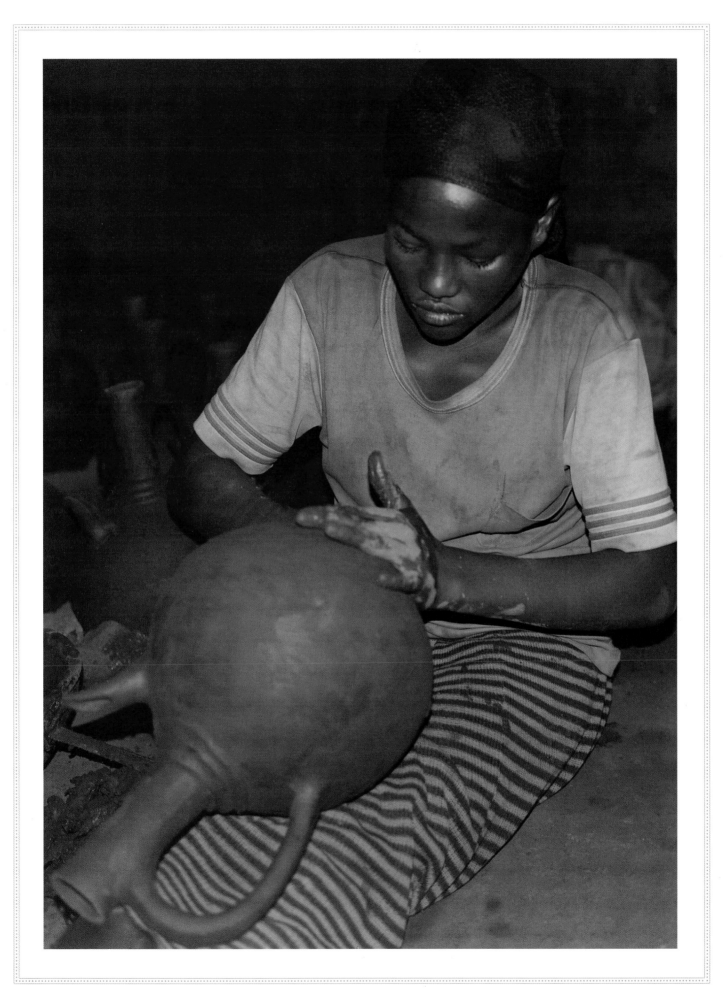

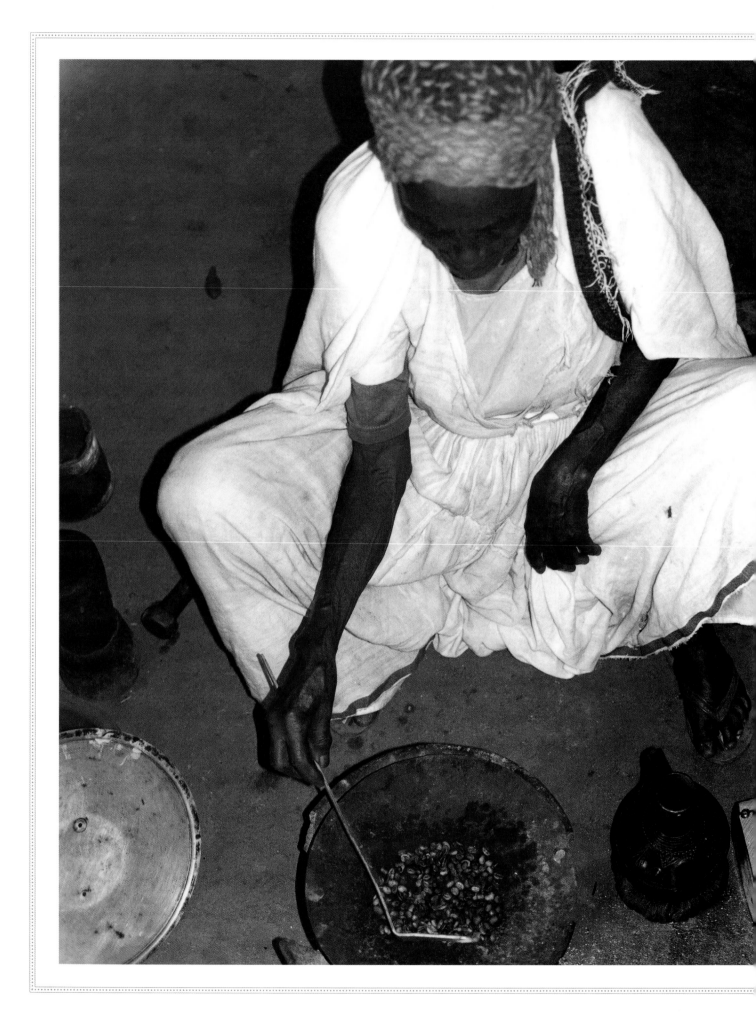

THE COFFEE CEREMONY:

ROASTING THE BEANS

Mulunesh Yadete, in the village of Dengego

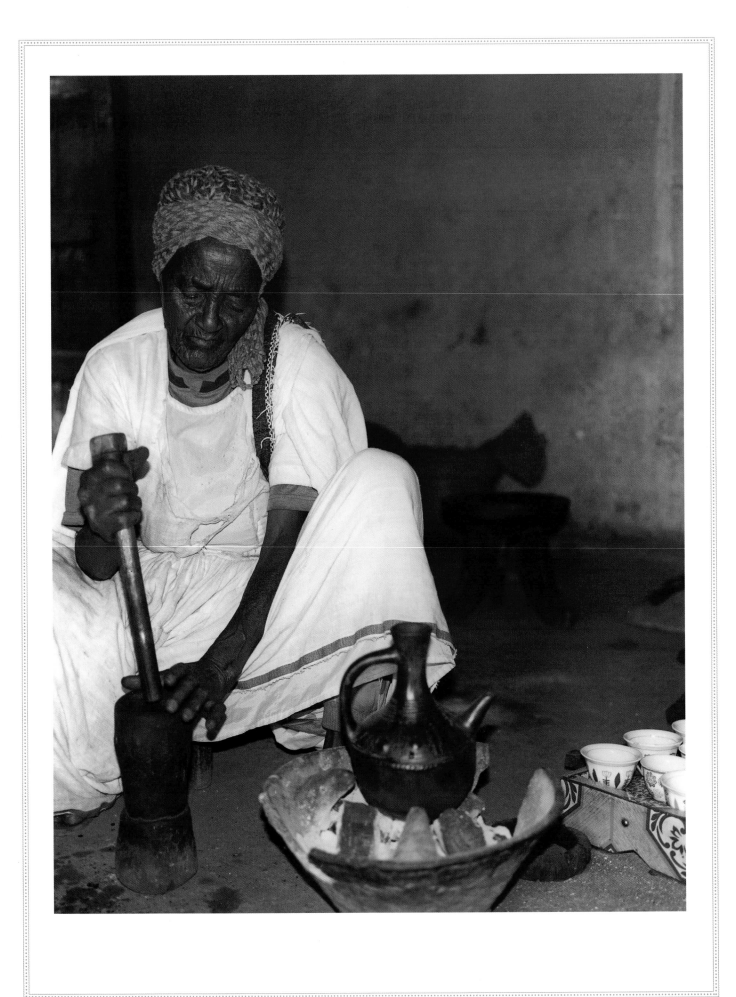

THE COFFEE CEREMONY:
POUNDING THE BEANS

While Ethiopian men and women work together in the fields to grow and produce coffee, women alone turn the unroasted beans into fragrant beverage. Traditional implements for this process include a pan on which to roast the beans and a tool with which to turn them, a clay jebena *in which to make the sweet beverage, and small, handleless cups from which to drink. Tradition likewise dictates the steps each Ethiopian woman follows: first roasting the beans, then preparing the coffee and lighting* itan, *a myrrh incense, while waiting for it to brew—processes that might be the ancient precursors to those employed by modern coffee aficionados around the world.*

But there is a difference. Coffee is indigenous to this culture and the tradition these women follow is as old as the brewed beverage itself.

Outsiders, observers, and travelers coming to Ethiopia have watched women preparing coffee this way for centuries. In this process they have found a grace and beauty, a sensuousness that seems to transcend the task's simplicity. Here one senses the history of coffee, its connection to this soil and its age-old legacy.

Many call this unique preparation a ceremony. We prefer to think that it is simply the Birth of Coffee.

YEMEN

A LAND OF AMAZING CONTRAST AND FASCINATING HISTORY, Yemen is a modern country with one foot still set firmly in the past. Across this land on the Arabian Peninsula, camel caravans journeyed over ancient frankincense trade routes; and as early as the tenth century, news of a dark beverage drunk by the Arabs began to spread beyond its realm. First cultivated in the semiarid highlands of present-day Yemen, coffee was exported from its shores on the Red Sea to destinations around the world. Over time the old-world port town of Al Mokha would become so closely identified with coffee, its major export item, and the growing demand it created around the world, that the name of the port would become synonymous with the bean itself. Even today coffee from Yemen is often referred to as Yemeni Mocha, although it has long since ceased to be shipped from there.

Historically, the region was called Arabia, and often Arabia Felix. The latter name originated with an anonymous Greek writer in the first century C.E., although the intent remains unknown. But it is not hard to imagine why Arabia might have been thought of as fortunate or happy. It gathered wealth over many centuries from its strategic location along land and sea routes, becoming a way station and market center for travelers, merchants, and traders. Arabia benefited as well from yearlong temperate climates in its highlands, enhanced by mild rainy seasons, providing a fertile growing region before the highlands began to drop toward the sands of the vast Arabian desert.

Before coffee, Arabia's primary commerce was derived from the resins of two trees that flourished along the coast of the Red Sea. From these resins came myrrh and frankincense, perfumes traded by Arabian merchants the world over. Responding to the increased demand for the essences, huge caravans—sometimes containing more than a thousand camels—traveled the peninsula on the overland route, known as the Frankincense Road.

When and how coffee crossed the Red Sea from the Horn of Africa to Arabia remain unknown. Although Arabians were familiar with the coffee cherry as early as the sixth or eighth century, roasted and brewed coffee may not have originated until later. The Arabian physician Rhazes was the first to write about coffee's medicinal purposes, in the ninth century. By the mid-1400s, coffeehouses were serving patrons in Mecca and Medina. Even so, coffee remained essentially an Arabian beverage until sometime around the fifteenth or sixteenth century.

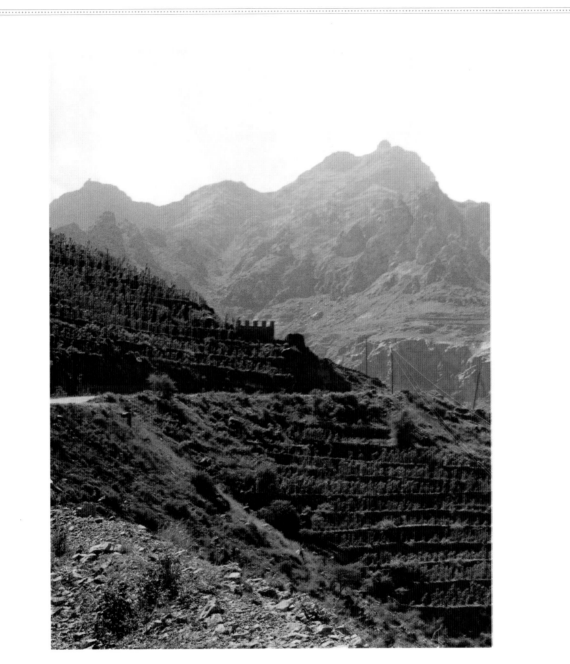

ANCIENT COFFEE TERRACES

At first glance it is hard to imagine coffee growing upon such topography. First brought to the Arabian Peninsula from Ethiopia, coffee trees were cultivated on intricate terraces as early as the tenth century—making the western highlands of Yemen the oldest commercial coffee-growing region in the world. Today, more than a thousand years later, coffee continues to grow on the same ancient terraces.

By the sixteenth century, the port of Al Mokha was well on its way to becoming the world source for coffee. The city was founded by Sheikh Ali Shadili, likely in the fifteenth century; some say that it was the sheikh himself who was responsible for bringing coffee to Yemen for cultivation. A coffee lover, he enjoyed offering the then-unknown beverage as a welcome drink to foreign sailors. Beans coming to Al Mokha were grown in the nearby highlands and transported across the rugged mountains by camel. Under the rule of the Ottoman Turks, Al Mokha prospered into the early eighteenth century as the Arabians held the world monopoly on coffee. But competition, first from Dutch-grown Javanese coffee, then from coffee grown in the New World, weakened the demand for Arabian-grown beans. By the early 1800s the British occupied the port to benefit from its strategic location on the Red Sea. Decreasing demand for coffee combined with British occupation and competition from the natural deepwater port of Aden nearby sent Al Mokha into a decline from which it never recovered. Today Al Mokha is a silted port and little survives from its glory days except the aging remains of luxurious houses once owned by wealthy merchants.

But back in the 1600s coffee was just beginning to be known outside of Arabia, and there was a steadily growing demand for the bean. In 1610 Sir Henry Middleton, director of the British East India Company, arrived in Al Mokha to establish trade and returned to England with bags of coffee. The Venetians began importing coffee from Al Mokha in 1615, and in 1616 the Dutch East India Company sent Captain Pieter van der Broeke to Al Mokha. Upon returning to Holland, van der Broeke reported having seen in the Arabian port goods from both Venice and Nuremberg, and more than thirty ships from as far away as India and Persia. By the late 1600s coffeehouses were beginning to appear all over Europe and in America.

The Arabs were secretive about coffee and tightly maintained control of their monopoly. Before export, green beans were reportedly boiled or dried to prevent the seeds' germination. But given the growing worldwide demand for coffee—along with sharply rising prices and an ever-increasing shortage—it was only a matter of time before fertile beans were smuggled out of Arabia and successfully planted abroad. In this way coffee came to be grown in both Ceylon (now Sri Lanka) and India. Ultimately the Dutch were successful in seizing the coffee monopoly from the Arabs. In 1712 they exported their first coffee from the island of Java to Amsterdam, challenging the Arabs with their first competition in the European market. As late as 1721, however, the Dutch East India Company was still importing 90 percent of its coffee from Al Mokha. The transition happened quickly—just five years later Dutch East India Company imports had increased to twenty times the amount in 1721, with the majority of that coffee coming from Java. Able to produce and sell at lower prices, Holland became the world's leading producer and exporter.

THE CITY OF SANA'A PLAYED A MAJOR ROLE IN THE ARABIAN COFFEE TRADE, even though its own history predates that time. This present-day capital of the Republic of Yemen is

said to have been founded by Noah's son Shem. The walls around the medina, or ancient center of the city, still stand, inside of which an old-world way of life still seems to be actively taking place. Streets are lined with four-hundred-year-old houses, built of stone and mud-colored brick just as they were a thousand years ago. Ornamented with circular and arched stained-glass windows and decorated by white bands of geometrical patterns, they are magical by day, even more enchanting when lit from within at night.

In the heart of the city, near the Bab al-Yaman, or Gate of Yemen, is the Suq al Milh. This is the traditional central market of Sana'a, made up of forty or more small suqs, each specializing in a commodity, such as silver, corn, spice, or coffee. In ancient times, the suq was not only a center for commerce and the exchange of news, but also an inn for traveling merchants, whose pack animals were housed in the lower level while they slept above. Today goods that were traded in Arabia Felix continue to be bought and sold in the same age-old locations. Throughout the market there is such an overwhelming atmosphere of days-gone-by that it is no surprise to look past a well-used wooden doorway into an unlit suq and see a camel turning a huge old millstone used for pressing oil. To inhale the fragrance of the freshly pressed olive oil mixed with the heady, strong scent of the camel is to forget the traffic and noise of the modern city—just a few blocks away.

Many of these photographs come from the Suq al Milh. Being inside this old, walled city—by day and by night—was simply magical. From market to market, stall to stall, traders and shopkeepers welcomed us into their worlds—to converse, to bargain, and even to drink coffee. The overseer of the coffee market was especially cordial. He explained how he travels to regional markets to purchase coffee. Upon learning that we were planning to travel to the Manakhah Coffee Market the next morning, he assured us that he would be seeing us again, because he was taking a truck there the next day as well. At daybreak the following morning, true to his word, a large vehicle noisily passed us high in the Harraz Mountains. With lights flashing and horn honking, he leaned out the window and gave a sweeping wave for us to follow.

MANAKHAH, A MOUNTAINTOP TOWN SIXTY MILES WEST OF SANA'A, SITS ALMOST invisibly along the tops of several peaks. Down narrow alleyways, past carved wooden doors and shops selling a great variety of wares, is Manakhah's well-known coffee market. It continues to serve the region's residents, as it has for centuries.

In modern Yemen, united in independence only since 1990, renewed emphasis is being placed on coffee agriculture. Coffee is grown entirely by small growers in this tribally based country where 75 percent of the population still live in small villages. In spite of Yemen's important role in the history of coffee, today most of its production is exported and it is primarily a tea-drinking country.

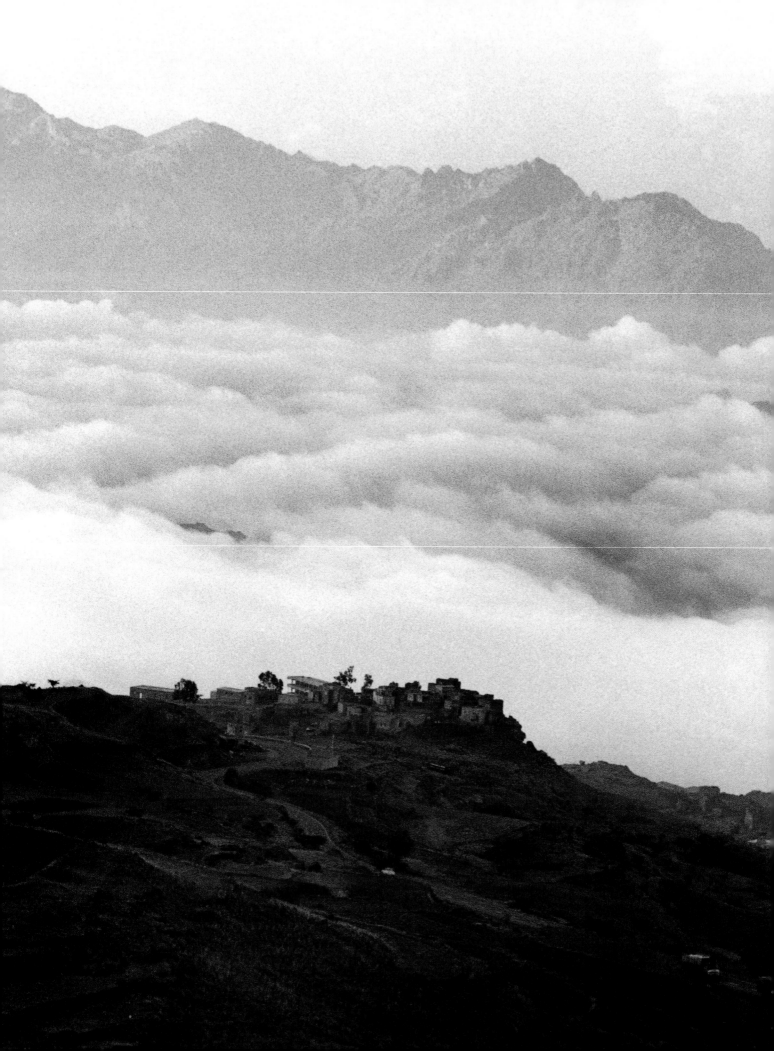

THE ROAD TO MANAKHAH

Coffee can be found growing almost anywhere in the immense, rugged Harraz Mountains of Northern Yemen. Initially intimidating, this road first takes its passengers to the valley of Al Haymah, lying miles below in dense cloud cover, a journey that might easily be compared to driving to the bottom of the Grand Canyon. Thankfully the road is smooth and wide, allowing travelers to enjoy, without distraction, the amazing views of terraced farms where coffee has grown for centuries. Climbing the mountains on the other side of the valley, the road leads to Manakhah, high atop a mountain peak. The walled town, built of rock and mud, is so well camouflaged as to be nearly invisible.

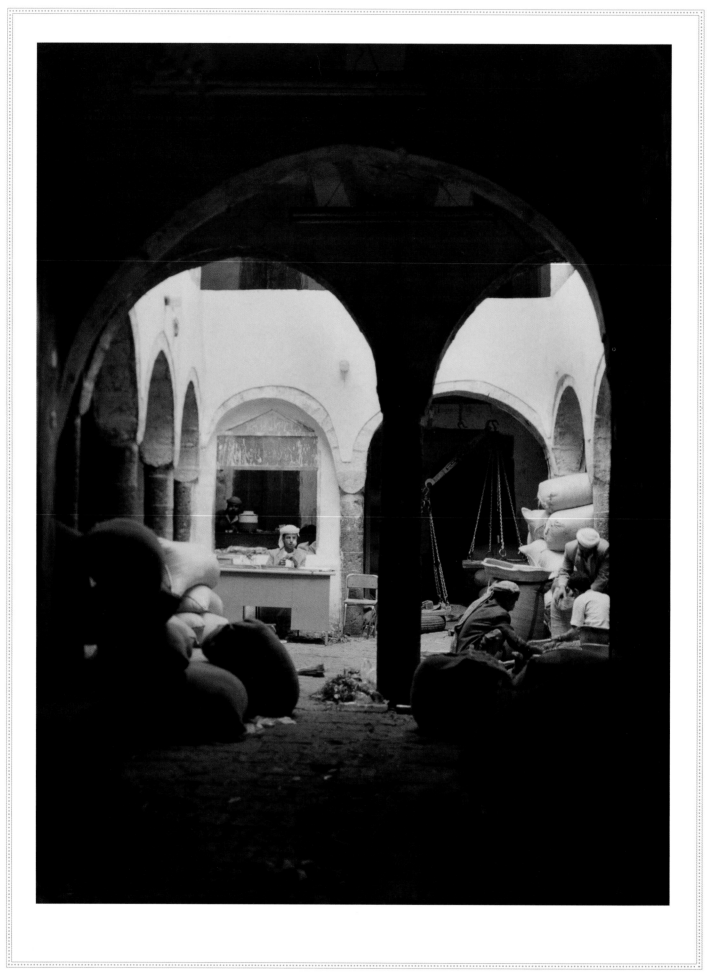

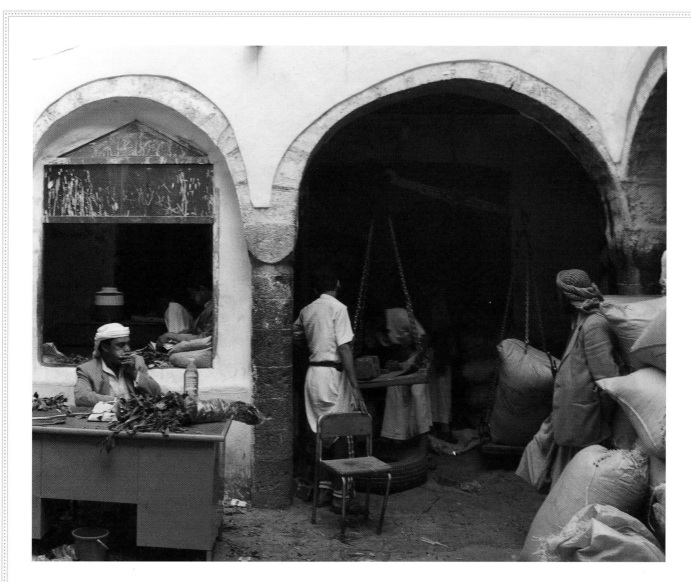

THE SUQ AL-MILH

Yemen is a harmonious mixture of ancient and new. In the capital city of Sana'a, the comforts of the modern world exist alongside a market that has remained basically unchanged for centuries. Here one finds the coffee market, where coffee has been traded for more than eight hundred years. From brokerages like this one, the first cultivated coffees were purchased and exported around the world.

Standing at the doorway of the coffee market, one straddles two entirely disparate worlds. Outside the market are cars and buses, paved streets and telephones; within these walls men attend to the coffee trade the way it has been handled for centuries, almost entirely without the benefit of modern convenience. Without question it is business as usual.

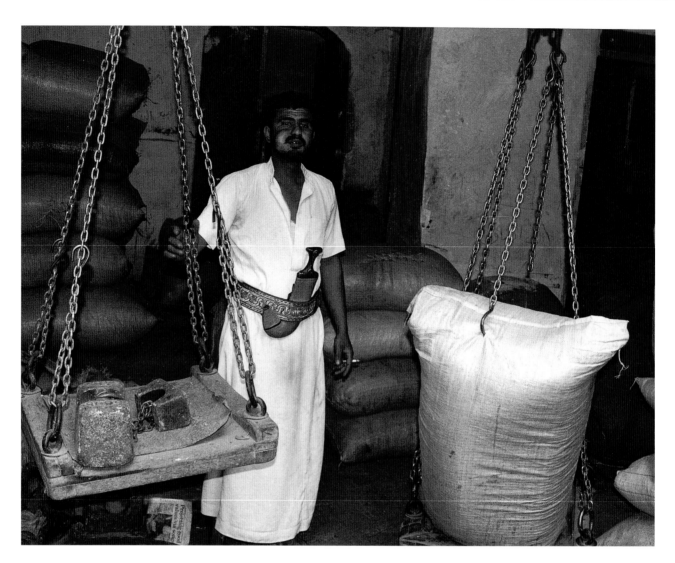

THE SCALES

*The keeper of records in the coffee market weighs a
bag of coffee on a traditional scale against an age-old
counterweight. Just as in early times, every bag of coffee
entering the market has to be weighed and recorded. The
dagger, or* djambia, *he wears is traditional as well, and
worn by men throughout Yemen. Symbols of status and
social position rather than defense,* djambias *are often
handed down from father to son. The older the dagger, the
finer its workmanship, and the rarer the materials it is
made of, the greater social and monetary worth it connotes.
Along with his style of dress, a* djambia *identifies this
man's tribe.*

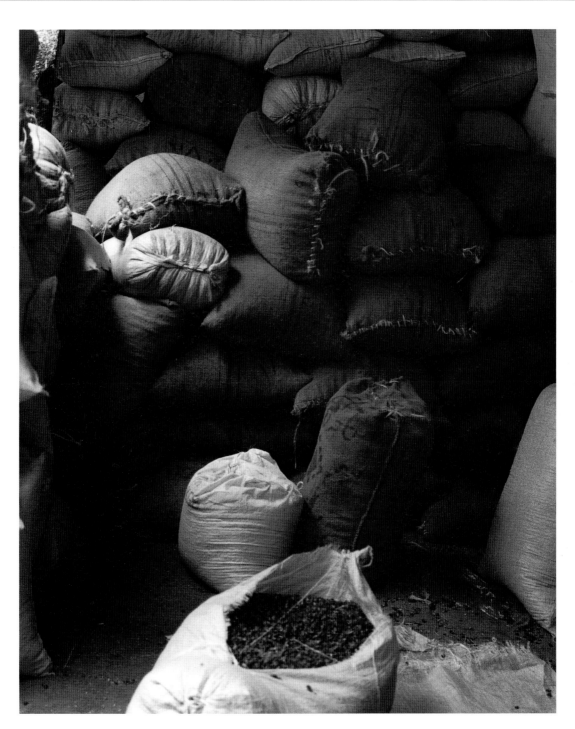

COFFEE BAGS

Hand-sewn bags of coffee are found stacked in every recess of the Sana'a coffee market. Wandering from room to room, one is conscious of how cool this ancient stone building remains even in the heat of the day. Experiencing it is reminiscent of visiting a very fine, old wine cellar— the feel of the old world is conveyed by the wonderful scent of aged stone walls and well-used jute bags, mixed with the distinctive aroma of new green coffee.

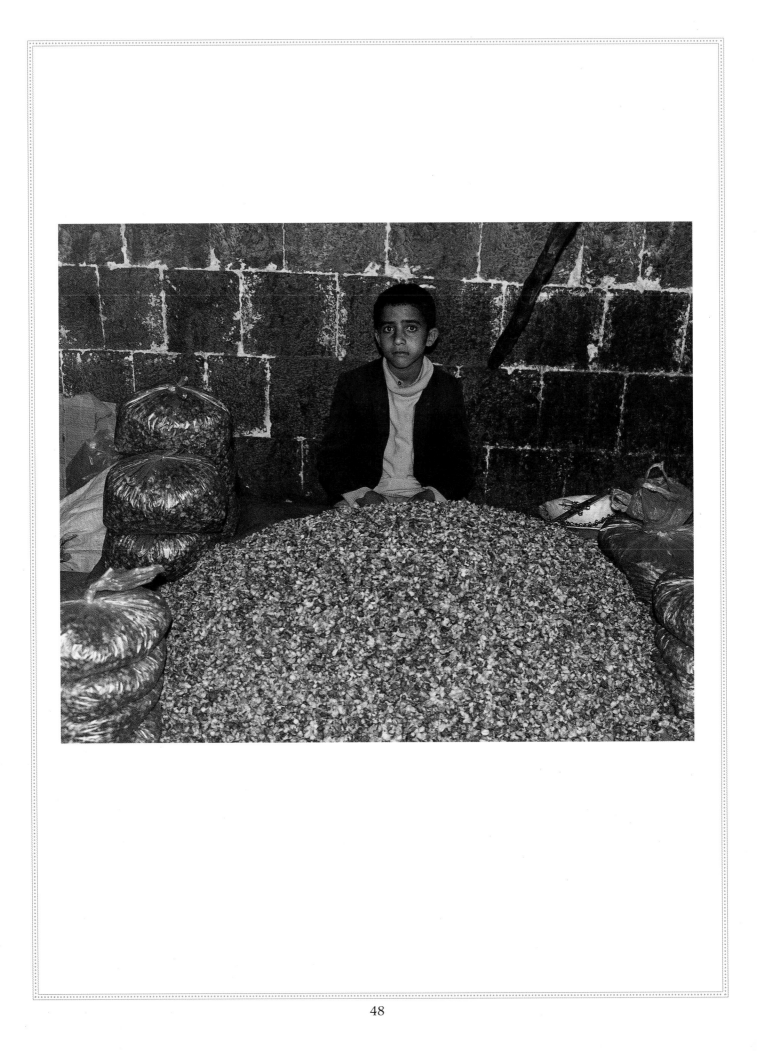

QISHAR BOY

At night, under the light of sparsely placed electric bulbs, the Suq al-Milh has a mysterious air. In one of the market's dim corners, this Yemeni boy sells dried coffee husk. In other coffee-growing nations the dried fruit of the coffee cherry is discarded, usually composted and spread on fields as mulch. But in Yemen the husk is used to prepare a popular drink called qishar.

Qishar *is made by steeping the milled husk and sugar in boiling water with spices such as ginger, cloves, or cardamom. The hot, sweet beverage is so well liked that, locally, it brings a higher price than coffee, most of which is exported.*

Coffee as we know it today—roasted, ground, and brewed—was not drunk until perhaps the thirteenth century. Before that time, the whole dried cherry was infused in boiling water to make a beverage. That might make qishar *the oldest coffee beverage in the world.*

WINNOWING COFFEE

In an arid country like Yemen, ripe coffee cherry continues to be dried in the age-old method—unhulled in the sun. The flat roof of a house is often used for this purpose. Afterward the coffee is hulled, generally by grindstone, then winnowed. Here a young man is removing the husk from the beans.

While these men attend to work and conversation in the coffee market, their cheeks bulge with qat, *a mildly narcotic leaf.* Qat *grows on trees that look similar to coffee trees, and while driving through the terraced countryside, it is often hard to distinguish coffee and* qat *trees, especially since the two are often grown together. Because* qat *is the more lucrative crop, farmers prefer it to coffee. As a result, both the cultivation and the use of* qat *are rapidly increasing in certain regions and throughout the country men proudly display swollen cheeks as a status symbol.*

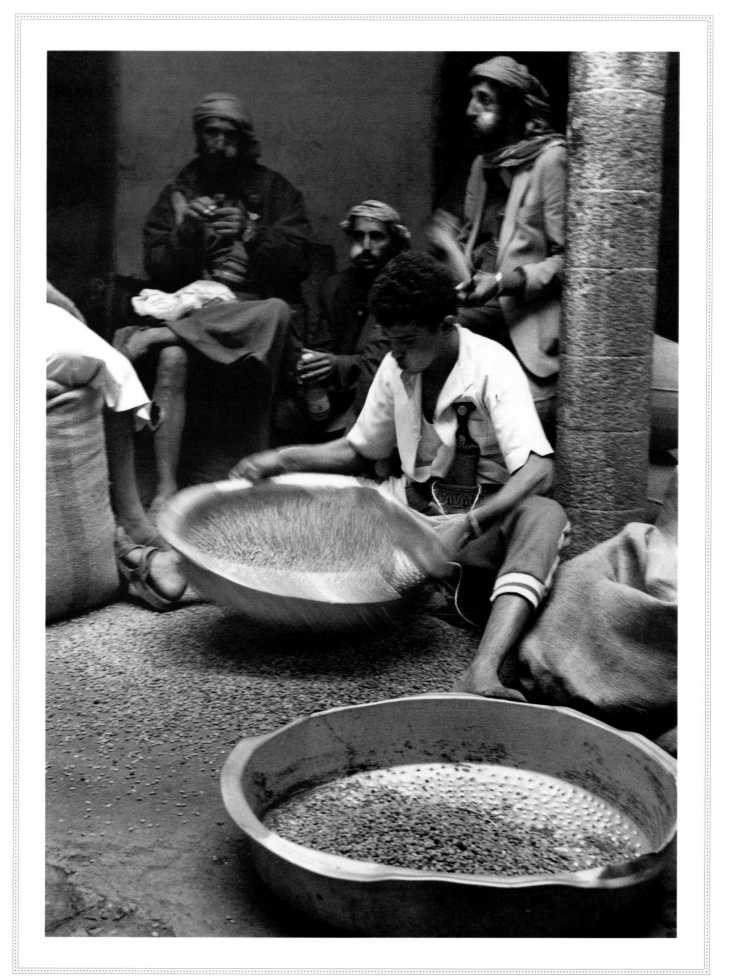

THE STREETS OF MANAKHAH

In the small town of Manakhah, several hours by car from Sana'a, the old city is a maze of narrow streets. Women, often behind full veil, are seen only fleetingly. Photographing them is against tradition.

Coffee is strictly in the male realm in Yemen. Whether transporting coffee to market, pulping, winnowing, weighing, measuring, buying, or selling—the industry is exclusively composed of men conducting business with other men. When they are old enough, their sons will be initiated into the revered cultural tradition.

This man stops for a moment to rest his heavy load of coffee as he nears the Manakhah coffee market.

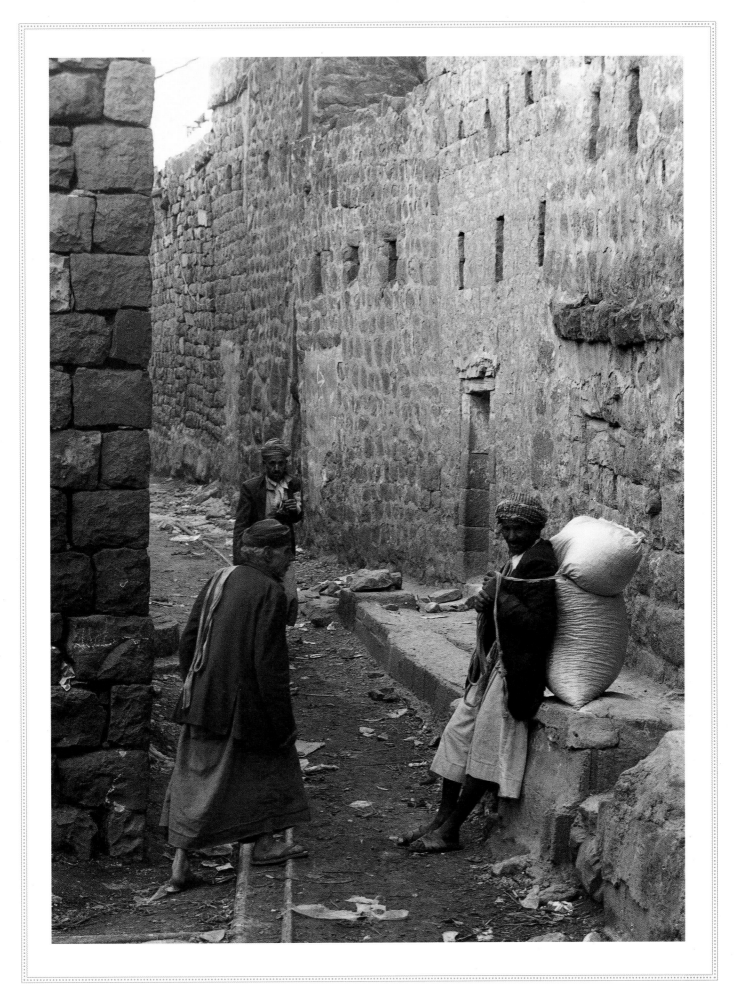

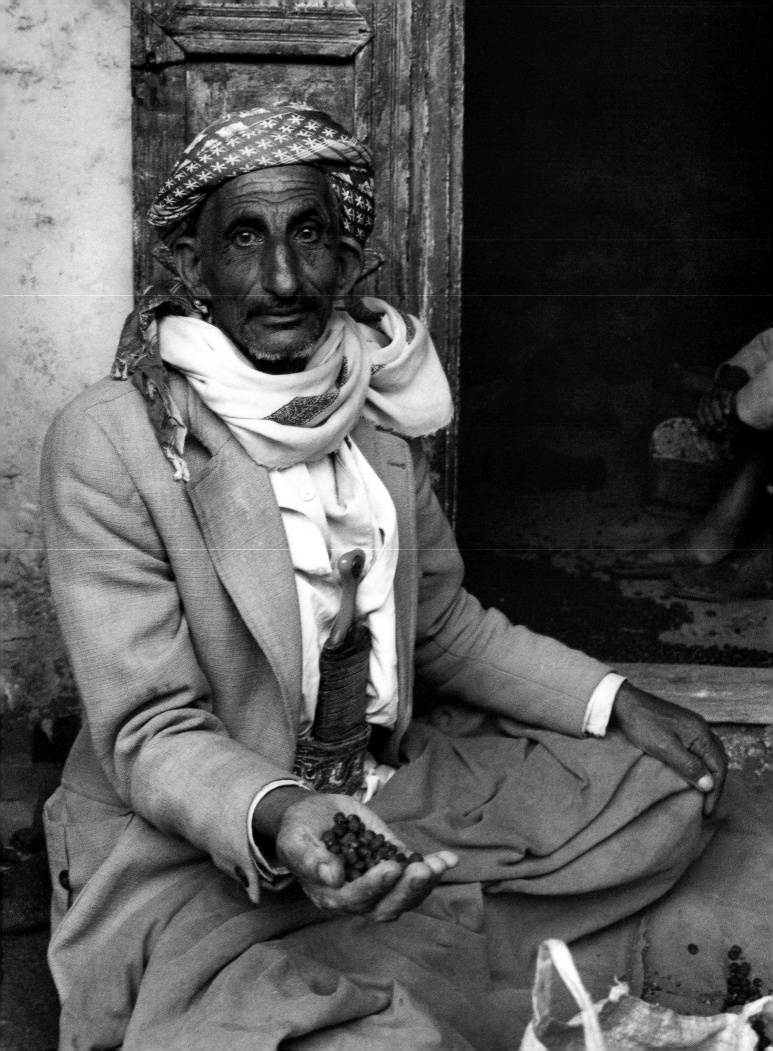

THE COFFEE MERCHANT

In the simplest display, this man holds out his coffee for passersby to see.

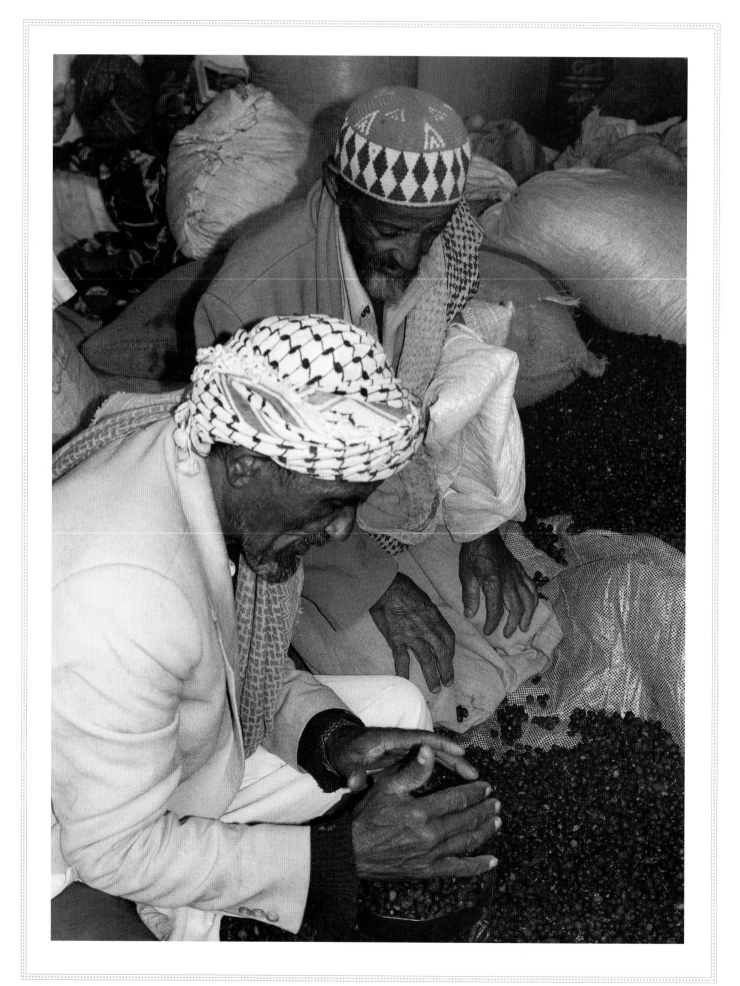

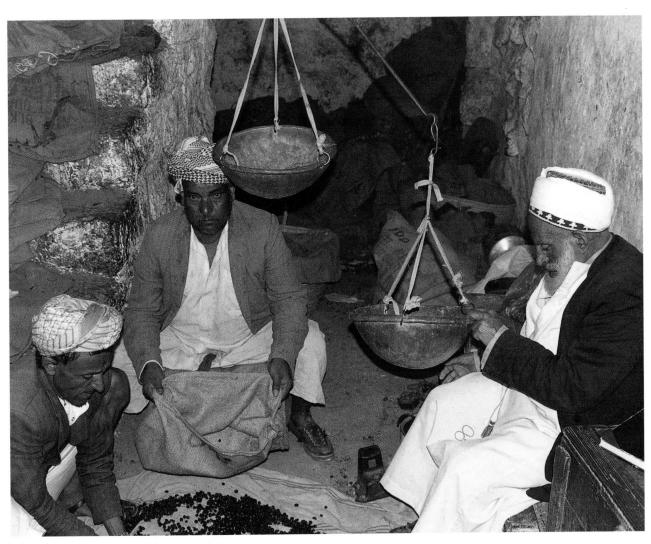

THE TRANSACTION

Not all of the coffee sold in the Manakhah market is green and destined for export. This man purchases roasted coffee from a vendor, maybe to serve during the daily afternoon social time when men gather to converse and chew qat *together. These spontaneous gatherings often take place in the* mafradsh, *the formal room at the top of the host's house. Initially marked by enthusiastic dialogue, conversation gradually subsides as the effects of the* qat *begin to take hold. Late in the afternoon, coffee or tea is served before the gathering disperses.*

WEIGHING COFFEE

On a scale made of goatskin, these men weigh coffee in the Manakhah coffee market. Even though they gave permission to be photographed, one man later objected and waved us off after the image was taken. A local imam, or Muslim holy man, he was displeased because of a strict Islamic tenet that forbids the making of portraits.

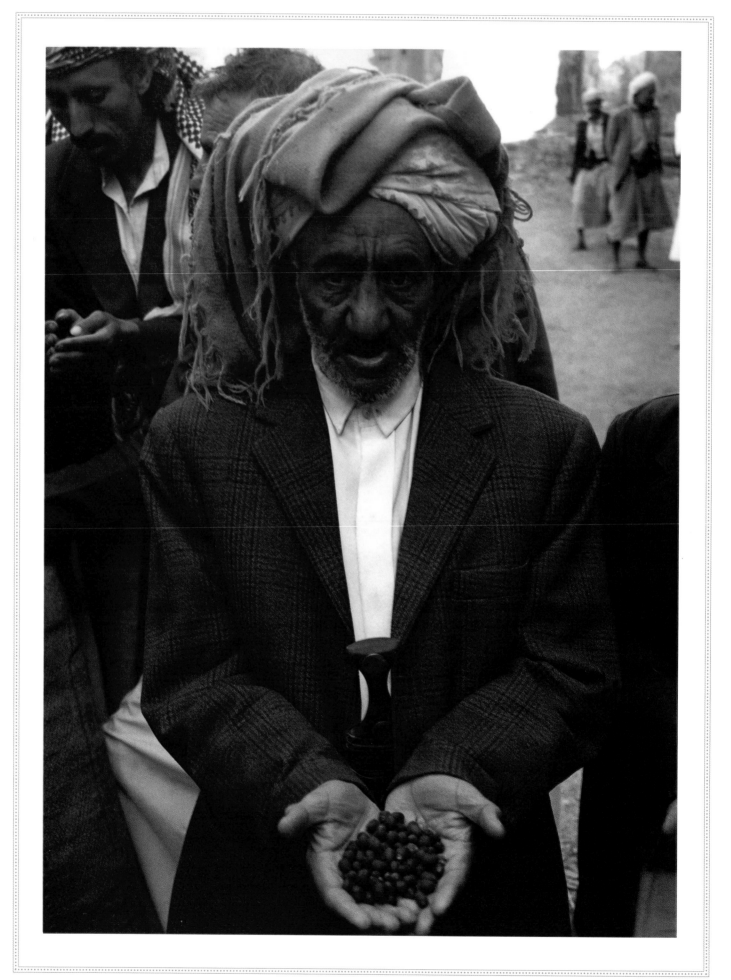

THE COFFEE SELLER

This man proudly shows his coffee in an effort to sell it in front of the Manakhah coffee market. Coffee is one of many crops he grows on his small farm in the mountains nearby. Growing coffee, he gravely states, has been a family tradition for many generations. Now, he says proudly, his son grows coffee, too.

INDONESIA

INDONESIA IS AN EVER-CHANGING MOSAIC OF CULTURE—ALMOST incomprehensible in its diversity and fascinating in the complex backgrounds of its many ethnic people and eruptive landscape. Each of Indonesia's social cultures contributes its unique art and architectural forms, cuisines, dialects, mythologies, traditions, religions, and even dress. With more than 300 ethnic groups and 583 languages and dialects, it is truly a land of contrast. But while each of the Indonesian islands is singular in culture and history, many share rich, volcanic soil—ideal for growing coffee.

The fertile land that grows Indonesian coffee results from the island nation's location. An archipelago of nearly fourteen thousand islands, Indonesia stretches along the equator between the Pacific and Indian Oceans, spanning more than 8,000 miles from Asia to Australia. Beneath these islands two continental shelves, the Indian and the Pacific, meet in perpetual agitation. The result: the islands of Indonesia sit atop one of the world's most active volcanic chains. With more than three hundred volcanoes, the region has a history marked by many volcanic eruptions, some of extraordinary size. The sound of Mount Krakatau's 1883 eruption—the most powerful in recorded history—was so loud that it caused sheep to stampede nearly 2,500 miles away in Southern Australia.

Coffee grows almost anywhere in Indonesia, but the islands of Java, Sumatra, and Sulawesi have long been known for their coffee and remain Indonesia's major exporting islands. While some of the coffee on these islands comes from large plantations, most is grown on village farms, often in remote locations. Throughout the country there are more than 3.6 million small farms on which coffee is grown.

For the better part of three hundred years coffee has been a vital part of these islands' economies. Although the coffee industry came to a temporary cessation in the late 1800s when disease swept through the islands killing the trees, today coffee is again one of Indonesia's greatest exports.

The story of Indonesian coffee begins with the islands' first contact with Western travelers. Marco Polo, who landed on Sumatra in 1232, is credited with being the first European to come here. Explorers, mariners, and adventurers followed, lured by the aromatic spices found growing in abundance and virtually unknown in the Western world at that time. Indonesia became a destination for

RAIN GIRLS

Drying coffee is an exercise in vigilance—until they dry to a stable stage, coffee beans must be constantly turned, protected at night from dew, and covered or taken to a dry shelter when rain is imminent.

As storm clouds move across the impressive ruggedness of Sulawesi's landscape, two young women run to the edge of a cliff. They quickly remove their coffee from the woven straw mats where it has been drying in the sun, pour it into woven baskets, then carry it to shelter until the rains have passed.

Their coffee will eventually be sold in the market town of Rantepao, which lies in the valley far below.

its pepper, clove, cinnamon, nutmeg, mace, and vanilla. The Dutch eventually seized the islands, renaming them the Dutch East Indies.

JAVA

THE FACT THAT JAVA—THE NAME OF THE ISLAND—AND JAVA—A WORD USED for coffee—are the same is no coincidence. If Ethiopia is known as the birthplace of coffee, and Yemen the site of its first cultivation, then surely the island of Java is the source of coffee's world renown.

Dutch planters were the first to propagate coffee on a large scale outside Arabia. Planted successfully in Malabar, coffee-tree cuttings were brought to Java in 1696 to test whether the island's growing conditions could sustain a coffee crop. Grow it did! By 1712, 974 pounds of coffee were shipped by the Dutch East India Company from Java to Amsterdam, and the reception was so positive that the Dutch began planting coffee in Java in earnest. It was not long before the Dutch surpassed the Arabs in coffee production, assuming the world lead. Only twelve years later, in 1724, Java exported 1,396,486 pounds of coffee.

The Arabs did not stop exporting coffee, however, and Europeans still purchased the Arabian beans they called Mocha. Upon reaching Europe, it was not uncommon for the two coffees to be combined. Thus, the first blended coffee in history—Mocha Java.

Other enduring coffee traditions were born in those days as well. Coffee traveled by sail from Asia to Europe past Africa's Cape of Good Hope, a voyage that took many months. Stored in damp ship holds for the duration of the journey, coffee was exposed to all manner of substances and conditions—exotic hardwoods, loads of spices, the incessant ocean spray, and fluctuating temperatures as ships sailed from the oppressive heat of the tropics to cold northern waters. The combined effects of these exposures imparted a certain mustiness to the absorbent beans, adding flavor and changing the color of the coffee. Over the years this distinctive flavor came to be so much associated with Javanese coffee that it was preferred. With the introduction of the steamship, the length of the voyage was dramatically reduced, disappointing many coffee drinkers who thought the beans had "lost" their flavor. Thus "aged" coffee was originated and coffee beans were left to warehouse in the damp climate of the islands for two or three years until they had mellowed. Aging was thought to imitate the flavor of the coffee of the sail era, and was reflected in the name Old Government Java. One can still purchase aged Indonesian coffees, often warehoused by small villages.

Today Java is one of the most densely populated islands in the world. On its easternmost side, under the cloud of Mount Merapi, a smoldering volcano that has killed thousands in recent history, people are drawn to the rich soil, perfect for growing coffee, spices, bananas, and chocolate. But resident farmers pay a heavy price for the fertile soil, living in constant uncertainty under the volatile mountain.

As we journeyed toward Kaliklatak, a Javanese coffee and rubber plantation, we found people growing coffee in every small village we passed. Much of their day is spent outside, tending their coffee production while engaging in social exchanges with friends and neighbors. Little has changed in coffee technology in these villages from the days when coffee was introduced to them by the Dutch.

SUMATRA

By 1852 the Dutch East Indies were producing about one-fourth of the world's coffee. The island of Java, where Dutch-introduced coffee was first grown, came to be synonymous with coffee from the entire region, even though a great deal of the bean was actually grown and produced in Sumatra. Ironically, today Sumatran coffee is more highly regarded than that from Java.

About four times the size of Java, and much less densely populated, Sumatra is the sixth-largest island in the world. Like Java, Sumatra has a unique geologic history that plays a major role in its coffee industry. Volcanically formed, Sumatra has more than ninety-three mountain peaks. Lake Toba, in the northern part of the island, was formed over 100,000 years ago by an eruption thought to have been the most massive on the planet. Today some fifteen of the mountains that form the island's backbone are active volcanoes. Combined with rich, volcanic soil, Sumatra's constant climate varies little throughout the year, making it ideal for growing coffee.

In both the northern and western growing regions, coffee can be difficult to find. Although we had determined guides, modern means of communication, including telephones, are not common, making it impossible to plan ahead. To make matters more difficult, Indonesia's coffee grows primarily on small farms in remote areas. Once we were on the road, our guides tried their best to find coffee for us, but were often unsuccessful. Finally, we discovered that the best way to locate coffee farms was simply to keep the car windows open as we drove. When we sniffed the unmistakable aroma of freshly roasted coffee, we stopped, and that was how we met a number of families growing coffee throughout the area.

Exceedingly efficient, neat, and well-ordered, the culture of the Minangkabau in the uplands of western Sumatra is fascinating and beautiful. The town in the heart of the region, Bukittinggi, is surrounded by mountain volcanoes. One family who showed us their coffee farm explained every step they follow in semiwashing their robusta coffee while enlightening us about life in a matrilineal society. Though most Minangkabau live with their immediate families in simple houses, traditional Minangkabau houses, called *rumah adat,* are huge and elaborate, with curved roofs and brilliant ornamentation. The profiles of these houses, scattered throughout the countryside, stand out dramatically against the lush countryside.

SULAWESI

WITH ARMS THAT SPRAWL IN ALL DIRECTIONS, THE ODDLY SHAPED ISLAND of Sulawesi was known for centuries as Celebes. In the 1800s the English naturalist Alfred Russel Wallace theorized that Sulawesi existed long before Java, Borneo, or Sumatra had even begun to form. Like Java and Sumatra, Sulawesi also has its share of volcanoes, eleven of which are active. By 1750 the Dutch were beginning to plant coffee on Celebes. It was shipped from Makassar, the port city, now called Ujung Pandang. Today some of Sulawesi's best-known coffees come from a central region of the island known as Torajaland, inhabited by the Toraja people. Modern-day ancestors of one of Indonesia's oldest cultures, the Toraja have traditionally lived in long, double-prowed houses that are said to symbolize a bull's horns, a sacred symbol in their culture. Torajans have a heavily structured social order and a strong sense of ritual and belief. They stage complex funeral ceremonies, which can last many days and require numerous animal sacrifices, especially of the esteemed buffalo. Most striking are the hand-carved lifelike wooden effigies of the deceased and extraordinary crypts, carved out of stone, into which the bodies are placed.

Kind and generous people, Torajans welcomed us to their markets, onto their farms, into their homes, and even to one of their funerals. They showed us how they grow coffee, often offering us a cup made from their own beans. Wherever there were freshly roasted beans, a welcoming cup of Indonesian-style coffee was not very far behind.

Rantepao is a market town in the heart of Torajaland where local farmers bring their coffee to sell. Because coffee is primarily grown on remote, small farms, transporting it to major markets is impossible. So growers take it to regional markets like the ones we visited in Toraja and Kalossi, another growing region. There it is sold to middlemen, who often make the larger profit when it is sold to buyers.

THE DUTCH COFFEE MONOPOLY, ASSUMED FROM THE ARABS IN THE EARLY 1700s, lasted only about 150 years. By the late 1800s coffee leaf rust had come to Indonesia, bringing an abrupt end to coffee production. The arabica trees, weakened by the disease, were completely lost. Introduced from Brussels, heartier robusta trees were planted in the early 1900s, and robusta production began to flourish. But the mid-1900s brought political disruption; the Japanese occupied the country during World War II, and in 1949 Indonesia became independent from the Netherlands. Almost immediately afterward, robusta trees were replanted and coffee production began to prosper once more. Today Indonesia produces both arabica and robusta coffees. It is the world's leading producer of robusta and the third-largest supplier of coffee in the world.

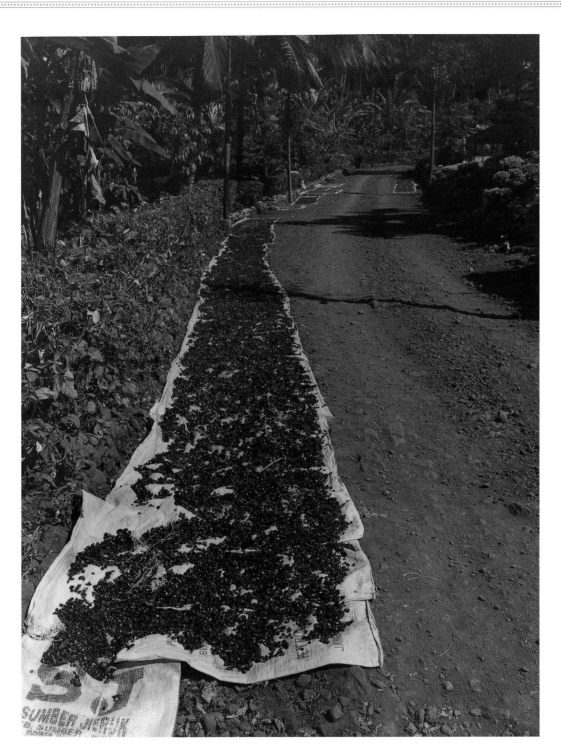

ROAD TO KALIKLATAK

*This unpaved, steep road provides a rocky trip to Kaliklatak,
a coffee plantation on eastern Java. For miles alongside lies
tarp after tarp spread with coffee drying in the hot sun. Not
only cars pass this way but all manner of conveyance and
living being—buses, goats, children, motorbikes, horses,
trucks—none paying the slightest notice to the extraordinary
fact that the road is literally lined with coffee!*

JAVA MAN

This Javanese businessman's prosperity comes from a variety of sources. A bountiful coffee harvest dries in front of his home, from which he operates a small warung, *to serve local villagers as they pass by during the day. Thus, his home becomes the site of morning and evening gatherings, keeping the owner abreast of local news, as villagers stop by for conversation, a cool drink, some simple food, or a small cup of Indonesian sweet coffee, called* kopi manis.

Java has the largest Islamic population in the world. In most communities women do not veil and tend to remain in the background of the society, while seemingly taking responsibility for the majority of the daily workload. But if you want to stop and talk, to exchange pleasantries or ask a question, it is invariably the man who will step forward to "handle the business."

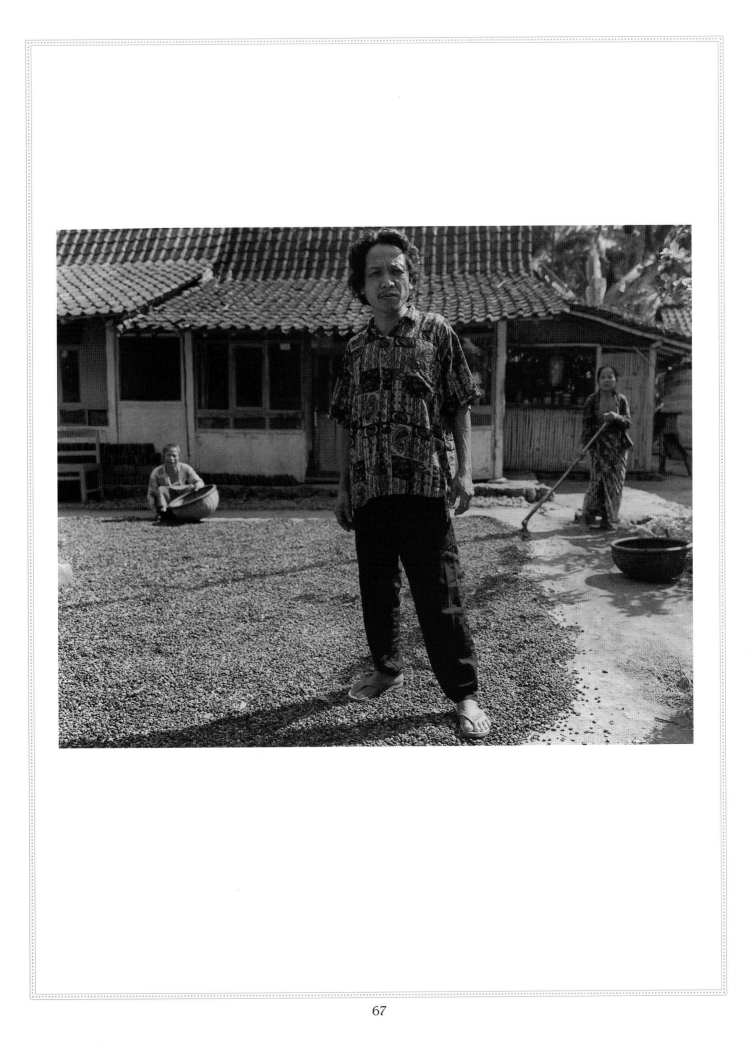

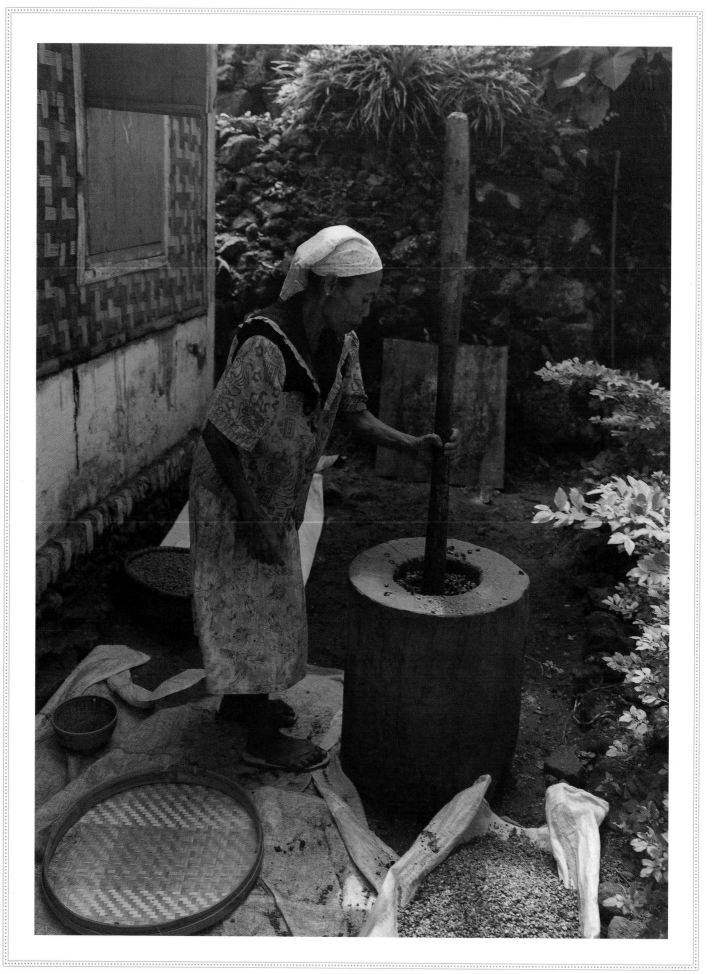

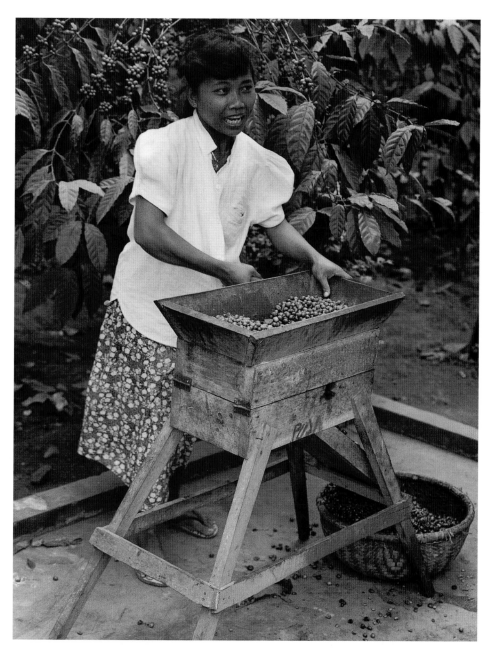

POUNDING COFFEE

The scarcity of water on the heavily populated island of Java is a key reason why small farmers continue to dry their coffee naturally. In preparation for drying, this woman stands outside her home and pounds the ripe, just-picked coffee cherries to remove as much of the pulp as possible. The wooden mallet she uses is very heavy, and the sound of its weight dropping can be heard from a long distance. The dull thud is answered by the deep, repeated rhythm of other women doing the same work throughout the village. When finished, each will spread the semipulped fruit to dry in the sun.

GRINDER GIRL

This young Javanese woman also pulps freshly harvested coffee cherry, but with a wooden hand grinder. Although it might seem an improvement on the simple mallet, this is a hard-to-turn, cantankerous device—its advantage is that each batch of coffee cherry passes through only once. Even though it is difficult to turn, this woman uses it so frequently that she manages her task with seeming ease.

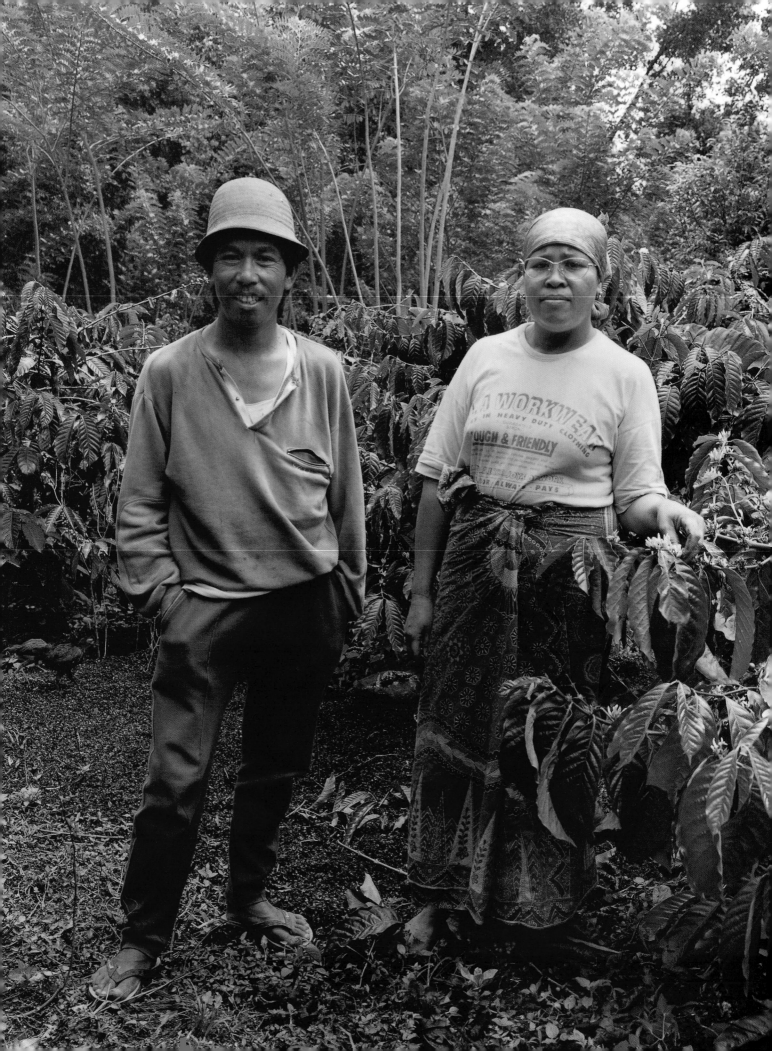

ERNI AND MARSWAFEI

Western Sumatra's population is predominantly people of the Minangkabau culture, thought to be one of two existing matrilineal societies in the world. Though Islamic, the Minangkabau women hold visible positions of importance in household, business, and community. In fact, it is primarily the women who take charge of day-to-day decisions and responsibilities—and most things in this part of Indonesia run remarkably well!

Like many of their neighbors, this couple, Erni and Marswafei, are Minangkabau. When they married Marswafei took his wife's last name. Additionally, the land upon which they grow coffee is in her name and will be passed not to their sons but to their daughters. The couple divides their responsibilities equitably, Erni making many of the business decisions and managing the finances. It is Marswafei's responsibility to sell their coffee once it has been harvested and dried. Near their home he also maintains a small warehouse for the village. Closely monitoring selling prices, he waits until they are high before transporting the beans to the local market in Bukittinggi.

ROADSIDE ROASTER

Finding coffee in Sumatra is often difficult. Coffee is somehow everywhere and nowhere: every farmer in the coffee-growing districts grows some coffee, but because the coffee trees are surrounded by other crops and lush vegetation, one can drive for miles and not see a single tree. The same is true of local processing facilities. Although they are quite common, they are often simple buildings, which one can quickly drive past without even noticing.

Following our noses led us to our first Sumatran coffee-roasting facility down a narrow, overgrown walking path. This man, the roaster for a small village, was preparing coffee to sell at a local market the next day. First, he roasted the beans in a large metal basket over a wood-burning fire, later spilling them onto a concrete floor to cool. Here he scoops the darkly roasted beans into this handwoven basket for transport.

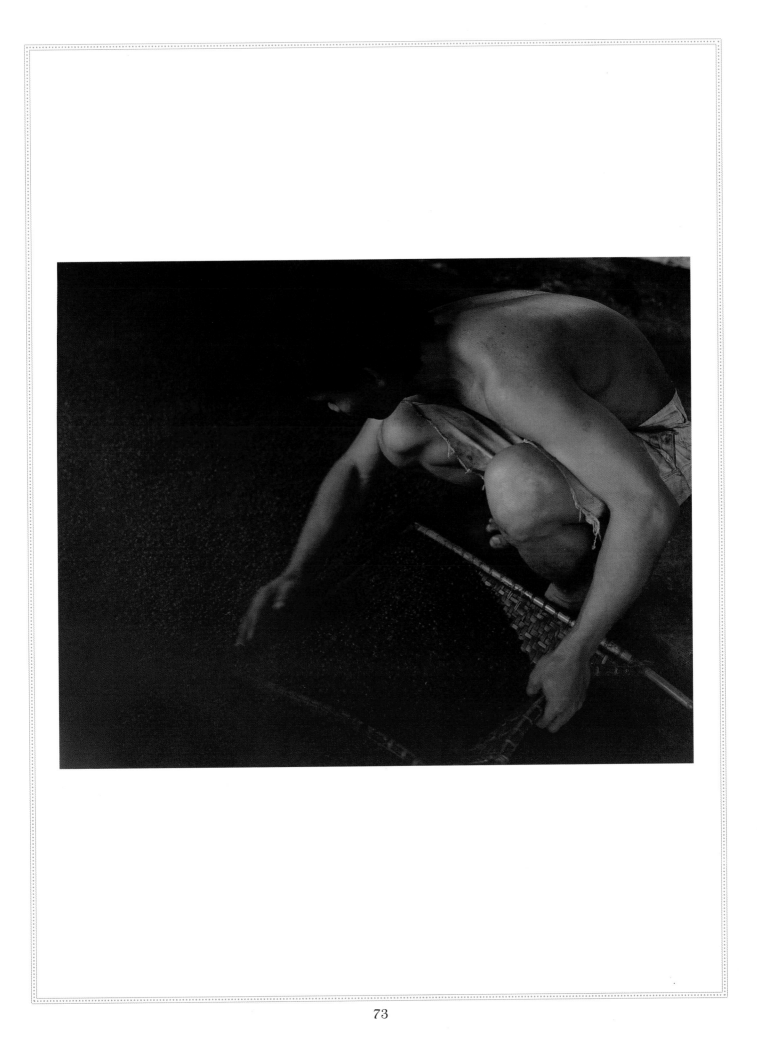

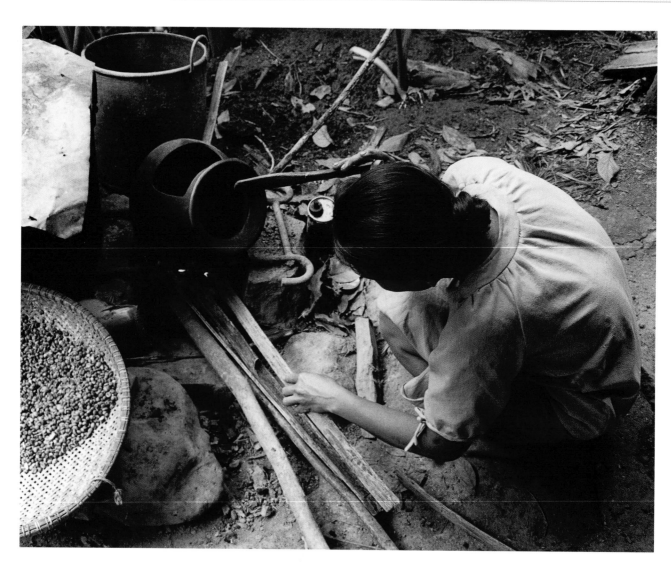

TENDING COFFEE

On a remote hilltop in the Tana Toraja region of Sulawesi, everyone in this extended family pitches in to help with the coffee production. The man of the house works full-time in a nearby coffee-processing facility, leaving his wife to run the household as well as to take primary responsibility for maintaining their own extensive coffee crop. With his mother's supervision, even their young son vigilantly watches homegrown coffee roasting over an open fire.

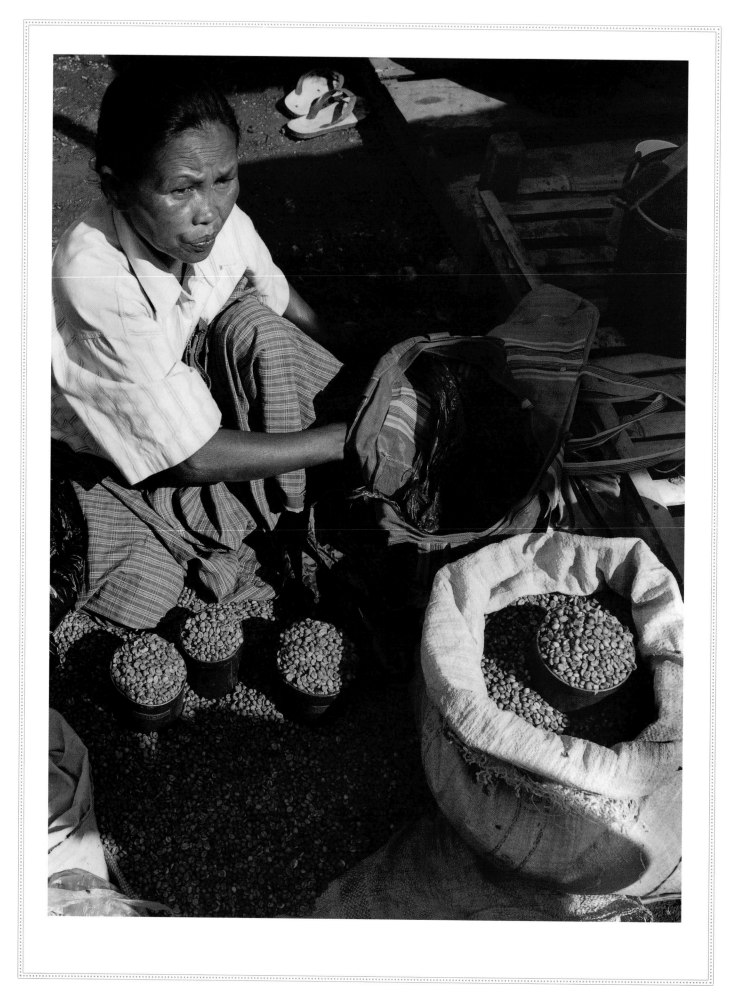

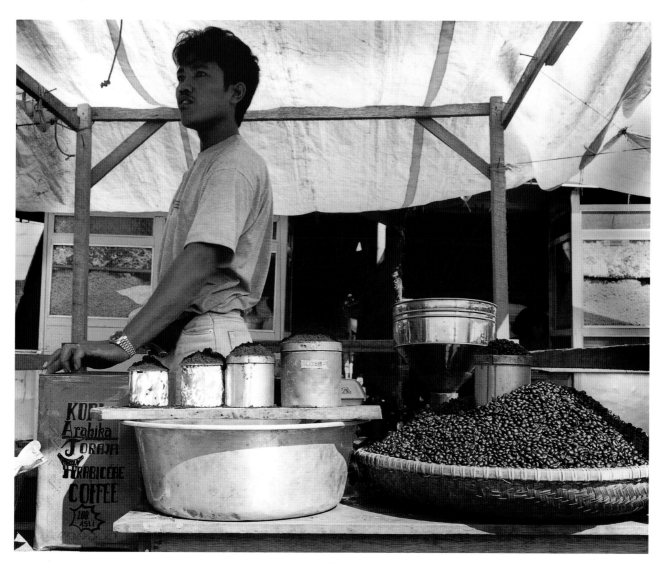

MARKET AT KALOSSI

Coffee aficionados might recognize Celebes Kalossi as the name of a particular Indonesian coffee. Celebes is the age-old name for the island of Sulawesi. Kalossi is a region on the island, well known for its fine arabica coffees. Thus the name is one of geographic identification, in much the same way that we might think of Tuscan wine or Darjeeling tea.

This woman is selling green, unroasted coffee beans in her local market. She has walked to town, carrying the heavy load by herself. Her beans might well be purchased on the spot by a coffee broker, eventually reaching consumers anywhere in the world.

KOPI TORAJA ARABIKA

In Sulawesi coffee is sold not at large centralized brokerage houses but in small village markets such as this one in Rantepao. Their focus is so localized that farmers hardly believe that Torajan-grown coffee can be purchased all over the world.

Indonesia is a coffee-consuming, as well as a coffee-producing, country and this vendor sells dark-roasted coffee for local consumption. Although it can be bought as whole bean, Indonesians prefer coffee ground very fine. In preparation, the grounds and sugar are brewed together, then poured into the cup. The sweet, dark coffee is not drunk until a minute or two have passed, allowing the grounds to settle to the bottom of the cup.

SULAWESI SMILE

His one-day production may be small, but this man takes pride in his coffee beans as he tells about his life in a small village in Sulawesi. Although prices at the local market fluctuate, this year's coffee crop will not bring him much of an income, leaving him equally dependent upon the monies generated from the other small crops he grows. "This is my life," he says simply.

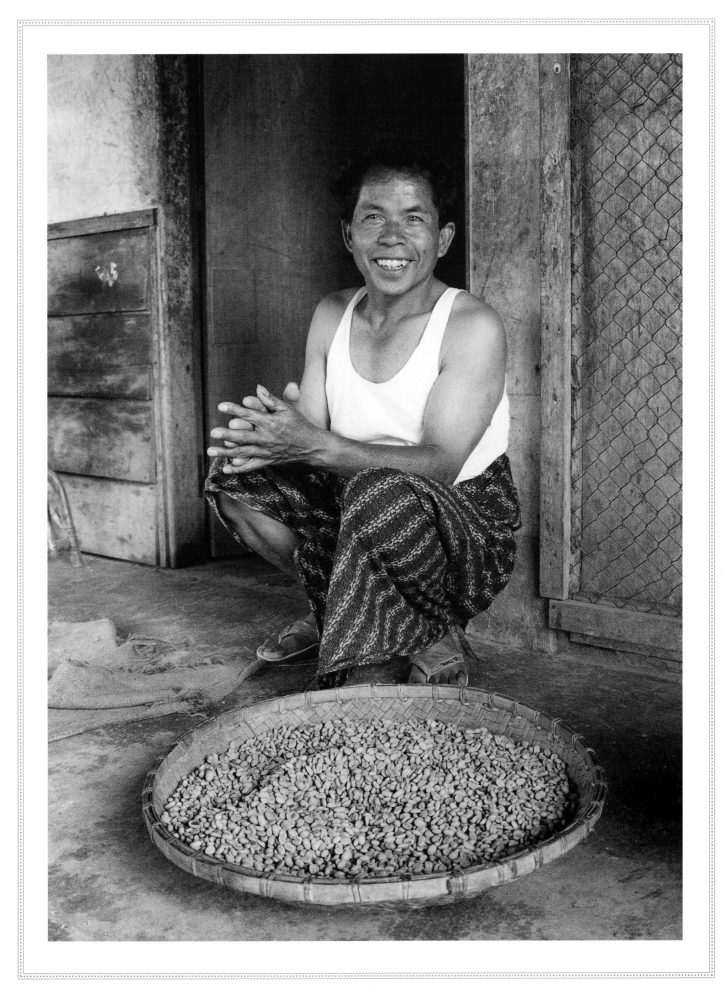

BRAZIL

WHEN IT COMES TO COFFEE PRODUCTION IN BRAZIL, THERE are few comparisons—coffee seems to thrive nearly everywhere throughout the expansive nation. And it is largely because of the country's immense size, combined with its optimal climate, that coffee can be grown on a scale unmatched by any other coffee-producing country in the world.

But in Brazil everything seems big. Larger than the continental United States, the country is fifth in the world in both size and population, and encompasses nearly half of the landmass of South America. The largest river in the world, Brazil's Amazon River, is so massive that 10 of its 1,100 tributaries contain more water than the Mississippi River. Not surprisingly, the Amazon basin supports the Earth's most diverse ecosystem, home to the greatest variety of primate, amphibian, and plant species on the planet.

As the world leader in coffee production, Brazil produced more than 34 million bags of coffee in 1998, approximately one-third of world production. To manage the more than 5 million acres of land planted in coffee requires more than 3.5 million people working on more than 221,000 farms. And more coffee is being planted every year.

Considering the prosperity of the country today, it is hard to imagine the disappointment of the Portuguese coming to Brazil in the early 1500s. Finding neither riches nor gold, they determined that there was nothing of value in this new land. Eventually they began to export the red dye obtained from the *pau do brasil,* a local hardwood. The profitable natural dye was highly valued in Europe but even as King João III tried to encourage settlement in Brazil, Portuguese nobility remained determinedly focused on riches from Asia.

Like most coffee-growing countries, Brazil's history is a rich composite of politics, opportunity, and possibility. After initial reluctance, Portuguese settlers eventually came to Brazil for the promise of land. With severely limited resources to finance the settling of such an expansive territory, the Portuguese crown gave away vast tracts to those who would take them. These land grants, called *sesmarias,* were mostly taken up by fortune seekers with neither title nor wealth. Upon their arrival in the New World, settlers were in desperate need of two things: financial assistance and a labor force to work their huge tracts of land.

From the very beginning, Brazilians farmed on a large scale. Settling along the coastal areas, the first wave of immigrants built huge plantations and placed their hopes for fortune in sugar. In what would be the first of many boom-and-bust cycles, Brazil's initial cash crop was ultimately overshadowed by aggressive competition from sugar plantations in the West Indies. In the late 1600s, gold was discovered in central Brazil, and for the first time large numbers of settlers began to move into the country's interior. Towns sprang up overnight, flourished for a brief period, but fell into decline less than fifty years later. Indigenous to the Brazilian rain forest, rubber was the next boom crop. Magnificent cities soon grew up along the Amazon River, replete with grand opera houses and all the amenities of an extravagant lifestyle. But competition, this time from Asian-grown rubber, forced the Brazilian planters out of another market. Undaunted, the fortune seekers tried again—this time placing their hopes on coffee.

Romanticized over time, the story of coffee's arrival in Brazil has become legendary. According to the tale, coffee was brought to Brazil from Cayenne, French Guiana, by Captain-Lieutenant Francisco de Mello Palheta. Unable to obtain coffee beans from the French Guianan governor, the captain-lieutenant wooed the governor's wife instead and was rewarded when she secretly gave him the sought-after beans, hiding them inside a bouquet of flowers presented to him as a going-away gift.

But compared with its rapid spread as a cash crop in other nations, coffee was relatively slow to become an important commodity in Brazil. Initially planted in the Brazilian state of Pará sometime in the early 1700s, it began to appear in states as widespread as Rio, Bahia, São Paulo, and Minas Gerais. It was only when their other export crops began to falter, however, that Brazilians began to plant coffee in earnest.

With their focus now firmly fixed on coffee, future coffee barons planted the trees with the same unrestrained ambition with which they had planted sugar years before. Taking advantage of the vast expanses of land available to them, planters repeatedly clear-cut native vegetation from immense regions, carving out large-scale plantations, called *fazendas*. The *fazendas* required enormous amounts of labor, not only to clear the virgin land, but to plant, tend, harvest, and process the massive coffee crop on a yearly basis. Early in their history, Brazilian colonists had hoped to rely on the labor of the indigenous population to achieve their lofty dreams of fortune. But the *indígenas*, who had taught the *colonos* how to survive on their soil, rejected servitude and fled into the interior regions. Eventually the native population was largely decimated by exposure to European diseases. Desperate for a workforce, *fazendeiros* began to purchase African slaves. Between 1550 and 1888, Brazilian planters purchased more than 3.5 million slaves, one-third of all those brought to the New World.

Brazil was the last nation in the Western Hemisphere to make slavery illegal. As the country came under intense political pressure to abolish slavery, planters and politicians debated the complicated dilemma concerning the future of the country's massive coffee industry. Initiating a solution in 1871, seventeen years before slavery ended, the Brazilian government began to invite immigrants to what was then a sparsely populated country. By the time the aggressive program ended in 1895, more

than 800,000 foreigners had immigrated, contributing to the diverse cultural mixture that characterizes contemporary Brazilian society. The new wave of laborers came from all over the world—Italy, Germany, Portugal, Spain, Switzerland, England, Central Europe, Russia, the Canary Islands, Lebanon, Syria, China, and Japan. By the time slavery was abolished, many *fazendeiros* had already replaced their workforces with these newcomers, often using slaves to build more accommodating living quarters for the new immigrants. Some coffee barons, however, many of which were in the state of Rio de Janeiro, stubbornly continued to rely entirely on slaves to work their *fazendas*. When the edict abolishing slavery was issued at harvesttime, their crops were left unpicked. Unable to pay off extensive debts, most of the growers simply abandoned their *fazendas*. In spite of the country's difficult transition to a new labor force, coffee survived and became stronger than ever.

By the early 1800s Brazil was becoming a substantial coffee exporter and Brazilians in every region of the country were encouraged to plant coffee. In certain areas, such as Alta Mogiana in northeast São Paulo state, municipal law required property owners to plant and maintain twenty-five coffee plants. Coffee was quickly becoming the backbone of the Brazilian economy, surpassing sugarcane, gold, and rubber as the mainstay upon which Brazil's future would be established. Huge cities, such as São Paulo and the port city of Santos, would be built upon it. Even today, in the diversified Brazilian economy, coffee continues to dominate.

The massive scale of Brazilian coffee production has resulted in growth and depression cycles of equal magnitude. In the early 1900s there was so much overproduction that more than 1.4 billion coffee trees were abandoned before World War II. When demand increased during and after the war, planters returned. Hard freezes are also not unknown in Brazil. Seeming to occur every decade or so, their effects can be devastating. In 1994 severe frost combined with drought cut Brazil's total production from nearly 30 million bags to less than 16 million. But even in the light of such severe setbacks, the Brazilian coffee industry endures and prospers. Today coffee booms, and more trees, both arabica and robusta, are being planted every year.

UNLIKE THE RUGGED TERRAIN OF MOST COFFEE-PRODUCING COUNTRIES, Brazil's geography is one of gently rolling contours and wide-open vistas. Beyond the sharply rising Serra do Mar mountains, which parallel the eastern coastline, the Planalto Brasileiro, or high plain, stretches through much of the country. On this giant plain moderate temperatures complemented by consistent rainfalls nourish Brazil's vast coffee fields. There are no volcanoes here; the country's deep orange and yellow soil comes from ancient, eroded rock formations, some of the oldest on Earth.

There is only one harvest in Brazil and it takes place during the dry months of winter when Brazilian planters harvest their entire crop, picking all the cherry in one pass. Just as during the country's early history, modern-day *fazendeiros* struggle to maintain a sufficient labor force to bring in the

huge crop. Because Brazil's flat, rolling countryside lends itself to automated picking, many planters are turning to mechanization to solve the ongoing problem.

DESPITE THE GRANDIOSE SCALE OF BRAZILIAN COFFEE PRODUCTION, THE small farm continues to exist as a cornerstone to a large industry. In the Alta Mogiana growing region, where many years ago every farm was required to plant trees, cultivation of coffee remains a proud tradition. We met a man there who spent his childhood on a small coffee farm. His Italian ancestors came to Brazil in the nineteenth century to work for a *fazendeiro*, later purchasing a relatively small parcel of land upon which they planted the crop they knew everything about—coffee. They would not make a fortune from this land, but it would provide a decent livelihood. In his youth the man we met left the farm, got an education, and began a career in the shoe business. But when the Brazilian shoe industry went into a recession, he turned back to the family farm, taking his wife and children with him. They now continue the family tradition of growing coffee. It is a business that they, and many other Brazilians, know and work with pride.

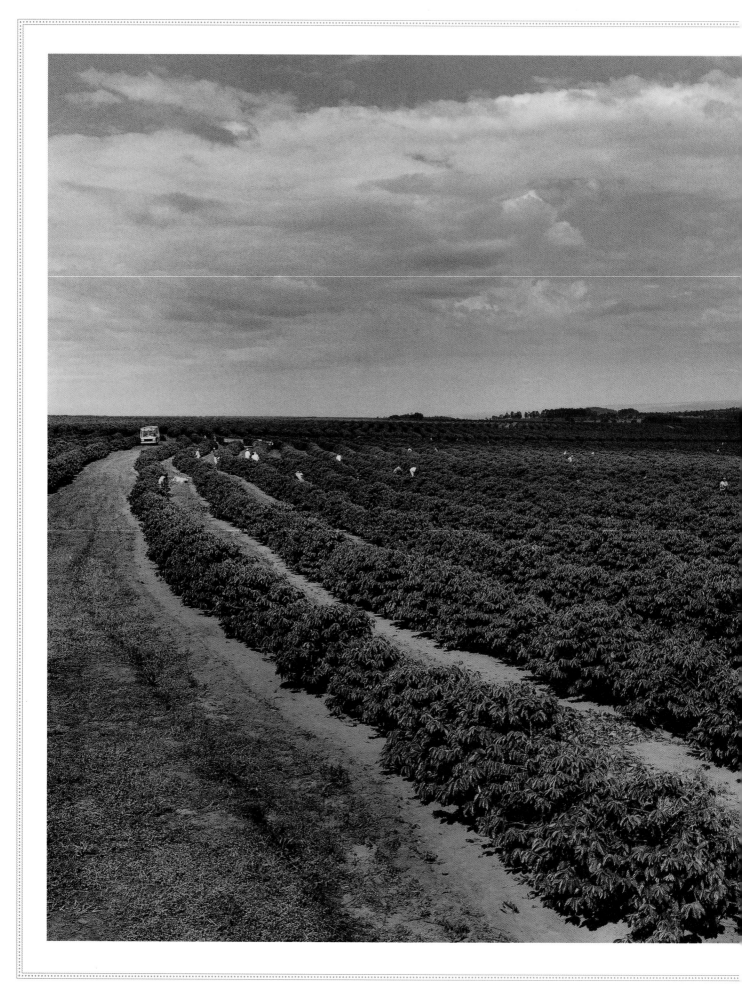

LANDSCAPE MINAS GERAIS

At an average altitude of 3,600 feet, the Triangulo Minero, in the state of Minas Gerais, is one of the richest coffee-growing regions in Brazil. Situated on the immense Brazilian Plateau, for miles in every direction the eye sees only the vast sky above and coffee trees below. While an average fazenda, *or coffee plantation, in this region might contain 200,000 arabica coffee trees—already huge by world coffee-growing standards—it is not uncommon to visit a farm with trees numbering in the millions.*

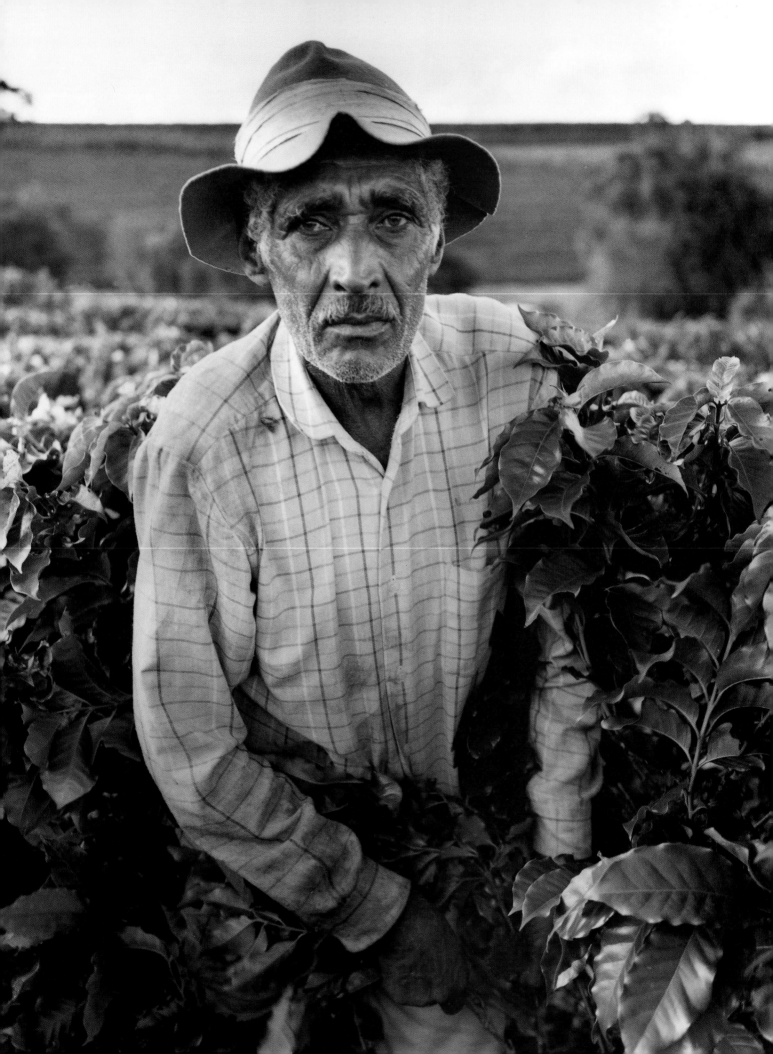

BAHIAN MIGRANT

Brazil's rich cultural history is evident in the faces of coffee workers throughout the country. Coffee barons, and sugar barons before them, purchased African slaves for the labor-intensive task of planting, growing, and harvesting coffee. While the barons' wives led sheltered lives away from the fazendas, *the barons were known to frequent the female slave quarters. A large mulatto population was the result. Even the Catholic Church turned its head because the vast country was so underpopulated that it was considered a service to contribute to the size of the available work pool.*

This migrant worker travels to the state of Minas Gerais from Bahia every year to work the coffee harvest. Never having met the fazendeiro, *upon our arrival he asks a co-worker, "Are they the owners?"*

PAPAI NOEL

This worker's nickname is Papai Noel, or Santa Claus. He begins his workday as he will end it—carrying the tools of his trade. Soon, his picking bags will be heavy with coffee cherry, and for the first of many times during his long workday, Papai Noel will bear the unwieldy load to a receiving truck. As he reboards the bus for town at day's end, he will be parched and dust covered from the winds of Brazil's dry season, the traditional time of harvest.

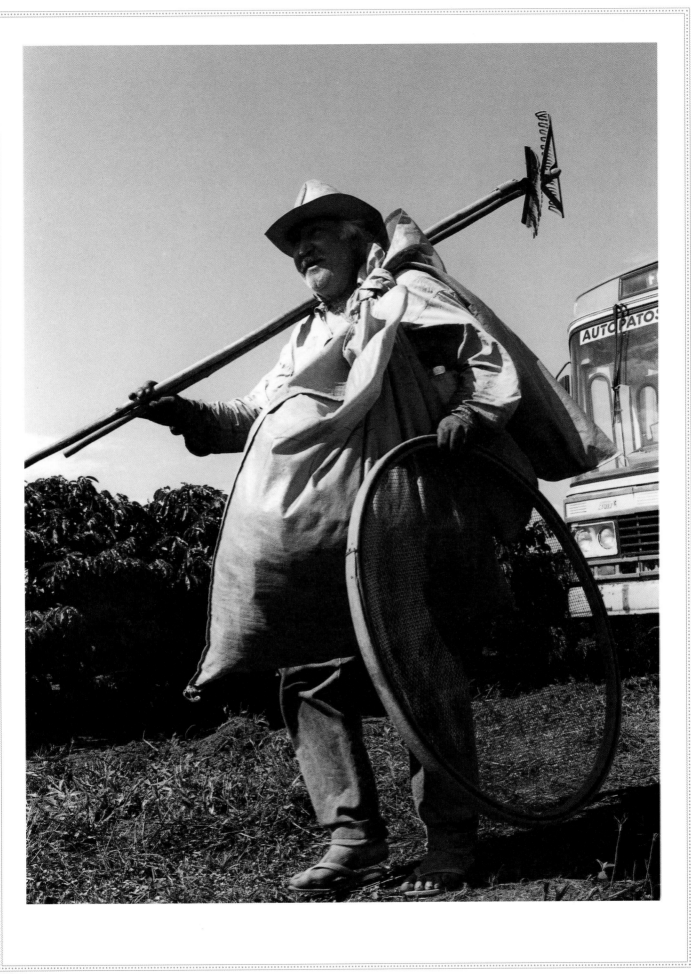

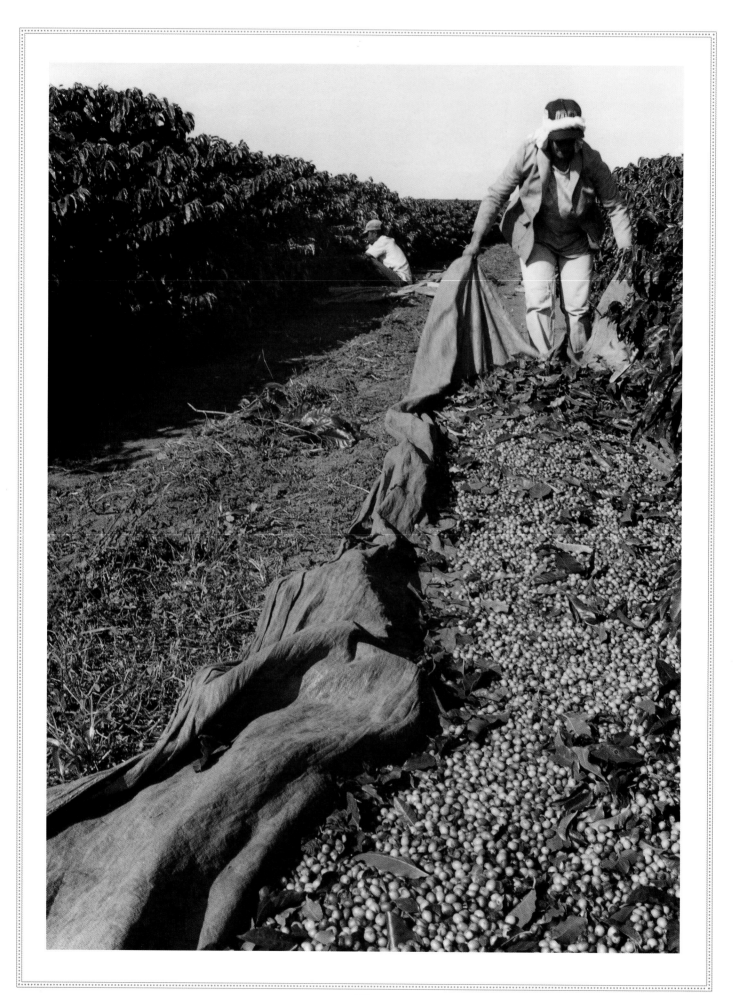

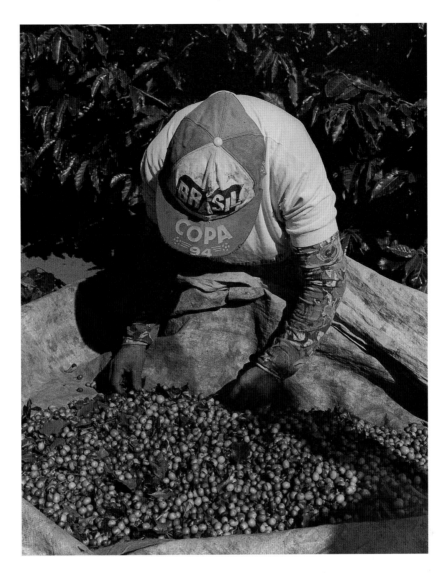

SORTING CHERRIES

In Brazil coffee is harvested once a year. Whether it is done by hand or by machine, the entire crop is stripped from the branches of the trees at one time— including the green, ripe, and dried cherries, which will be sorted mechanically upon reaching the processing facility.

When strip picking is done by hand, the cherry falls onto a tarp spread on the ground underneath the coffee trees. This method of picking allows Brazilian pickers to work much faster than those who harvest in countries where only the ripe fruit is collected. But strip picking also has its drawbacks. As they remove the fruit, workers also pull leaves and twigs from the small, fruit-laden branches. Because they are paid by the cleanliness as well as the weight of their daily work, they must remove the debris by hand, a slow, tedious job.

AT PLAY IN THE FIELDS

Children of migrant workers often accompany their parents into the fields. While his parents work, this young Bahian boy and his friends amuse themselves playing a noisy game of hide-and-seek among the coffee trees. Suddenly he appears out of nowhere, turns to look momentarily, then charges off, disappearing completely into the dense cover of the low-lying coffee branches.

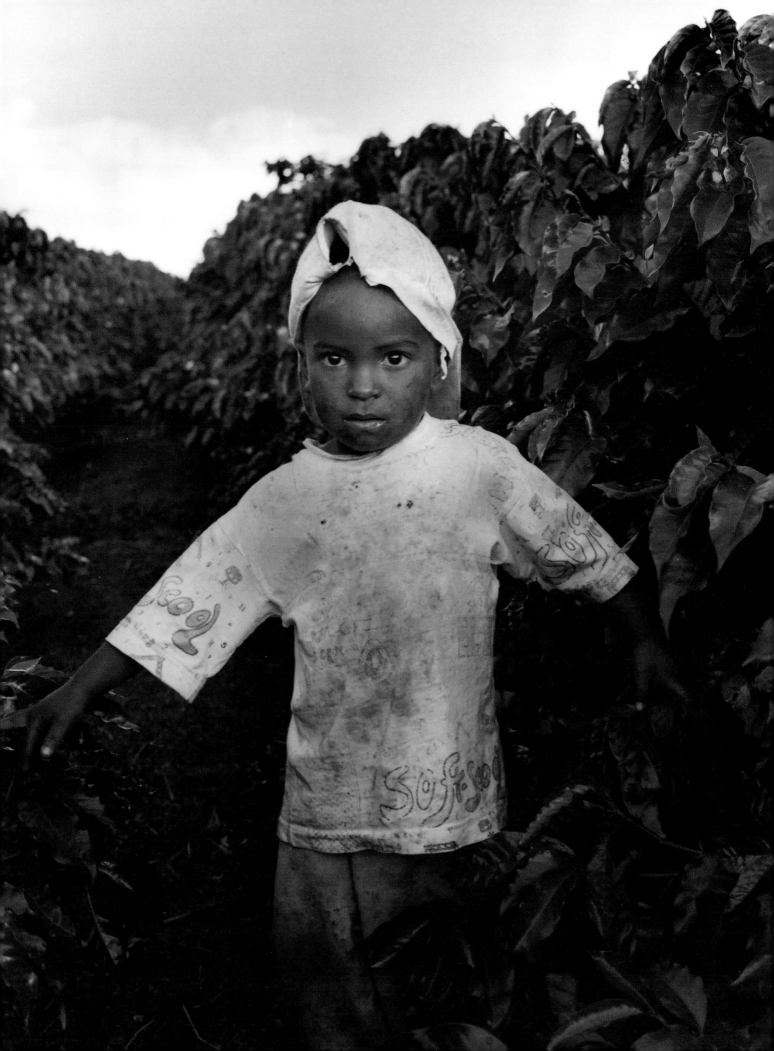

THE PEREIRA LIMAS

The Pereira Lima family manages a large coffee fazenda *for its off-site owner. Mrs. Lima handles the office work, while Mr. Lima manages the* fazenda's *1.5 million trees. Their son, Carlos, works with his mother in the office when not assisting his father with the fieldwork and production. Like many large Brazilian plantations, this one increasingly relies on state-of-the-art mechanization—for irrigation, harvesting, and processing. Even so, Mrs. Lima does all the record keeping manually, without a computer.*

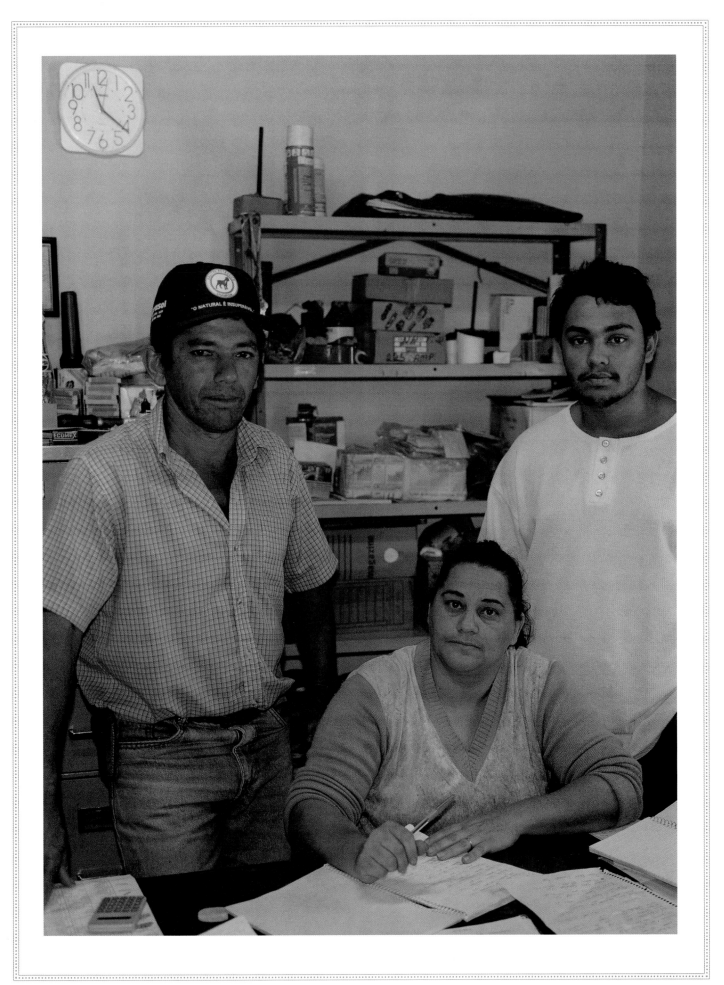

COFFEE SEEDLINGS

Each season, prime coffee seeds are selected for planting. After they have been gently washed, then dried in the shade, they are put in a moist environment to sprout. When the germinated seeds, or semente germinada, *are ready for planting, two seed sprouts are placed in a plastic envelope filled with enriched soil. The just-planted seeds are covered with sand to keep them moist, then with a layer of straw to protect them from the sun. Later the stronger of the two seedlings will be left to grow, the weaker pulled. On this* fazenda *alone 1.5 million seedlings are being planted this year to replace old, diseased, or unproductive trees.*

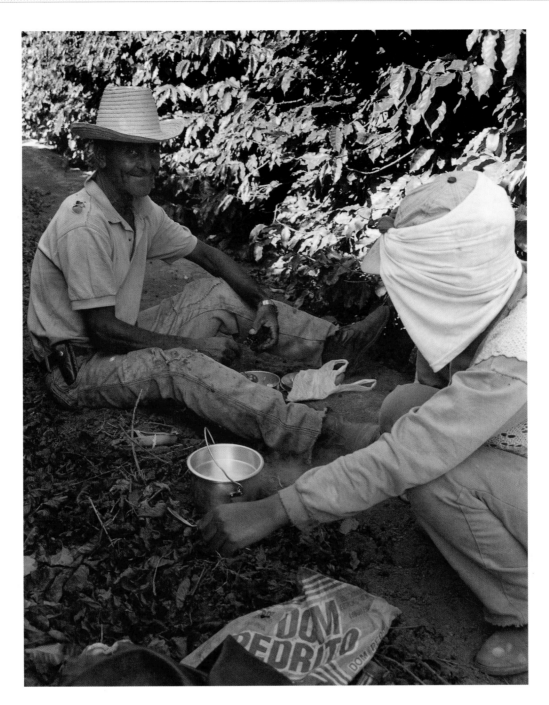

WORKERS' LUNCH

Brazilian fieldworkers begin their workday early in the morning, while it is still cool. Because this husband and wife are picking coffee trees that are tall, their work this day is slower and more difficult. By midday they begin to break for lunch. Over a small fire made from coffee twigs, they warm a traditional repast of meat, rice, and beans. Like many Brazilians, this couple will end their mealtime with coffee. Cafezinhos, small servings of sweet, black coffee, are drunk throughout the day by most Brazilians and are the customary ending to any Brazilian meal.

THE DRYING FIELD

In Brazil the slow process of drying coffee often takes place on huge outside drying terraces called terreiros. *The hulled beans must be turned regularly throughout the day or they will begin to ferment, tainting the flavor and making them worthless. Each day's harvest is kept separate from the previous day's because they will complete their drying cycles at different times. Depending on the weather, it can take a single batch of freshly picked coffee up to fifteen days to dry, requiring countless turnings.*

At this fazenda *in the Cerrado region of Minas Gerais, a work horse is used to pull a large wooden rake, which turns the coffee. Watching man and horse at work, one is mesmerized by the constant rhythm of the horse's hoofs as it pulls the squeaky-wheeled rake back and forth across the immense field of coffee.*

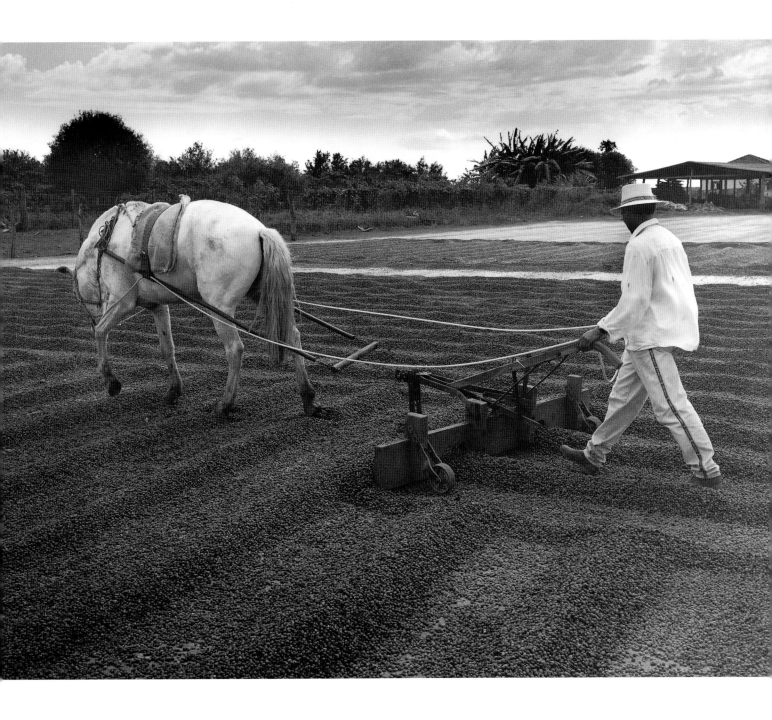

MAKING BAGS

Keeping a country like Brazil well supplied with coffee bags is a daunting task. Bags are constantly being made, repaired, and resewn. As they have been for centuries, bags are constructed of jute. This natural material is preferred over synthetics because it does not taint the taste of the coffee beans, which can easily pick up the odor of other substances. These natural-fiber bags are also perfect for letting the beans breathe. Each of these new sixty-kilo bags, to be used for export, is hand-stenciled CAFE DO BRASIL.

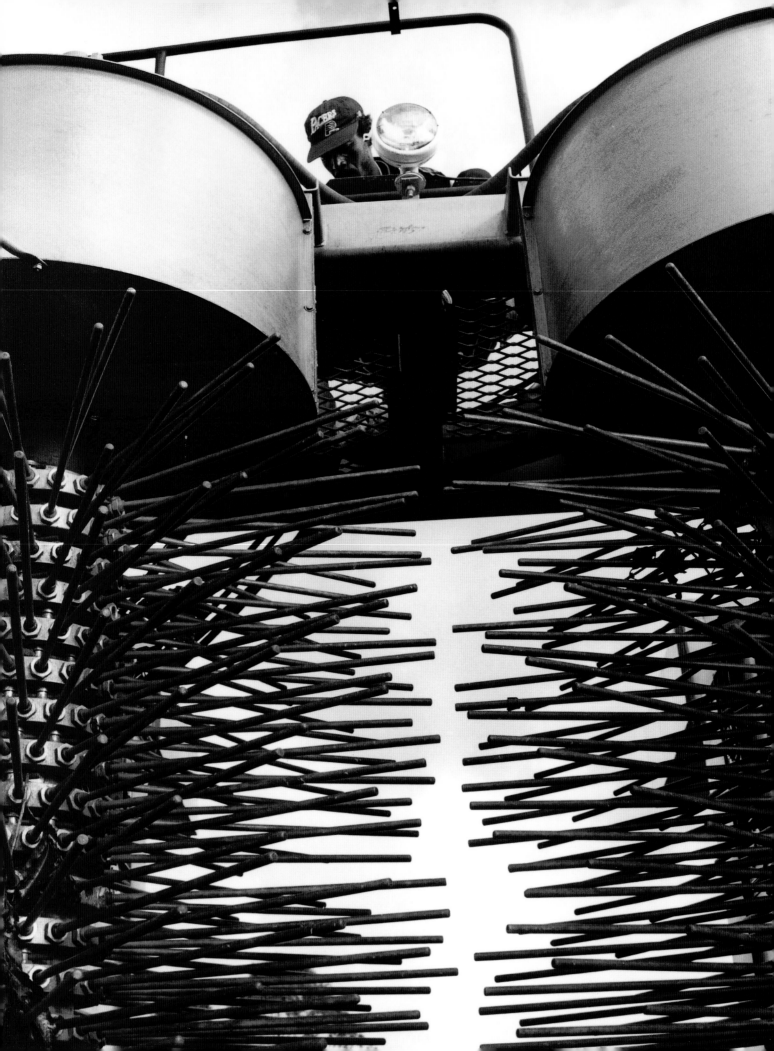

THE MACHINE

Until recently, to visit a Brazilian coffee field at harvesttime was to hear the sounds of laughter, singing, joking, and storytelling among pickers. Today those sounds are quickly being replaced by the din of state-of-the-art mechanical harvesters. The workers who are still employed to rake and clean up after the huge machine can scarcely communicate over the commotion it creates. Still, it picks and bags 500 to 1,000 sacks of coffee a day, the work equivalent of 250 people. Even more impressively, it is reliable and does not damage coffee trees.

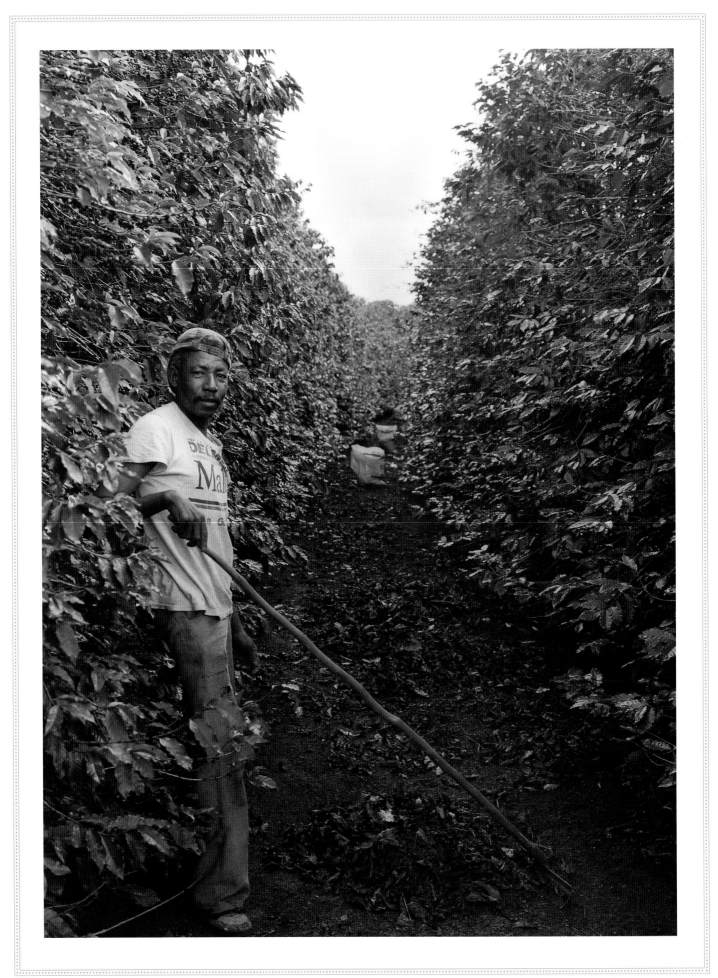

COFFEE TREES IN FRANCA

In most coffee-growing countries, trees are pruned short so they can be handpicked. But in Brazil, coffee trees are sometimes allowed to grow very tall, dramatically increasing their production potential. The trees grow so close together that they form a dense, uniform coffee hedge that is repeated row after row, mile after mile. These cafezais, *or coffee groves, are an extraordinary sight.*

At the end of a day of picking, Brazilian fieldworkers rake and remove the debris of leaves, beans, and twigs. Even in the face of modern technology, it is the simple, time-worn tools—wire screens and rakes made of coffee wood—that prevail.

COLOMBIA

NO OTHER COFFEE-PRODUCING COUNTRY IN THE WORLD HAS invested as much as Colombia to ensure the connection between product and place. The result is that anyone with even the slightest knowledge about coffee knows that a lot of it grows in Colombia. But, even without slick marketing, Colombia deserves enormous recognition. In world coffee production it ranks second only to Brazil, a country more than seven times its size.

How does Colombia show such success in the world coffee market? The country's geography, climate, and geology are key to understanding its bountiful coffee production. The Andes Mountains, the awe-inspiring range spanning northward along the length of the South American continent, end in Colombia. There the mountains fan into three ranges, the Eastern, Central, and Western Cordilleras, creating Colombia's distinct topography of sharply rising crests and valleys that cover nearly one-half of the country's land. The other half of Colombia is primarily lowland, made up of vast savannas to the north and the Amazon Basin in the south. Within such a diverse terrain, Colombia is home to the largest number of bird species in the world and is second, again to Brazil, in biodiversity.

Because the equator runs through the heart of the country, ambient temperatures in the Colombian highlands depend entirely on altitude and fluctuate little from season to season. At moderate elevations the weather is temperate: neither too hot nor too cold, too rainy nor too dry. Except at very high altitudes—far higher than where coffee is grown—there is no threat of snow or freezing temperatures. Ash from both ancient and modern volcanic activity provides fertile soils perfect for sustaining the rich vegetation that covers the mountains and valleys.

But it is the geography itself that ultimately defines coffee in Colombia, ironically providing both a suitable location and a limiting one. Lying atop the steep terrain, the boundaries of small coffee farms, called *fincas*, are frequently drawn by nature itself. The topography also presents Colombia with another great challenge—the difficult task of transporting coffee from field to market.

Coffee has become so closely associated with Colombia that many think the product originated there. In fact, coffee entered the region's history many centuries after its first inhabitants migrated there during the Ice Age. Relatively little is known about the pre-Columbian cultures that existed in the northern regions of South America. Forming independent communities, these early inhabitants did not merge

into a cohesive culture like the Mayan and Incan empires. Nor did they construct monumental architecture. Instead, they crafted goldwork with amazing sophistication. A relatively small body of the intricate work survives revealing their remarkable skill. It was an art that would radically affect their future.

Lured by illusive tales of El Dorado and their insatiable desire for gold, the Spanish made their way to this region soon after discovering the New World. In 1499 Alonso de Ojeda landed in Colombia on his second voyage to the Americas. Almost immediately, a number of European settlements were founded after the Spanish saw for themselves the wealth of the indigenous cultures. Chroniclers noted that the *indígenas* ornamented themselves not only for ritual and communal work but to dazzle and confuse enemies during confrontation. In their first century in the New World, the Spanish pillaged hundreds of tons of gold, first seizing the intricately wrought goldwork, later enslaving *indígenas* to mine gold for their benefit. They melted all of it down to make ingots, which they took back to Spain. As for the *gente indígena*, they were stripped not only of their craft but of their way of life and considered by the Spanish as little more than a potential labor force.

In the early 1700s, more than two hundred years after the Spanish arrival, coffee was introduced into the south of the region by Jesuit priests, and limited cultivation began. Later coffee would be brought into the northeastern regions from Venezuela, again by Jesuits, among whom the drink was said to be so popular that one priest made sinners plant coffee as penance. The harvests were primarily for local consumption. Even though the government encouraged coffee cultivation, a serious lack of transportation in the rugged land made it too difficult to expand the crop outside of isolated areas.

But there were far more immediate problems throughout the region than the transportation of coffee. By the early 1800s, political unrest was growing strong within every social faction. By that time the original indigenous cultures had been largely decimated and replaced by black slaves. The Spanish settlers were staunchly divided, some remaining loyal to Spain while others sought independence. The Creole class, South American–born Spaniards, were increasingly resentful of the heavy-handed rule from Europe. Though widespread and divided, dissatisfaction began to take the form of cohesive rebellion. Simon Bolívar emerged as the leader, and independence was won for Colombia in August of 1819. During the remainder of the nineteenth century, the new nation's history was marked by eight civil wars and a continual progression of new governments and constitutions; between 1863 and 1885 alone, there were more than fifty insurrections.

While politics remained chaotic, coffee production continued to grow, steadily developing into an export industry. Under Bolívar's leadership, and despite the absence of his wholehearted endorsement to grow coffee, the government passed a law prohibiting coffee importation. Several years later coffee plantations were excluded from taxation by the Catholic Church. In 1834 the country recorded its first commercial exportation, and in 1880 it exported 100,000 bags. Colombia was well on its way to becoming a major player in the world coffee industry. After visiting Brazilian coffee plantations, a Colombian general returned to his country so enthusiastic that the slogan "Colombians! Plant Coffee!" was initiated.

To address the country's crippling lack of transportation, monies derived from the sale of coffee helped to fund projects to enable its efficient transport. Steep mountain altitudes, perfect for growing coffee, not only made coffee agriculture labor- and time-intensive but also made early transport of the crop nearly impossible. Transportation problems were solved regionally, utilizing whatever natural attributes were available. Where the rivers were navigable, longboats, and later steamboats, were introduced. Railroads were built where feasible. Roads and trails were improved to connect towns and villages for travel by mule, and later Jeep. Aerial cables spanned across mountains so that coffee could be lowered from the highlands to the rivers below without arduous road travel. Colombia reportedly had the first regularly scheduled air travel in the Western Hemisphere—a seaplane that cut the trip on the Rio Magdalena from thirty days to several hours. All forms of transportation had one thing in common—they carried coffee.

In the early 1900s Colombia became the second-largest coffee producer in the world, and has maintained that position ever since. The country's entire crop is exclusively washed arabica. As the only South American country with ports on both the Atlantic and the Pacific, today Colombia produces approximately 12 million bags of coffee a year and ships from its three main ports: Santa Marta and Cartagena on the Caribbean, and Buenaventura on the Pacific. More than one-third of the rural population of the country is employed by the coffee industry.

Traditionally, Colombian coffee has been grown by *cafeteros*, or small farmers. Becoming the centers of rural family life, *fincas* have also maintained the coffee industry during extended, often turbulent, political periods. Living in remote areas necessitated that farmers grow their own primary food supplies. Small vegetable gardens of corn and cassava, banana, orange, and other fruit trees, along with a few rubber or cocoa trees and some animals, supplied food staples and augmented incomes. Because their livelihood did not depend solely on the income from coffee, farmers could survive price fluctuations, profiting when coffee prices rose but not going bankrupt when they plummeted. The small coffee farmer became the mainstay of the Colombian coffee industry, while the industry itself became the backbone of an emerging Colombian economy.

Colombia's primary coffee-growing region is the Zona Cafetera, a rugged, two-hundred-mile-long valley that runs between the Central and Western Cordilleras with the Rio Cauca at its heart. The area was settled primarily by Antioqueños, whose determination and aptitude for business led to their success at growing coffee. In the late 1800s this region's boom stabilized the economy of the entire country long enough for it to diversify its economic base.

Throughout the Zona Cafetera, hillside after hillside is covered with coffee trees. Both the cities and the countryside display an orderly, well-kept efficiency, providing evidence that the profits derived from coffee are returned to communities through a variety of social programs. Colonial farmhouses, built in a distinctive regional style—white stucco with colorful wood trim—are immaculately main-

tained, with flower baskets hanging from balconies. Plant life in dizzying array surrounds the houses, as do a plentitude of songbirds. Still, it is the coffee trees that dominate—they are simply everywhere.

Such beauty, however, is anything but serene. The well-ordered pastoral topography can be tranquil one minute, chaos the next. In January of 1999 a severe earthquake rocked Colombia, hitting hardest in its primary coffee-growing region. Whole cities were reduced to rubble, damaging or destroying more than 6,200 homes and 3,400 coffee-processing facilities. So, once again, the fortitude of Colombian *cafeteros* was tested. Even as they struggled to rebuild their shattered lives, towns, and homes, they had to sustain the crop on which their livelihoods depend—coffee.

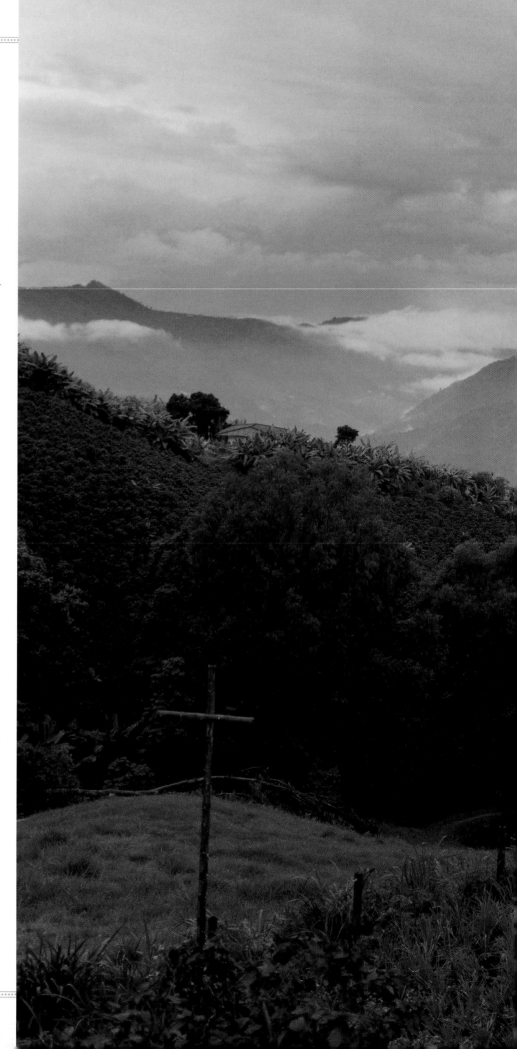

ZONA CAFETERA

The view from the balcony of La Arboleda, a coffee finca *in the heart of Colombia's Zona Cafetera, is typical of the region. It is early morning, and the rugged hillsides— heavily planted with coffee trees— are shrouded in cloud cover. Amidst the cacophony of birdsong, pickers sing and laugh as they begin their day's work in the fields.*

Nearby, the family vegetable garden is productive year-round. Beyond the garden is the secado, *a building fitted with a series of movable racks. Used to dry coffee, the racks can be pulled into the full sun or quickly returned to the roof's protection when there is rain. At this altitude, high in the Colombian Cordilleras, rain and sun appear in equal measure.*

The rustic cross is an important focal point for the extended family living here and the site of a May celebration called El Dia de la Cruz. On that day small offerings are placed at its base—coins to ask for prosperity, maize to symbolize good crops, and aspirin to wish for good health.

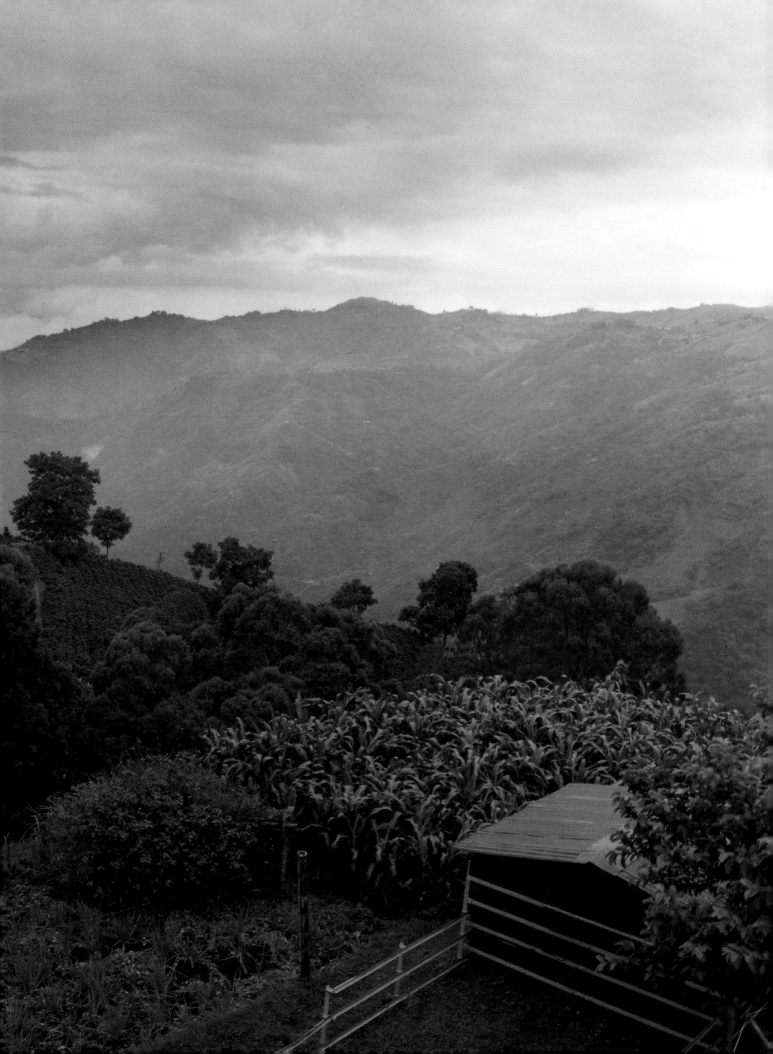

EL PATRÓN DE CORTE

Picking coffee in Colombia is men's work, and this field foreman, the patrón de corte, *determines where his workers will pick. He marks that place by tying a white flag on the end of a long piece of coffee wood that he drives into the soft, wet ground. Workers divide into small groups and will keep the flag in their sight all day. When the* patrón *wordlessly moves to another area and replants the flag, they begin to pick their way toward him. As foreman, he also provides a noonday meal for his men, many of whom are young and single, inclined to late nights out and the occasional argument in the field. The* patrón's *job is to keep them focused and productive; he works alongside them throughout the day, covered with plastic to protect himself from the light rain and the sharp branches of the coffee trees.*

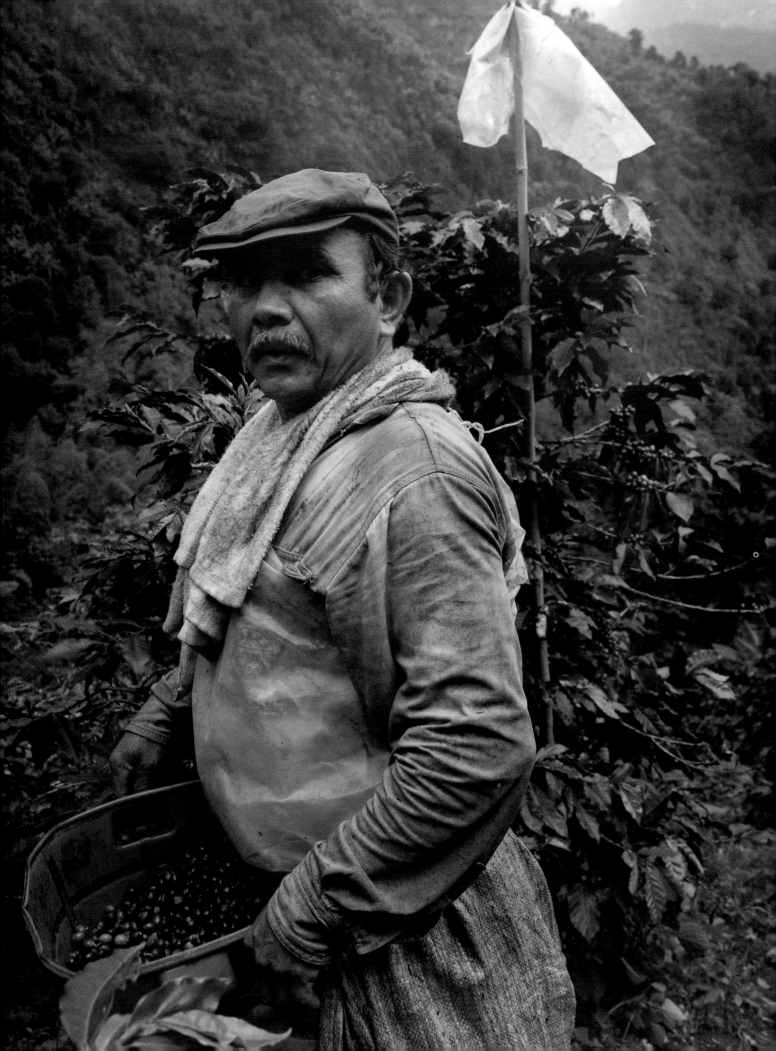

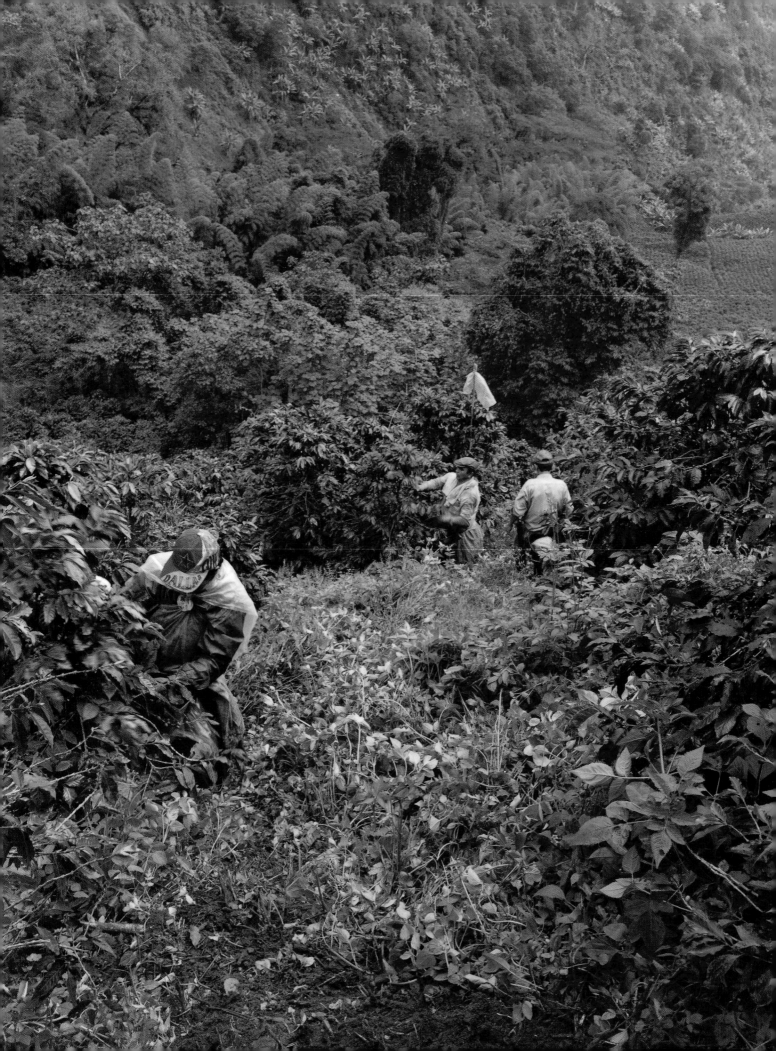

LOS JORNALEROS

Picking coffee on the Colombian terrain is an extremely arduous task. Only the ripe cherries are removed, and, because of the temperate equatorial climate, the trees bloom and produce throughout the year, necessitating nearly continuous picking. With altitudes averaging 5,200 feet, the mountainous topography is very uneven and steep. Where merely standing can be difficult, the possibility of mechanical harvesting is inconceivable. Colombian trees are maintained at a height of approximately six feet, making them accessible to the jornaleros, *or day pickers, who can easily reach the top of them without ladders.*

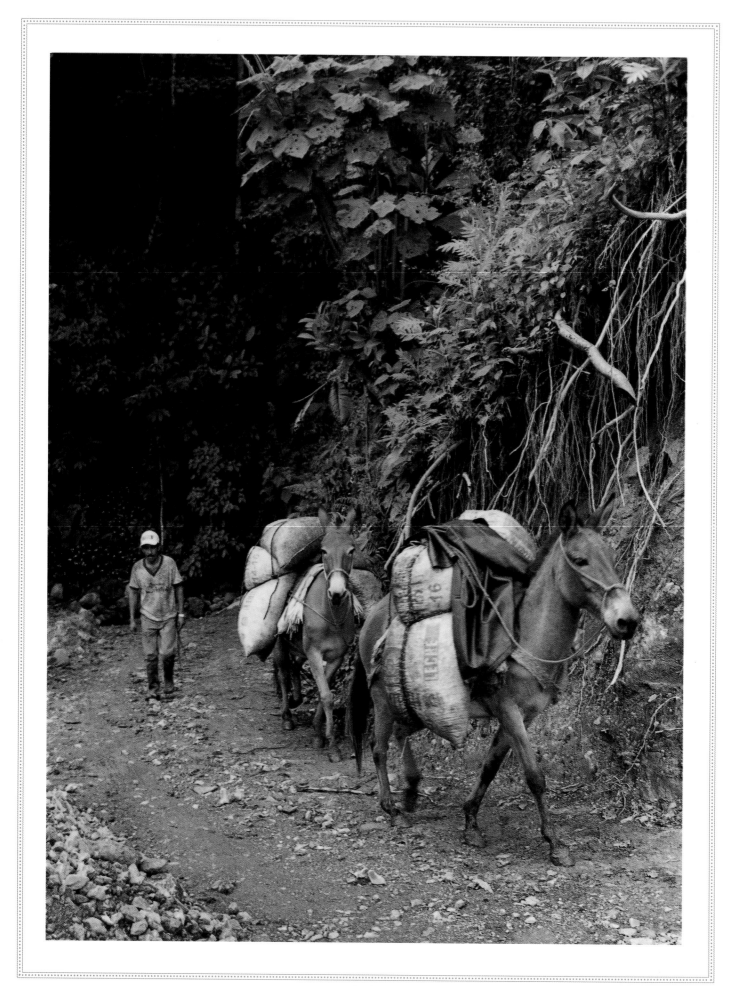

TO MARKET

Because coffee grows at high altitudes and in remote areas, transportation has been a major logistical problem the world over. In Colombia, the solution continues to be the mule, an animal sturdy enough to carry heavy burdens and surefooted enough to traverse rocky, often muddy, and uneven terrain.

At the end of a day of harvesting, this man transports ripe coffee cherries to a roadside tolva, *or weigh station. His load will be picked up by a jeep, the mainstay of mechanized transportation in the Colombian coffee industry.*

ZOCA

After twenty years many Colombian coffee trees begin to lose their productivity and must be replaced. The branches of the aging but still green trees are completely removed before the trees are severed at the base. Left to dry in the field, the zoca, *or dead wood, must later be cleared. Though occasionally used decoratively to make handicrafts, this* zoca *will be burned for cooking or for drying coffee beans. Working alone in the large field, this man uses only a simple jute coffee bag to protect his body from the stiff, prickly loads of wood he spends long days removing.*

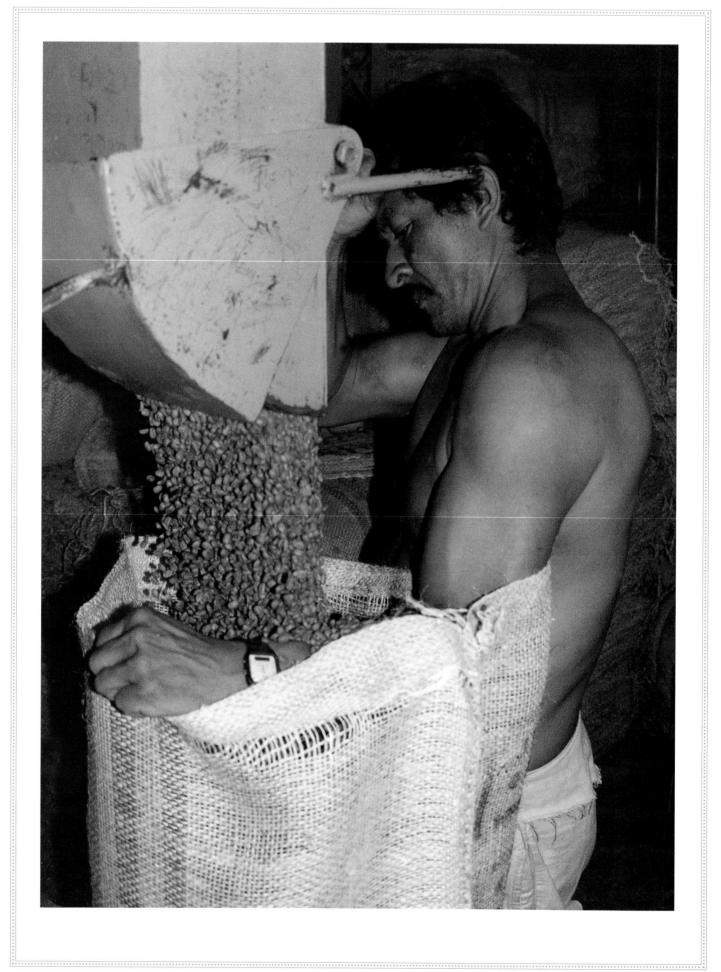

FILLING THE BAGS

With powerful grace of movement, this man works to fill the hundreds of empty bags stacked next to him with beans that have just been mechanically sorted and processed. Pulling a bag open at the top, he secures it at just the right angle against his body before inflating it with green beans. His day is spent filling, lifting, and sewing these heavy bags in a never-ending progression.

BY THEIR HANDS

After going through rigorous mechanical separation, coffee beans at the Cooperativa de Caficultores de Manizales must pass a discerning inspection by human eye. From a fast-moving conveyor belt, these women remove any discolored or otherwise damaged beans. The belt passes rapidly in front of them, accelerating even faster if the beans are of exceptional quality. The women wear earplugs to soften the deafening noise of the factory, and their fingers move at a constant, quick pace while they maintain complete concentration on the beans passing in front of them. The exhausting work merits a half-hour break after every hour of work.

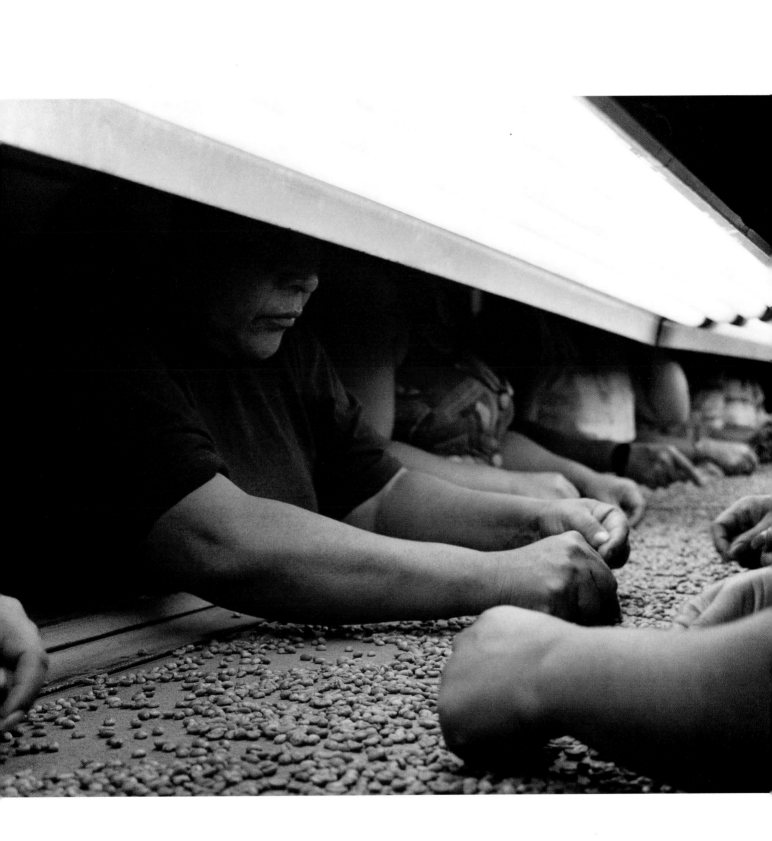

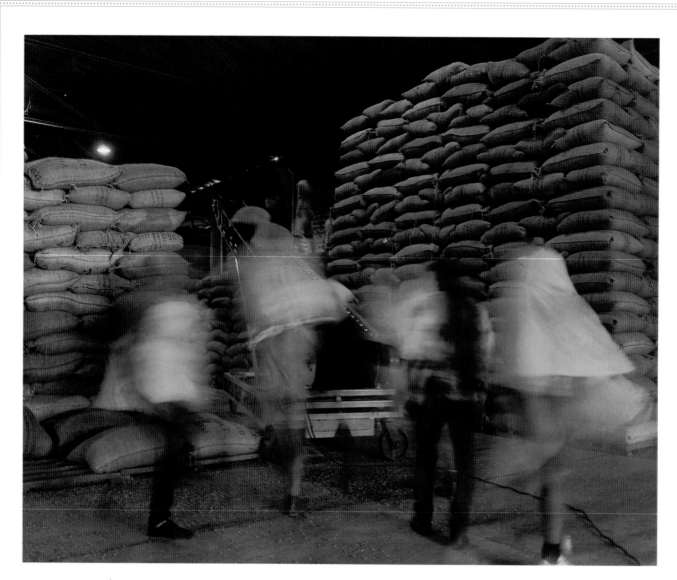

COFFEE GHOSTS

Until it comes, finally, to rest in a warehouse, coffee is in almost constant motion from the moment it is harvested. Again and again, its weight is born by the strength of human labor.

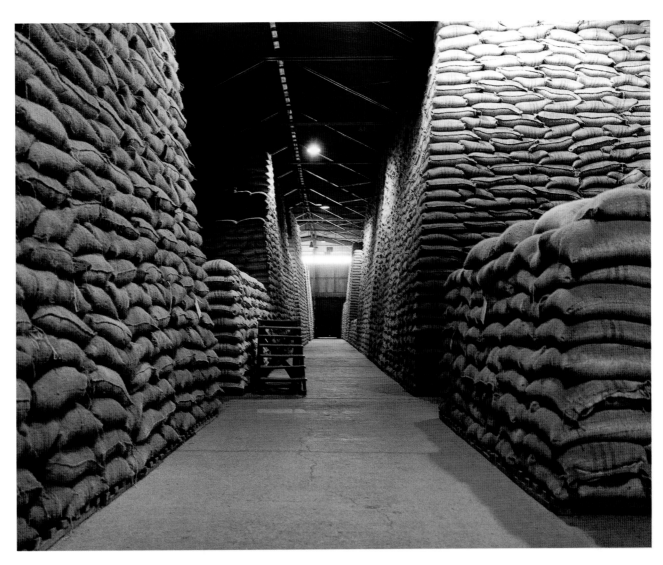

WAREHOUSE AT ARMENIA

More than a quarter of a million bags are stored from floor to ceiling in this regional warehouse. These dried beans, still in the parchment skin, will remain in this immense controlled environment until they are taken to a port warehouse for final processing and exportation.

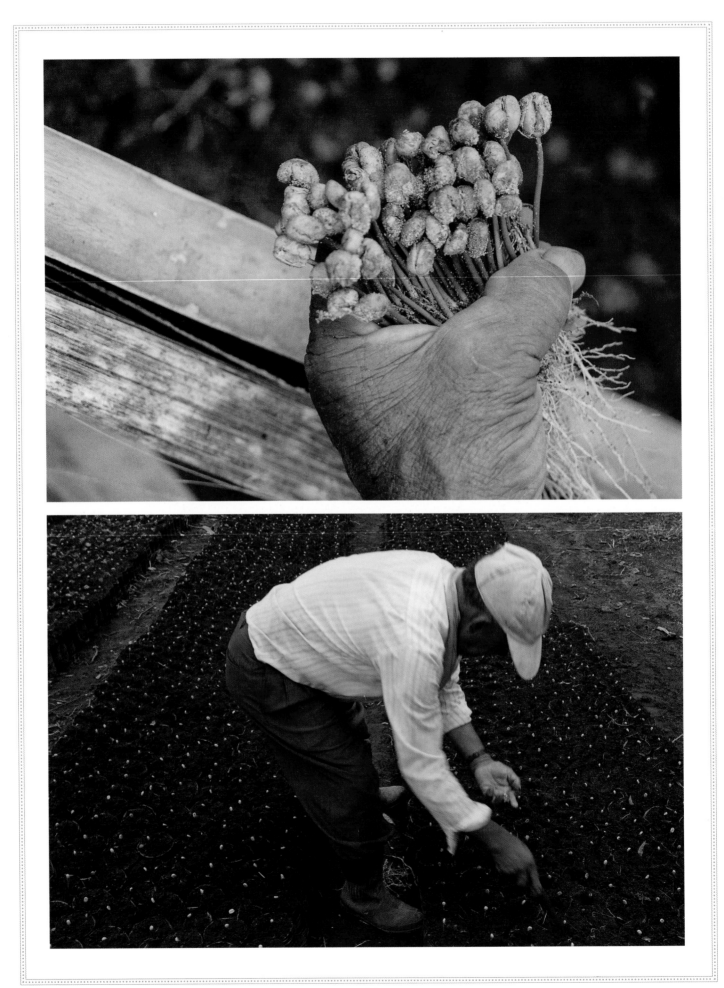

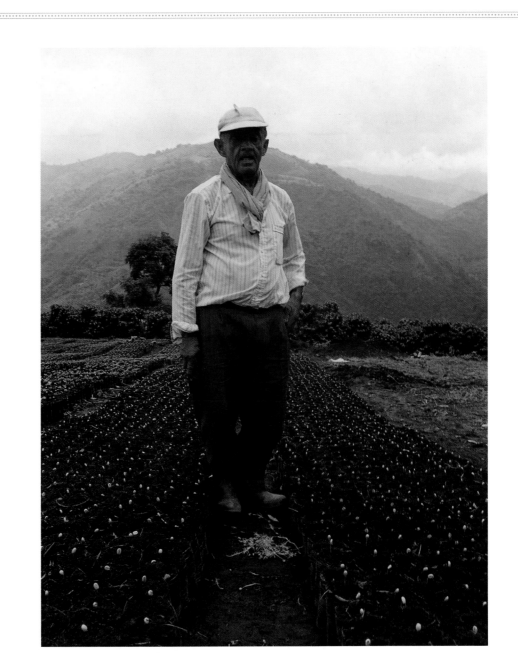

THE NURSERYMAN

Too old for the rigorous labor of harvesting, this man moves locally from farm to farm to plant and tend coffee seedlings. This day he works alone transplanting seedlings atop a high mesa, a place of great serenity. Several weeks before he had placed the coffee seeds in a bed of sandy river soil, covering them with straw for protection from the sun. Here, he gently coaxes the chapoleras, *now sprouting their first leaves, from their community bed to replant them in individual plastic envelopes filled with a carefully balanced soil and compost mixture. The seedlings will continue to mature at this nursery for another four months, or until they are strong enough to be moved to their permanent location.*

He continues to go about his work as we photograph, but after a while becomes impatient—perhaps because of the attention paid to him, perhaps because our presence interrupts the rhythm and quietude of his work. Suddenly he dismisses us by saying, "Gracias y adios."

COSTA RICA

WHILE ONE MIGHT NOT IMMEDIATELY THINK OF COFFEE WHEN thinking of Costa Rica, Costa Ricans themselves think a great deal about coffee. In fact, it was the first Central American country to grow coffee on a large scale, and it quickly became the cornerstone on which the country's economy and history were built. Even today Costa Rica's highly organized coffee industry is an economic mainstay.

The entire length of this coffee-growing nation spans the isthmus of Central America, measuring less than three hundred miles. But what the country lacks in size, it makes up for in exceptional beauty. Endowed with an abundance of fertile soil, volcanic mountains, lush forests, and plentiful waters, Costa Rica is truly the rich coast that its name implies. Such natural abundance provides astonishing environmental diversity as well as the perfect setting for a successful coffee trade.

Like other coffee-producing nations in the Western Hemisphere, coffee did not enter into Costa Rica's history until the arrival of Spanish settlers in the 1700s. Little is known about the agrarian cultures that inhabited this region before that time. Scattered across the mountainous highlands, these early societies traded as far away as Ecuador in the south and Mexico in the north. Although they ornamented themselves with gold, little of it was mined locally.

On his fourth voyage to the New World in 1502, Christopher Columbus arrived here. Gold had been the focus of his perpetual quest and when the *indígenas* greeted him wearing an abundance of gold jewelry, Columbus thought he had found riches at last. He sailed back to Spain with plans for returning to Costa Rica. But ill health and the death of Queen Isabella, his financial supporter, prevented his return. Columbus would never realize his fortune; neither would the Spanish who came to Costa Rica after him. What they found instead were rugged, unforgiving virgin lands that afforded a harsh life. Most did not stay, and Costa Rica remained essentially ignored and uninhabited by Europeans for decades. Finally, the Spanish crown ordered the settling of the country, and a small community was established in the interior in 1561. By the end of that century, most of the indigenous population was gone. They had died either of diseases introduced by the Spanish or in war. Others had simply fled.

Spread out across the land, early colonists set up meager farms, living in isolation and poverty. It would be many years before they replaced subsistence living with an affluent lifestyle based on

coffee agriculture. Their first successful trade was in mules, which they exported by walking them along the Mule Road to Panama. Lacking a standard currency system, cacao became an important early crop because the beans could be used in place of money. Later, tobacco was introduced and planted extensively. For a while it looked as if it might provide a good income and a processing factory was built. But unable to grow high-quality leaves, Costa Rican planters lost their place in the world tobacco market.

The first coffee seeds arrived in Costa Rica in the late eighteenth century. Although they were probably brought from Cuba by the Spanish voyager Don Francisco Xavier Navarro, some Costa Ricans credit Padre Carazo, a Catholic priest and a contemporary of Don Navarro's, with bringing them. However it arrived, coffee was slow to catch on as a cash crop but was often planted ornamentally for its deep green, waxy leaves, fragrant flowers, and bright red berries. But having failed at growing tobacco, the settlers tried coffee. It was not until 1831 that Costa Rican coffee was first exported to Chile. Less than ten years later, coffee had become big business. Costa Ricans responded to this success with an 1845 decree that required all residents to plant coffee. Soon coffee *fincas* were scattered across the high plateau, occupying most of the available farmland. Processed coffee was transported from the highlands to the Pacific port of Puntarenas by oxen. Because the Panama Canal had not yet been built, coffee traveled to Chile by ship before being sent to the European market.

In 1843 William le Lacheur, captain of the British ship *Monarch*, sailed into Puntarenas. Le Lacheur needed to take on ballast before embarking on the treacherous voyage back to England around Cape Horn. Coincidentally, Costa Rica had produced more coffee that year than it could sell—a surplus that the captain offered to take to England. He loaded as much coffee as his hold would allow and, acting as the country's selling agent, established Costa Rica's first direct coffee trade with Europe. Two years later he returned to Costa Rica to report his success and pay the planters. The direct connection le Lacheur established was key to Costa Rica's success in the coffee industry.

In 1821 Costa Rica received word of its independence from Spain. The Spanish crown had not governed the area strongly and the news arrived unheralded by mule-driven courier from the Spanish regional headquarters in Guatemala City. Independence plunged Costa Rica into turmoil, and for many years afterward it struggled to find its political and economic identity. With coffee emerging as an important crop integral to the country's economy, it is not surprising that many of the new leaders came either directly or indirectly from the coffee industry, though few of them were actual growers.

In the early 1900s Costa Rica built the Atlantic Railroad to the port of Limón on the east coast. It took more than $3 million borrowed from England to complete the project. Shortly afterward the bottom dropped out of the coffee market as import nations entered World War I. Costa Rica, now highly dependent on the income from its single major export, suffered a severe economic depression. Today, with a far more diversified economy, coffee and bananas are the country's main exports. Coffee alone employs more than 90,000 Costa Rican growers and generates approximately 25 percent of the

nation's export earnings. With parallel coastlines on both the Atlantic and the Pacific, Costa Rica exports to global destinations from either access.

In 1949 the country's army was disbanded and the monies that had been used to support the military were funneled into education, conservation, and health programs. One of the most notable outcomes is that, today, more than one-fourth of the country's land is protected under programs that include national parks, biological reserves, and wildlife refuges. With such a focus on preservation of the natural ecology, Costa Rica serves as a role model worldwide.

Sixty percent of Costa Rica's population lives in the central region of the country, which is called both the Valle Central and the Meseta Central. Both names are appropriate, since there is both a valley and a plateau. Stretching forty miles through the center of the country where two mountain ranges converge, it is a region of active volcanic mountains. Ideal temperatures and altitudes, ranging from 3,200 to 6,500 feet, also make it the country's primary coffee-growing region. More than 30,000 *fincas* are located here, some as small as an acre or two, others as large as several thousand. Because the soils are so rich, the yields are high. Costa Rica is so proud of its washed arabica coffee that it is illegal to grow robusta.

A newer coffee-growing area is the Monteverde region to the north. From the slopes of the Cordillera de Tilarán one can often catch a glimpse of the Peninsula de Nicoya on the Pacific Ocean, miles away. Much closer to this region, the peak of Arenal is Costa Rica's most active volcano. In this lush environment wildlife flourishes. The Monteverde Cloud Forest, one of Costa Rica's richest wildlife preserves, supports an astounding 2,500 plant species, 100 species of mammals, 400 species of birds, and 490 species of butterflies.

Most of the Monteverde farms are small, averaging five to seven acres, and have traditionally supported dairy farming. Quakers coming to the region from Alabama in the 1950s set up a successful cheese factory, utilizing the region's abundance of milk. Although coffee was grown on a small scale even then, it was not until the 1980s that it was introduced as an alternative crop to enable farmers to establish other sources of income. Today dairy farming is still the top income earner, but coffee is a close, and growing, second.

IN THE GROWING REGION OF TARRAZÚ IN THE CENTRAL VALLEY, JUST SOUTH of San José, is the noted plantation La Minita. Meaning "little mine," the name dates back to the Mayans, who found small quantities of gold in the region. Today coffee is Costa Rica's gold, often referred to simply as green gold.

Throughout Costa Rica emphasis is placed on farming practices that are harmonious with the natural environment. La Minita is a forerunner in its ecological approach. Though such methods are far more costly to maintain, the farm's owner feels that the environment cannot be compromised and he adamantly refuses the use of herbicides. Instead, weeds are controlled manually. The effort requires

a workforce of twenty men to clear two acres of coffee a day—a process that must be repeated three times a year. Most noticeable on the plantation—no doubt as a result of such ecological practices—is the abundance of birds, butterflies, and insects that seemed to be buzzing, flying, and singing everywhere. Many of the birds fly here on their yearly migration from North American winter.

In the Monteverde region, too, there is an especially strong emphasis on sustainability, which focuses on balance and interdependence among all aspects of life. Away from Costa Rica's major population center, the region's citizens are proud that they have helped to create one of the most successful ecotourism destinations in the Americas. Their approach to coffee is similar, and they are constantly exploring ways to use renewable resources in its production. Even though coffee is relatively new in Monteverde, it has already shown every sign of success.

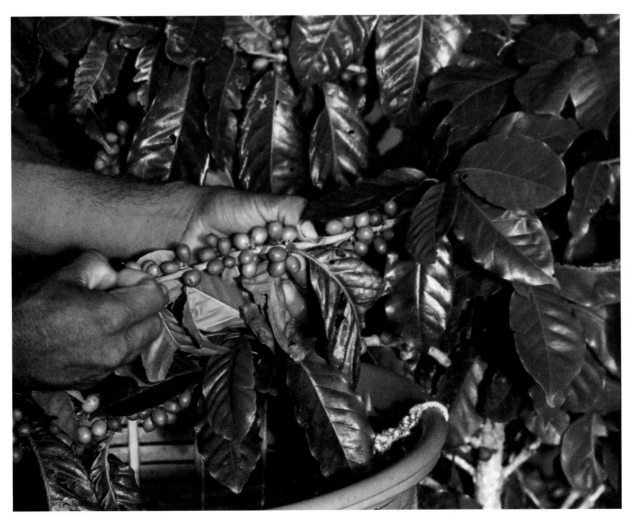

PICKING COFFEE

Throughout Costa Rica, only the ripe cherry is harvested, requiring each group
of trees to be picked at least three, even four times during the harvest. On this
plantation alone more than 5 million pounds of ripe cherry will be harvested.

PICKER AT LA MINITA

La Minita, a noted coffee plantation in the Tarrazú region of the
Valle Central, is surrounded by the wealth of natural resources that the
small country of Costa Rica affords. The Tarrazú River borders the
finca, *and coffee trees thrive in rich volcanic soil. With a strong*
emphasis on ecological growing, the finca *maintains two hundred acres*
of natural tropical forest, more than 20 percent of its land. La Minita's
steep hillsides vary in altitude from 3,750 to 5,000 feet, making work
extremely hard for those who harvest and maintain these trees.

This man is busy harvesting now, but his labor will not end when
the harvest is in. Because no herbicides are used, workers arduously use
machetes to cut away unwanted vegetation. In addition, 20 percent of
the farm's trees are pruned on a yearly rotating cycle, while 5 percent of
the finca's *trees are replaced—requiring the planting of approximately*
200,000 trees a year.

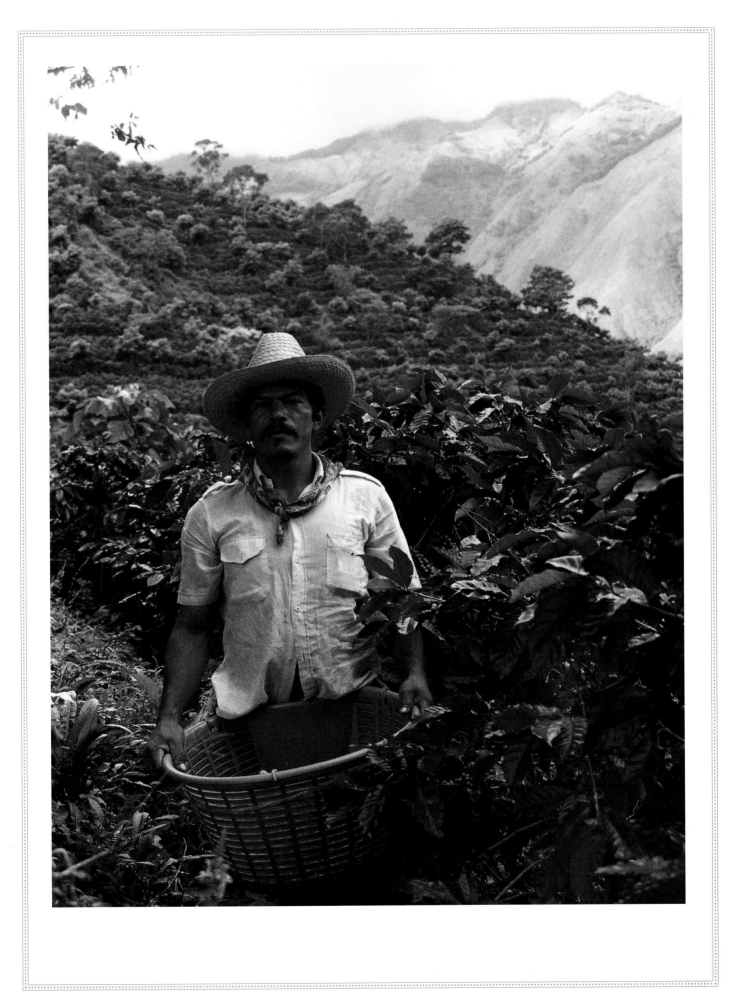

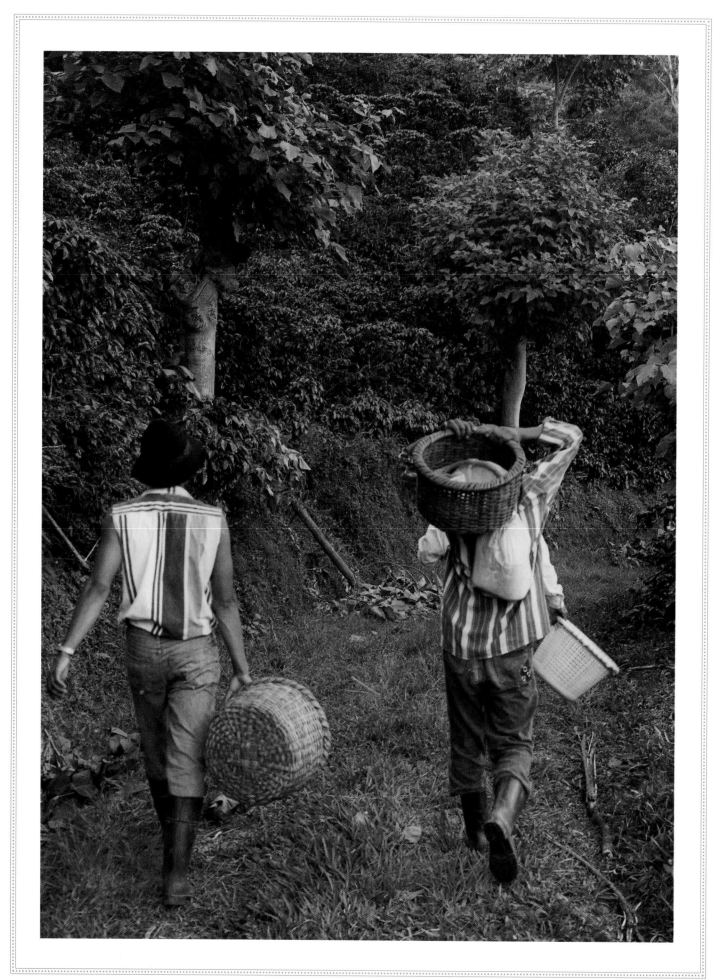

TO THE FIELD

Getting the coffee harvest in on time is everyone's priority, and these workers begin their days early—heading to the fields with an array of baskets, which will soon be brimming with coffee cherry. Even though the temperatures on Costa Rica's central plateau vary little throughout the day, mornings are good for working because they are cooler. An early start is also necessary because, near the equator, sunlight and dark are of nearly equal length throughout the year. By early evening it will be too dark to work.

LA CAJUELA

In the late afternoon each worker's harvest is weighed. A tractor and empty trailer are already waiting as the pickers, or recolectores, *arrive with their day's work—large, heavy bags bulging with red cherry. For a while workers sort through their bags to remove any unripe fruit, but soon the business of measuring and paying begins. Each worker takes his or her bag to the trailer, where the cherry is carefully poured into a basket that can be handed up to a man waiting in the empty trailer. As seen here, he pours the contents of the basket into a two-liter metal measure, called a* cajuela. *Each worker will be paid by the number of* cajuelas *he or she picked that day. The* encargado, *or foreman, tallies the count and puts the correct amount of money into the basket as it is passed back down to the picker.*

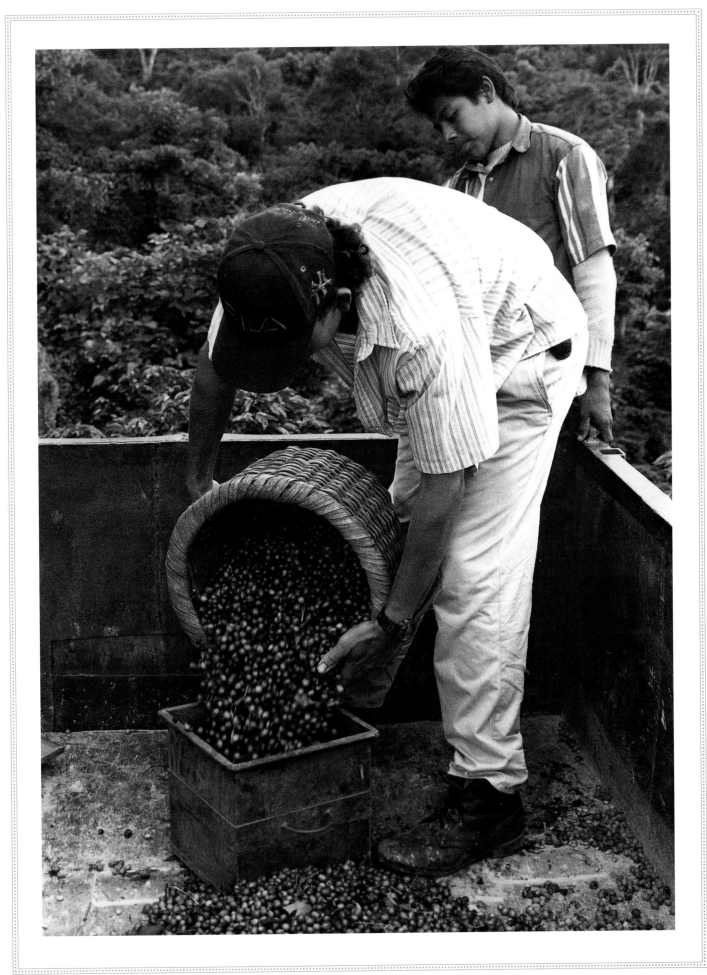

LA GANANCIA

Only a moment ago this harvest basket was brimming with the day's harvest; now it is returned to its owner filled with the monetary worth of his efforts. Tomorrow, he will again fill the basket with cherry.

IN THE TREES

It is not by chance that school vacation coincides with the coffee harvest in Costa Rica. The Fiesta de Café is a time of hard work in which the community and entire families participate. Although it requires tiring labor, the season is also a time of good weather and good pay. Christmas falls in the middle of the harvest, and with the extra income there are often exchanges of presents as well as dances and parties to celebrate.

This young girl is joined in the field by her family and friends. Even in the midst of laughter and fun, picking requires concentration. Each branch is heavily laden with fruit, the branches on the tree are dense, and the hillside is exceedingly steep. Going from tree to tree picking only ripe cherry needs one's complete attention.

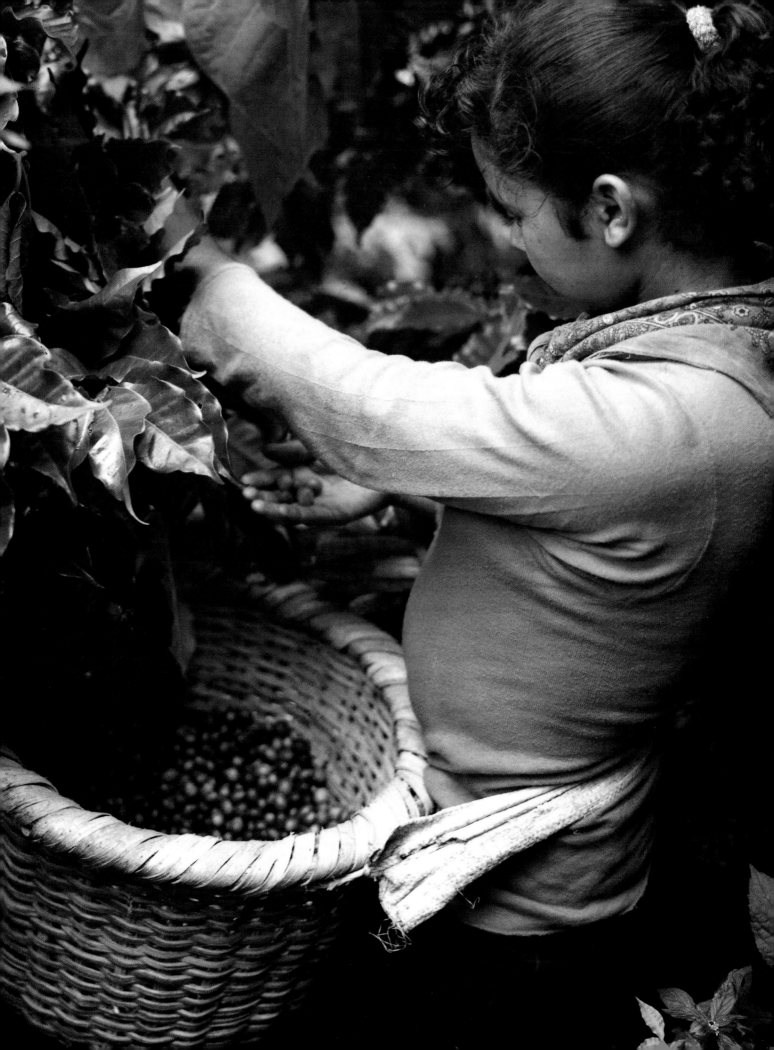

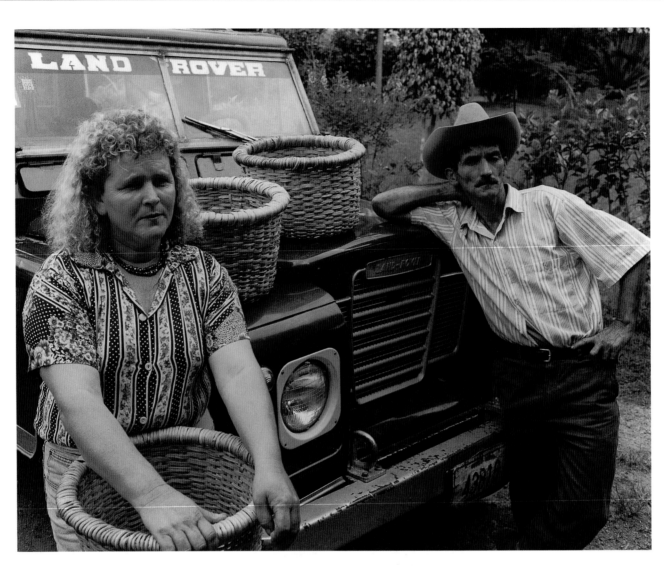

OFFERING BASKETS

*In Costa Rica natural-fiber baskets are preferred by many coffee
pickers, and there is a cottage industry for their production. While
baskets are often sold along the roadside, this woman has come to the
plantation, accompanied by her husband, to sell beautiful, handwoven*
canastos *from their Land Rover, which they've filled with a selection
of various-sized baskets. She weaves them using* cana, *a reed plant that
grows locally. It takes her nearly five hours to make each one, and her
hands are rough from using the strong fibers. She seems shy about
making a sale but justifiably proud of the sturdy containers, easily
capable of holding a heavy load of coffee. The workers who use them
will tie them around their waists using belts, or* cinchas, *to hold the
baskets in place.*

TENDING THE NURSERY

Stately and elegant, a grove of mature coffee trees can be a beautiful sight. But on any coffee farm there is nothing quite as extraordinary as a well-tended nursery filled with tender, young coffee plants. They are the key to the future of any coffee farm and are carefully nurtured around the world.

This finca *is no exception. With the small, waxy-leafed plants verdant against the rich, black soil, this man pauses to rest from the labor of spreading compost on tender, young trees.*

THE OXCART

Before modern transportation, oxen and oxcarts, or carretas, *were used throughout Costa Rica to carry heavy loads. Even today it is not unusual to see a heavily laden cart slowly drawn by these strong, capable animals. Decorative carts have attained the status of folk art and are meticulously painted in primary colors and intricate designs.*

This cart, however, is very much a working cart. Unadorned, it hauls compost to a coffee tree nursery in the Monteverde growing region. The slow, rhythmic turning of its wooden wheels is an unmistakable sound as the oxen lumber deliberately down the road bringing yet another load. The ox driver walks alongside them, matching his pace to that of the two massive animals. When they reach the nursery, he props the long pole he carries against their yoke, a signal for them to stand at ease until they are required to pull the cart once again.

GUATEMALA

Everything about Guatemala seems to exude mystery, from the peaks of the country's smoking mountain volcanoes to the depths of crater lakes like the luminescent Lake Atitlán. Massive carved stone heads left scattered across the Pacific lowlands are remnants of an ancient, unknown people who inhabited the region, while Mayan monuments, so numerous that they are still being discovered, are evidence of yet another highly developed culture that flourished here long ago. It was to this land of stunning geography and enigmatic past that the Spanish eventually came, finding a complex culture of people flourishing in a fertile land. The arrival of the Europeans—and the coffee plant that would inevitably follow them—would initiate a new cycle of history in which all would play integral roles.

The story of Guatemala's coffee does not begin in pre-Columbian America, but the story of its people does. By the first century C.E., the Mayan culture of Mesoamerica was thriving. One of the most highly developed early societies in the Americas, it prospered long before the Aztec and Incan civilizations. The Mayans were prosperous farmers, wealthy enough to form a hierarchical society. By 250 C.E., their cities were scattered throughout the region. In addition to building temples and pyramids, many of which still stand, the Mayans developed a hieroglyphic language, an advanced mathematical system, which included the concept of zero, a calendar, and astronomic observations of astonishing accuracy. Amazingly, they were able to accomplish these feats using only simple stone tools, without the use of pack animals or the wheel.

Why the Mayan culture located in the Petén region of what is now northern Guatemala began to disintegrate about 900 C.E. is unknown. But by that time, in distant Arabia Felix, Arabs may have begun the cultivation of coffee on their terraced mountains. It would be hundreds of years before the two—the descendants of the Mayans and the coffee tree named for the Arabs—would collide in the country to be known as Guatemala.

By the time the Spanish arrived in Central America, the advanced Mayan culture had disintegrated in the Petén and moved into southern Mexico. What existed in its place were diverse communities of Mayan descent, each a highly stratified society with its own government. Independent peoples, they were constantly at war with each other.

When the Spanish conquistador Pedro de Alvarado came to the region in 1523 with orders to

conquer the people who lived there, he met with little resistance. Instead of uniting to fight the Spanish intruders, some of the existing cultures allied with the Spanish in an effort to defeat each other. Unfortunately, it was a strategy from which none of the *indígenas* would benefit—even though they far outnumbered the Spanish, they were unable to defeat them.

After conquering the land, the conquistadores showed little if any respect for its native people. Later, when they ascertained that Guatemala did not contain rich deposits of gold, the Spanish lost much interest in the land. Although they maintained a governing force, they administered the region with indifference. Still, the indigenous population suffered. Thought of only as subordinates who could be subjugated, the *indígenas* were forced to become laborers, converted to Catholicism, and all too often slaughtered. Despite their bleak situation, they persistently held on to their beliefs and ways of life.

By the late 1700s the Spanish had gradually established a sizable presence in the region. Their economy was based on the export of two natural dyes, blue indigo and red cochineal, both in strong demand in Europe. Sometime around 1760 Jesuit priests brought coffee to Antigua, the Spanish capital, located at the base of an active volcano, El Agua. Even though the coffee trees grew well on the rich volcanic soil, they remained inside monastery walls. It is probable that the small harvests were used by the priests—who were rapidly spreading coffee from monastery to monastery across the Americas. By the mid-1800s the dye industry began to suffer a serious decline and Guatemalans were desperate to find an alternative export. Not surprisingly, they planted coffee—which by then was being planted by European colonists throughout the New World. Here, too, coffee flourished and soon the economy shifted from indigo and cochineal to coffee.

BUT EVEN AS THE REGION STRUGGLED TO ACHIEVE ECONOMIC PROSPERITY, IT fought to establish its political identity. In 1821, three hundred years after the arrival of the conquistadores, Guatemala declared its independence from Spain. The newfound freedom resulted in bitter political controversy. First allying itself with Mexico, its neighbor to the north, it later broke away to ally itself with its neighbors to the south by becoming part of a Central American alliance. By 1840 this alliance had also disintegrated, and Guatemala became fully independent. Torn apart by civil turmoil, the country struggled to find a cohesive social and political structure.

While the ongoing political unrest continued, coffee was quickly becoming the young country's main export crop. In 1835, to stimulate interest in growing coffee, the government offered prizes to the first four farmers who could harvest twenty thousand pounds of coffee. In 1845 it distributed a sixteen-page manual containing detailed instructions on every aspect of coffee growing. The government's efforts paid off. By 1859 seedling programs were responsible for planting more than 3.5 million trees, and Guatemala harvested its first commercial production, exporting 383 bags of coffee.

Encouraged by the results, the government began even more intensive efforts to stimulate the

planting of coffee by suspending export taxes, supporting the purchase of machinery and technical assistance, initiating credit programs, and building ports and railroads. The Catholic Church followed the government's lead by reducing its tithe on coffee. By 1877 the Guatemalan government was also passing laws to attract foreigners to settle available lands and plant coffee. Immigrants came from all parts of Europe; Germans, especially, came in large numbers, fleeing the Bismarck government.

Early coffee farmers had a far-from-easy life. Roads to the growing regions were crude and often nearly impassable. As a result, getting coffee processed or to market was sometimes impossible. From farm to port was often a week's journey by oxcart; then the coffee had to be transported to the ship by dugout canoe. Coffee growers' lives were isolated not only by poor roads but also by fierce competition between farmers. To make matters worse, communication was nonexistent, labor a constant problem, and diseases such as malaria a continual worry.

Despite these challenges, the Guatemalan coffee industry maintained steady growth, even though the young country's politics continued a path of uncertainty. Each new government was fraught with attempted coups, civil unrest, public distrust, and controversy. Emerging from this volatile state of affairs, an oligarchy began to take control—support and financial backing for this small but powerful political group came from the fledgling coffee industry. In the midst of political crisis, coffee had taken the lead to become Guatemala's primary crop.

But still the indigenous cultures were not faring well. As their native lands, optimal for growing coffee, were increasingly claimed by the Europeans, they moved to upland regions where the soil was less productive and life more difficult. At the same time, they were being pulled into a social and economic servitude by a political system that did not recognize them equitably. Just as the conquistadores and the Church had exploited the *indígenas* earlier, the Guatemalan government denied them their equal rights. Meanwhile, to give the appearance of validity, a multitude of social programs were initiated—all to the eventual detriment of the native people of this land.

TODAY GUATEMALA IS A DYNAMIC CULTURAL MIXTURE OF THE OLD AND THE new—combining the rich heritage of the indigenous people, who survived tenaciously, with the many others who arrived later. The *indígenas* comprise nearly one-half of the country's population and continue to live as close to their traditional lives as modernization allows. Originally of indigenous and mixed European descent, a large population of *ladinos* have been assimilated into the mainstream culture; they maintain more modern lives. Many other Guatemalans are of European descent. With time the lines between the latter have faded, while the indigenous Mayans remain colorfully visible through traditional dress and their adherence to ancient customs.

Paradoxically, even as much has changed in Guatemala, the country has continued to struggle politically. Coffee continues to be the main, though not sole, export, accounting for approximately one-fourth of the country's foreign trade. In the 1950s Guatemala endured a United States–backed

invasion over land reform issues; by the 1980s civil unrest and military repression had become so heightened that the whole country was embroiled in civil war. The signing of a 1996 peace treaty brought an end to thirty-six years of internal civil strife. Today many programs, both national and international, are attempting to help heal the wounds of such divisiveness. And so the story of Guatemala—very much like those of other similar coffee-producing countries—is still being written.

EVEN THOUGH GUATEMALA IS RELATIVELY SMALL, THE RUGGEDNESS OF ITS geography can make travel difficult. Traversing the mountainous terrain, where some thirty-three volcanoes actively smolder, is often slow going. But time is hardly an issue when the journey is so visually rewarding. We measured our way across Guatemala in small increments, traveling from one coffee-growing region to another. We saw the picture-postcard beauty of Lake Atitlán, enhanced by the multitude of surrounding coffee fields, all laden with ripe cherry ready for harvest. We visited coffee *fincas* near the picturesque colonial city of Antigua, the site of the old Spanish capital abandoned in 1773 after being leveled by a massive earthquake. Then we traveled northwest to the Cuchumatanes Mountains near Huehuetenango. Astonished by the sheer ruggedness of the growing region, we met growers whose families had been there for generations. Finally, we journeyed toward the Pacific, through the San Marcos growing region, where harvest was at its peak. Along the way people from every walk of this diverse culture greeted us, sharing their hospitality, their traditions, and, most especially, Guatemala's long and rich heritage.

THE ROAD TO HUEHUETENANGO

The Huehuetenango region of Guatemala is the epitome of a rugged coffee-growing landscape. Coffee trees cover the steep mountainsides in every direction and at nearly every altitude. Roads wind up, down, and across the uneven geography. They provide access to hard-to-reach coffee farms, which lie scattered throughout the region, some high on peaks, others in deep valley pockets. Varying altitudes receive different amounts of rainfall and sunshine, as well as a diversity of temperatures; throughout the region a single coffee farm will be composed of numerous such microclimates.

During the rainy season the roads suffer, as do the people who live on them. With the rains rough, dusty, jarring roads turn into slick mud. Some wash out completely, while others become so mired that they are traversed only with determination and skill. All will need repair when the rains cease. But for the people of Guatemala's highlands, this is merely part of the cycle of growing coffee on this rugged land rich with volcanic soil.

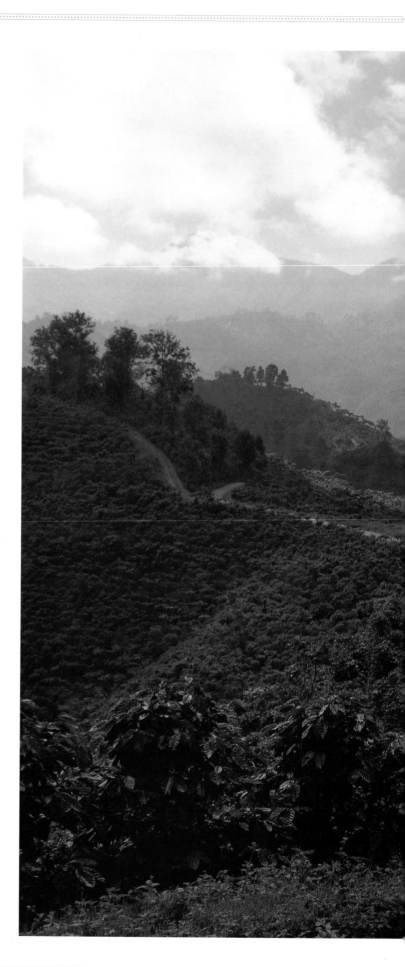

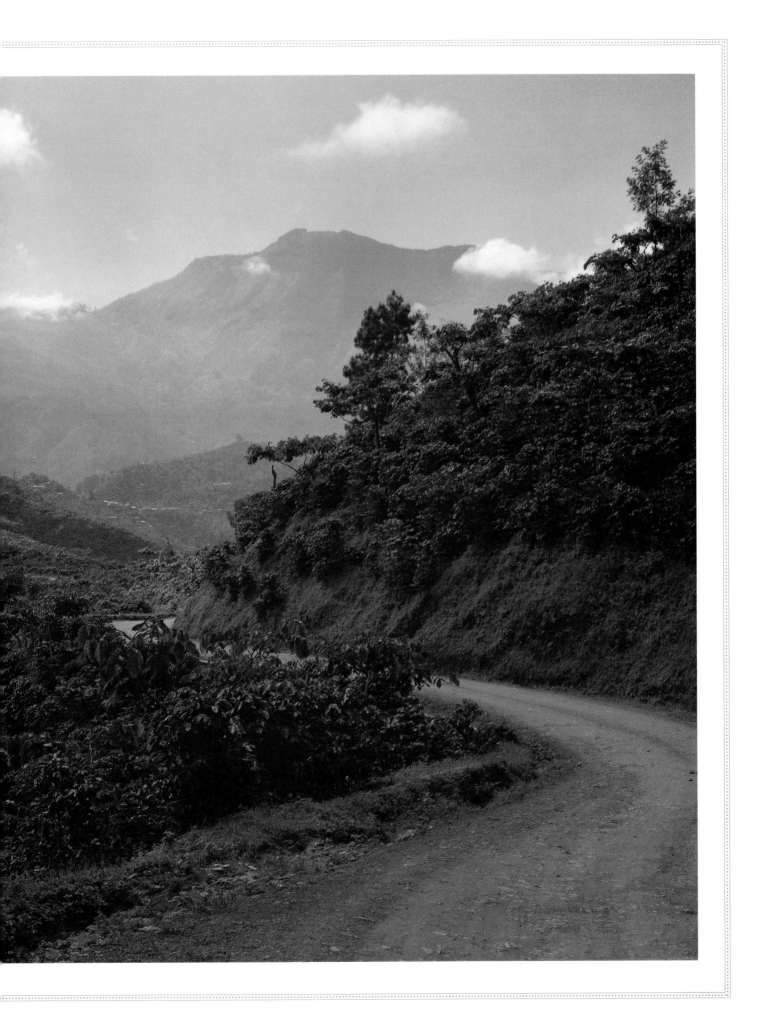

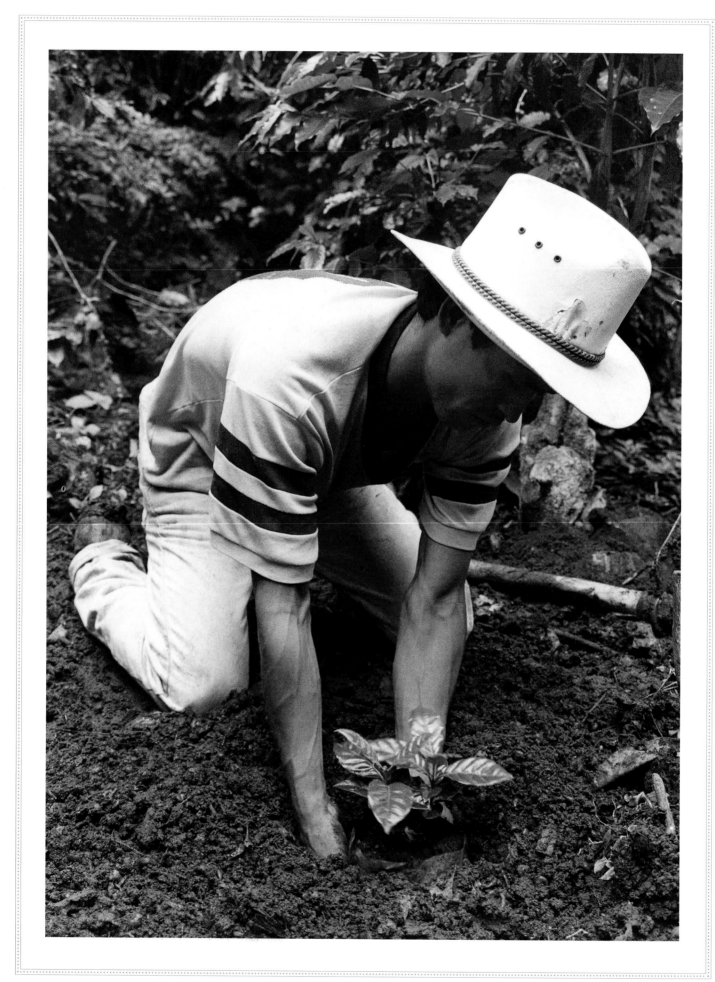

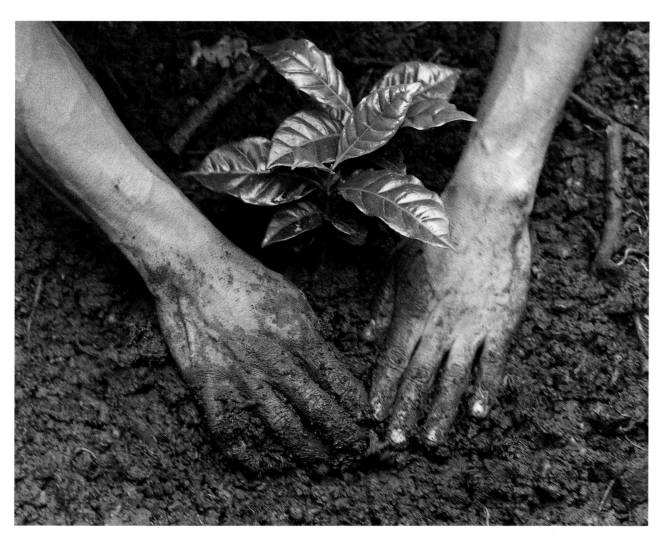

IN THE GROUND

In soil nourished by mountain rains, young coffee trees are being planted to replace older, less productive trees. New trees are planted at the beginning of the rainy season so that the roots can take hold during the prolonged and plentiful rainfall. An old, unproductive tree was first removed from this spot with this man's machete. Now, with great attention and care, he replaces it with a tender young sapling. It will be approximately five years before this tree bears its first harvest.

The planter completes this process with an efficiency born of having done this a thousand times before. Still, the agility with which he carries out his task instills the process with a sense of ritual.

WOMAN OF SAN JUAN ATITLÁN

Guatemalans of Mayan descent place great importance on maintaining their traditional ethnic dress. Women especially believe that to change a person's clothing is to change the person. This woman harvests in the Huehuetenango region with her husband and daughters but comes from the village of San Juan Atitlán, many miles away. She is of the Mam culture and speaks only that language. Her husband, who also speaks Spanish, tells us how proud they are of the handwoven and embroidered clothing his wife wears. Her traditional dress consists of a skirt, made from a length of fabric called a corte, *and a* huipil, *or top. Although it takes the equivalent of a month's earnings from the entire family to purchase these garments, they are so integral to her life that she wears them even to harvest coffee. Both of their young daughters are also dressed in the traditional style.*

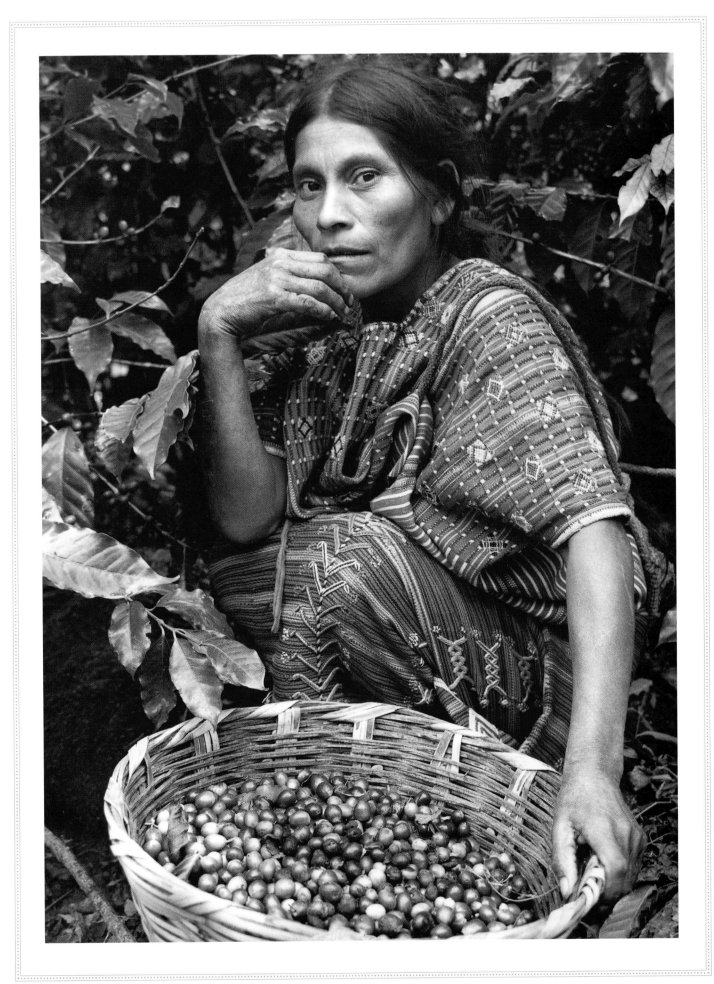

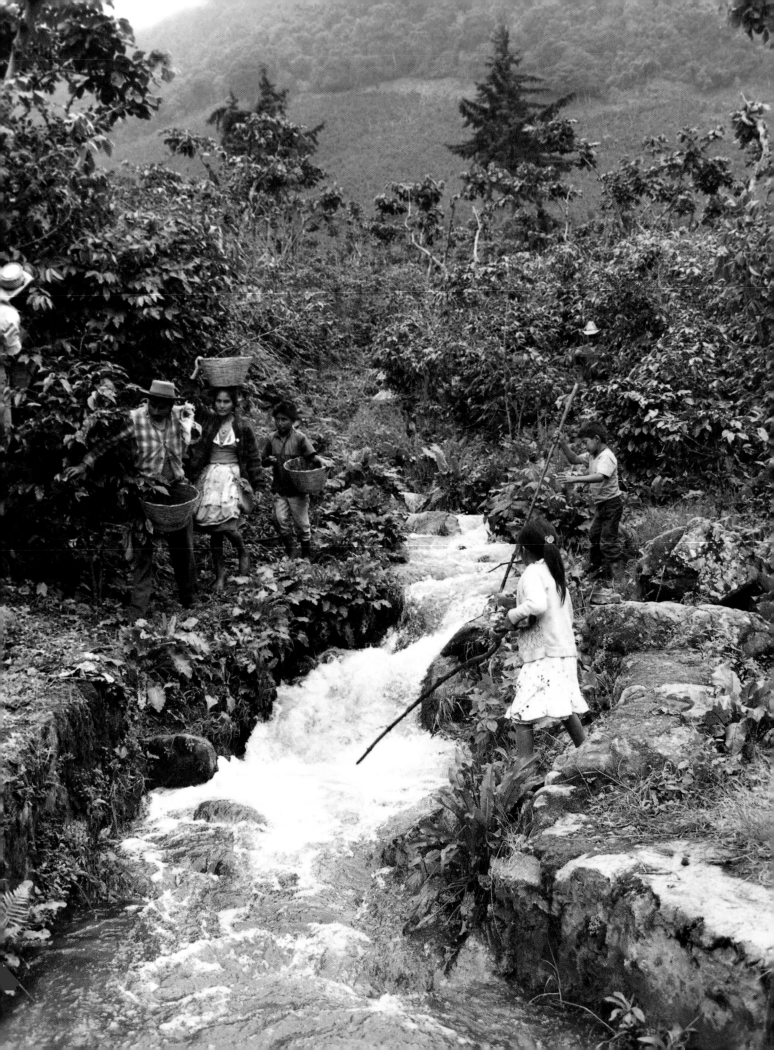

BY THE RIVER

In most coffee-growing countries whole families come to the fields, and it is not unusual for school holidays to fall, as they do in Guatemala, at harvesttime. While their parents pick, younger children are usually at play. Older children often assist their parents, by picking alongside them, by helping with meals, or by watching their younger brothers and sisters. Family meals are taken together, and at the end of the day everyone helps transport the harvested coffee to the weigh station.

Child labor is a complex problem with few simple answers. It is often hard for foreigners to appreciate the strong sense of family identity that motivates parents to bring children into the fields. The children are there as part of the family unit, not because they are being forced to work. Often whole villages will travel to a farm, where they will live during the harvest. Without child care, children are simply taken into the fields along with everyone else. The bonds between families and among families are clearly felt as one watches Guatemalans work hard together, relax together, take meals together, go to church together, and often celebrate together.

THE TREE BRIGADE

Coffee trees need to be pruned seasonally to produce optimally. Armed with the tools of their trade, these men traverse steep mountain coffee fields to trim trees. Each one carries a machete, either in his bag or in his hand, as well as a bent stick, which will be used to pull hard-to-reach branches toward him. Rubber boots are a necessity on the slippery, often muddy slopes.

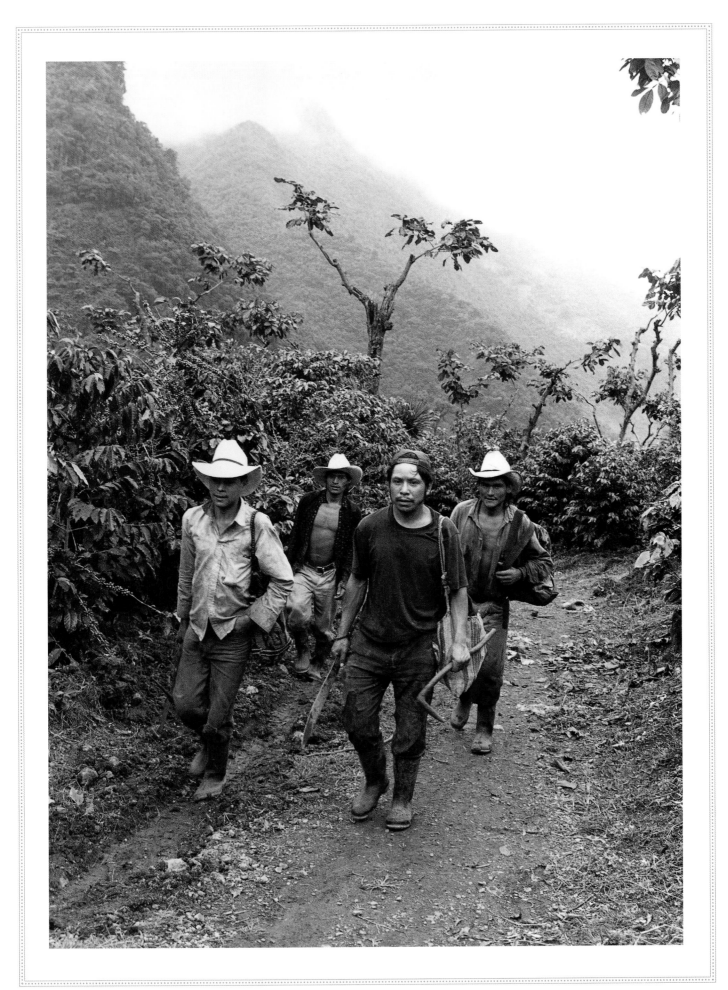

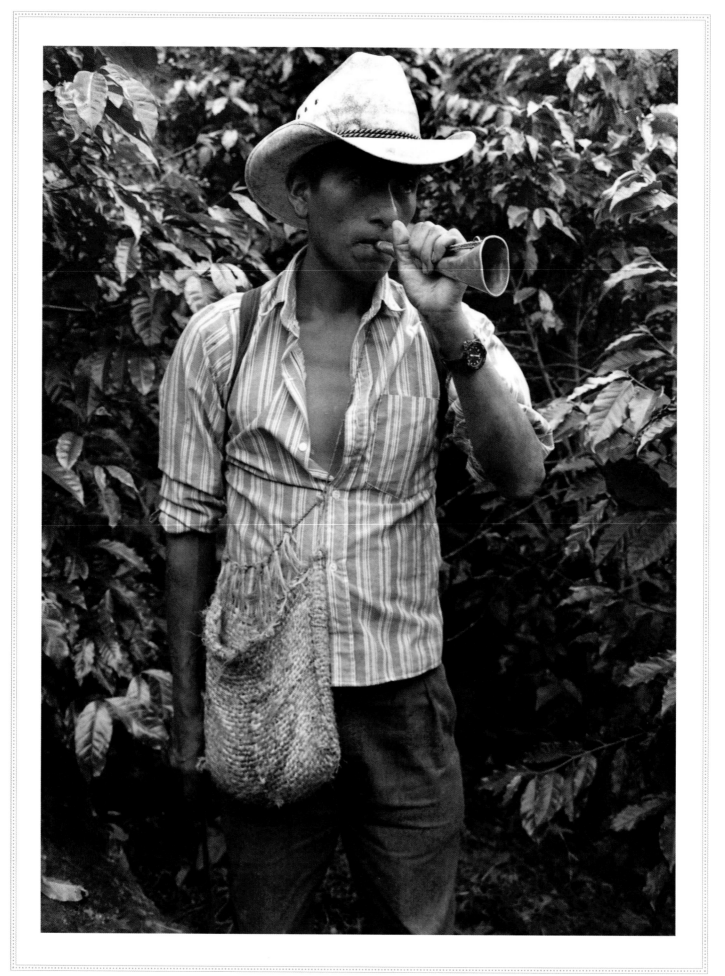

LA TROMPETA

This man, el caporal, *can be heard long before he is seen. With a small brass trumpet, he calls pickers to a particular area to harvest, blaring out communications in a single monotone note. Because the coffee trees are taller than the Guatemalans picking them, the commands easily reach everyone.*

This form of communication, thought to have come from Spain, is traditional in Guatemala. Blowing this toy-sized horn conveys status, and the responsibility is often handed down from father to son. This man, by virtue of his position, determines what area is picked each day. It is also with his call that the daily lunch break begins and ends, and that the welcome conclusion to a long workday is announced.

TWO BAGS

The strength of the people who work in the coffee fields is often astounding. Carrying a load that might very well exceed his body weight, this Guatemalan man brings his harvest from the field to the scales.

Coffee comes to us via an amazing array of transportation—horse, bicycle, pack mule, ox, Jeep, tractor, truck, motorbike, bus, wagon, cart, cable, or train. Still, more often than not, coffee comes to us by human strength—on the backs of men and women.

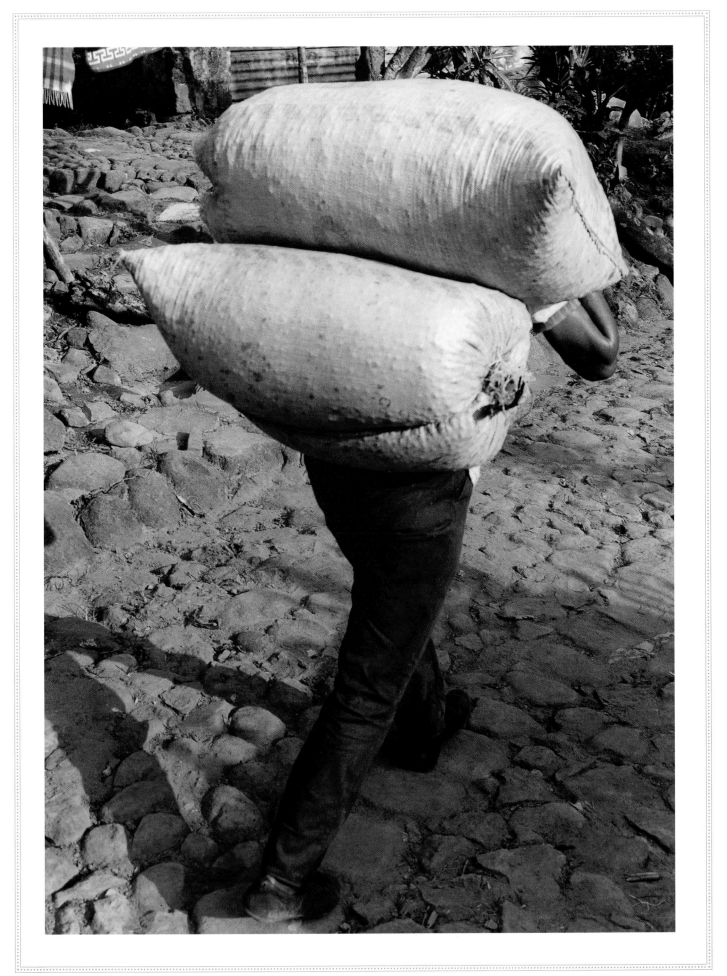

THE WEIGH STATION

At the height of the harvest, this weigh station is extremely busy—but what seems at first like chaos is actually a well-organized process of pickers bringing in their day's work. Easily a hundred people wait their turns at the scales. Each one's harvest will be weighed separately, the cherries poured from their bags into the huge scale. When this man's work has been weighed, the amount is stamped onto his pay card.

As the next person steps up, a lever is pulled, opening the bottom of the device. The previous worker's harvest is dumped into a huge truck waiting below—already so filled with coffee cherry that a worker must rake steadily to keep it from overflowing.

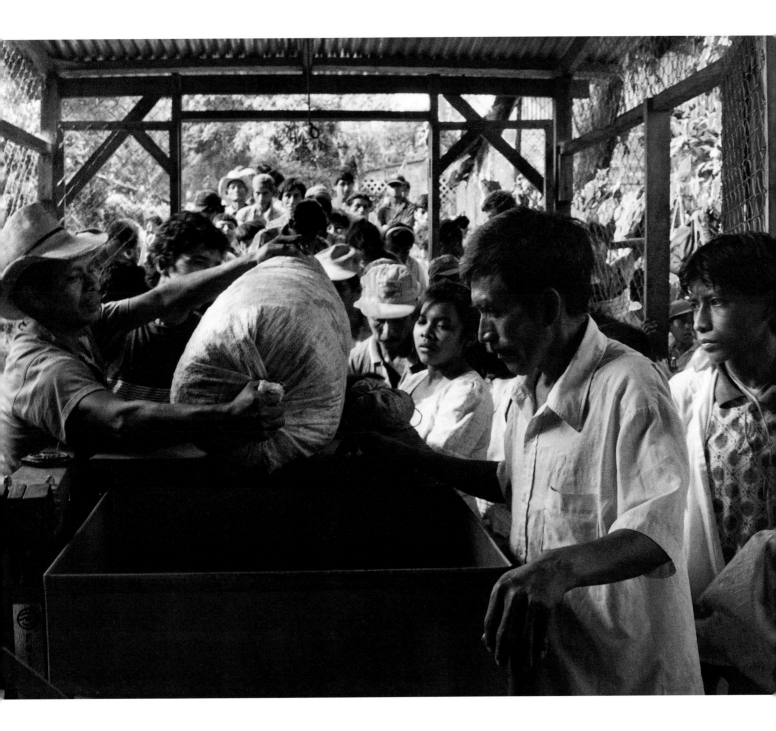

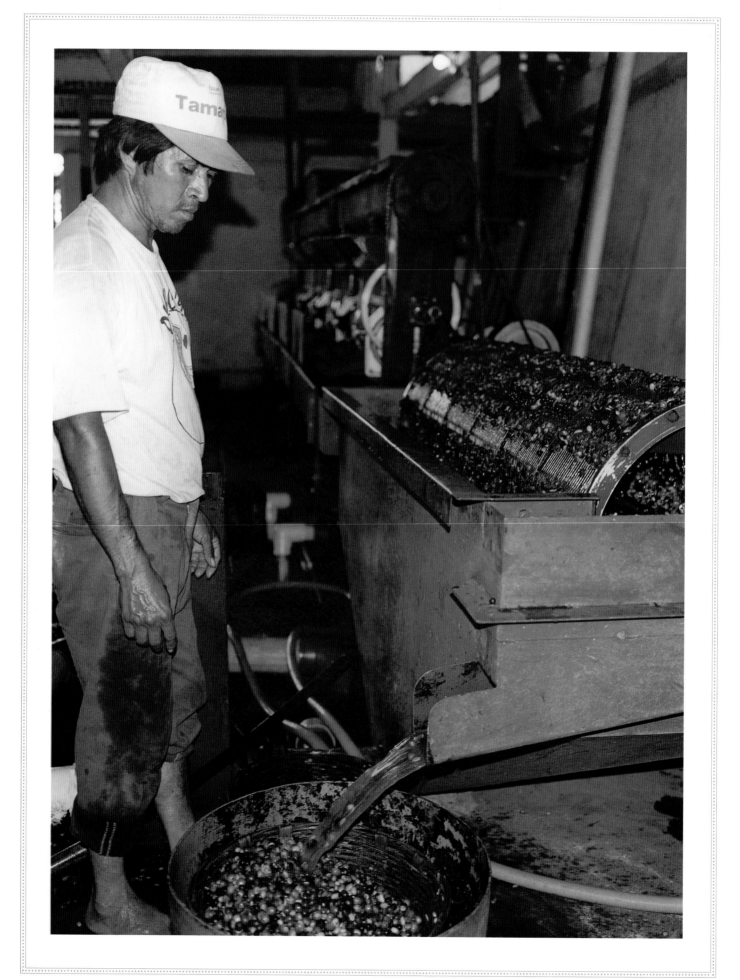

PULPING

A beneficio, *or coffee-processing factory, is a noisy place where many procedures occur at once. In most countries the facilities are mechanized, and people do not directly perform the work. Still, with every step workers are needed to carefully monitor the beans' progress.*

In washed coffee production, beans are mechanically pulped immediately after harvest to remove as much of the fruit as possible. Simultaneously, they pass through several large screens so that any cherry that did not get pulped is separated out before passing on to the next process. The entire procedure takes place with water, which transports the beans from one machine to another.

THE RAKE

This beneficio *is run entirely by hydro power—energy generated by a fast-moving river that passes through the* finca. *Because coffee is heavy and hard to transport, all* beneficios *optimize the use of gravity. Water is plentiful here and combined with gravity can move the freshly harvested cherry through all of the steps involved in its immediate processing after harvest.*

Still, there are always tasks that water and gravity cannot do, and for which human strength is ultimately required. The freshly pulped fruit in this huge tank is being spread by this man with a heavy and awkward rake. Soon water will fill the tank, initiating fermentation to remove the mucilage that still clings to the coffee beans.

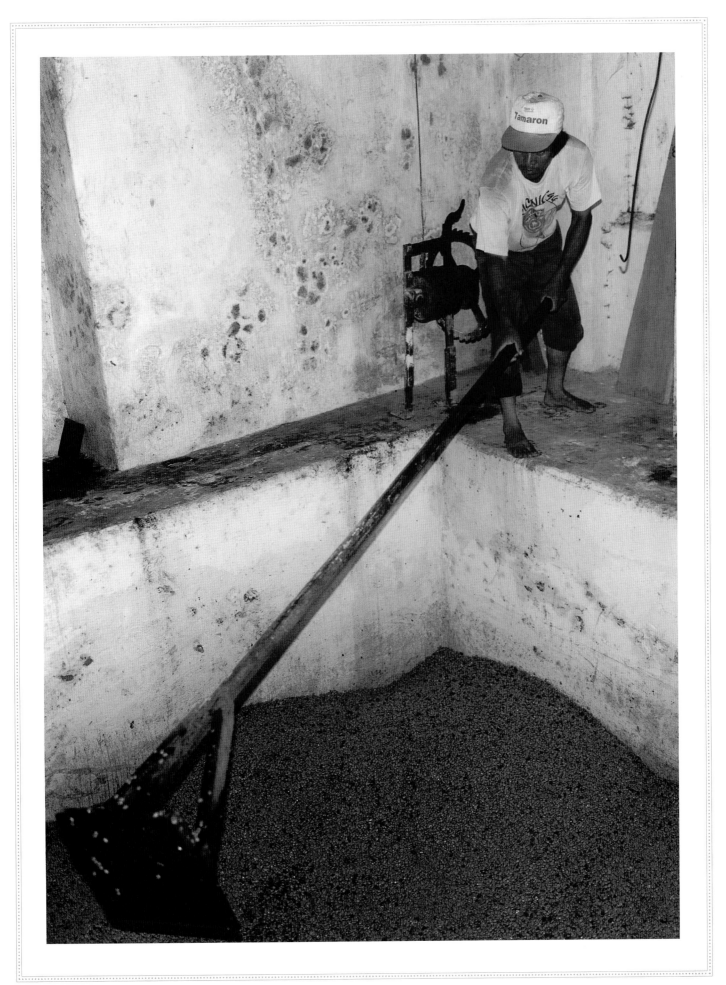

KENYA

WHEN COFFEE ARRIVED IN KENYA AT THE TURN OF THE twentieth century, it was completing a journey it had begun approximately thirteen hundred years earlier. The unknown tree with the bright red cherries first discovered growing in the highlands of Abyssinia had come full circle. It left Ethiopia virtually unknown, but coffee returned to Africa as a crop, commodity, and beverage recognized worldwide. It had not merely traveled south from Ethiopia to arrive there; instead it had made a complicated journey that had literally carried it around the world. With great expectation and excitement, white settlers immigrating to British East Africa in the early 1900s planted coffee seeds throughout the highland plateau. For most the effort paid off—Kenya proved an ideal location for cultivation of the now popular bean.

Contemporary Kenya and Ethiopia are two important coffee-producing nations that share a border. But before the Colonial Europeans arbitrarily began to draw political boundaries across the African continent, there was little delineation between the two countries. Indeed, much of their history is told in tandem and their geography shared. Oddly enough, even with such commonalities, coffee is not part of Kenya's past—though it is now very much a part of its present.

Unlike Ethiopia, too, the interior of this African region remained completely unknown to foreigners until the nineteenth century. Its coast, however, had been a well-traveled and lucrative trade route for hundreds of years; by the tenth century, it reached a golden age, with trade extending as far away as Europe and the Mediterranean, India, and China. In addition to goods from all over the world, trade brought an influx of new technology and business practices to the people of the region.

Now a major port city in the coffee trade, Mombasa was originally settled by Islamic traders and mariners who mixed with the black Africans already living there to become known as the Swahili people. Their distinctive language, influenced by Arabic, Hindi, and later Portuguese and English, became the language of trade; eventually it came to be spoken along the entire coast of eastern Africa. By the late nineteenth century, Mombasa would serve as the port through which white settlers immigrating to the region would arrive and depart. Then, as now, it also served as the arrival and departure point for all goods that flowed into or out of the land.

But in 1498 when the Portuguese sailor Vasco da Gama sailed into Mombasa, he did not receive

a cordial welcome. Having just rounded the Cape of Good Hope in search of a sea route to India, his ship was attacked by Arabs when it entered the port. Da Gama had a better reception in the nearby port of Malindi and left that city laden with gifts and a guide to escort him to Calcutta. Successful in his mission, da Gama returned to Portugal with tales of the incredible wealth he had seen along the African coast. Inspired by what da Gama had found, the Portuguese returned to Mombasa and by 1505 had seized control of the port from the Ottoman Turks—ending a centuries-old Arab trade monopoly. The Portuguese would maintain the stronghold until the latter part of the seventeenth century, when the Arabs reclaimed Mombasa. Although they would never prosper as before, the Arabs remained in power until the nineteenth century, when the English and Germans colonized the region.

Until the beginning of the nineteenth century, the tribal societies in the interior had little knowledge of what was going on along Kenya's coast—just as mariners and explorers were not familiar with the unknown inlands. In the mid-1800s two German missionaries were the first Europeans to travel into the interior and one, Johannes Krapf, beheld the white peaks of 17,000-foot Mount Kenya. In 1854 he produced a map and Europeans were incredulous to hear that there were snow-capped peaks in the heart of Africa. Word excitedly began to circulate throughout Europe, and within a decade England's Royal Geographic Society had sent its own men, Sir Richard Burton and John Speke, into eastern Africa for mapping and exploration. Germany and England would continue with years of exploration, competing for knowledge and, ultimately, possession of East Africa. By the end of the nineteenth century, there was fierce competition throughout all of Europe for control of the African continent.

To impede the Germans from moving north into the region, the British ordered the building of a railroad between Mombasa and Lake Victoria. The line was built strictly for strategic purposes; no commerce existed along this route. Construction began in 1896, took more than five years to complete, and cost the unheard-of amount of 9,500 pounds a mile—5 million pounds in all. Back home in England the project was nicknamed the Lunatic Line. Nairobi, Kenya's future capital city, began as a camp on the Nyrobi River at the railroad's halfway point.

Only then did coffee come to Kenya. When the Uganda Railway was completed in 1901, the British, hoping to recover their investment, encouraged white settlers to establish farms along the newly accessible land. Soon British entrepreneurs were plowing and planting, building their homes and lives upon the harsh but beautiful landscape. They quickly populated the soil-rich highlands around Nairobi, and within several decades areas that had traditionally been the primary home of the Kikuyu and Masai peoples were being referred to as the White Highlands.

Lord Delamere, one of British East Africa's earliest settlers, was a driving force behind the experimentation with and establishment of crops and livestock on this unfamiliar land. Full of enthusiasm and actively encouraging others to be as adventurous, he tried to farm nearly everything, from sheep and cattle to crops such as flax, sisal, and wheat. Many of his attempts ended in total disaster. First he lost all of his sheep, then his early herds of cattle. His crops suffered from blight, pest, and

disease. Finally, it seemed that his wheat crop would flourish, but Africa's wild animals soon discovered that they, too, had a taste for the exotic grain.

With the rapid influx of new settlers all practicing trial-and-error farming, it was only a matter of time before coffee was tested. It is probable that coffee arrived through a variety of sources at about the same time, though one account mentions that it was planted in Kibwezi as early as 1893. By 1900, however, coffee was growing in earnest, planted successfully near Nairobi at St. Austin's Mission, the seed having come from Yemen via another mission in Zanzibar. It may also have arrived from farms in Brazil, the French island of Bourbon, or even from Blue Mountain in Jamaica. Planted extensively by the determined and hearty settlers, coffee quickly flourished in the optimal soils of the highlands surrounding Mount Kenya.

As white settlers continued to immigrate, the indigenous tribes were forced farther and farther from their traditional lands, causing ever-increasing discontent. In 1963, after years of growing tension, Britain granted Kenya independence. Kenya's new government encouraged the Europeans to remain, and many did, though much of the farmland was broken down into parcels through aggressive programs that emphasize the small farmer. Today agriculture is still the heart and soul of the Kenyan economy, with coffee supporting more than 25 percent of Kenya's export revenue. Meanwhile, new growing regions are being planted and active educational programs are being introduced to compare and improve growing methods and increase production. Kenya grows strictly arabica bean, and its 1999 production was more than 1.3 million bags. Because it is a tea-drinking nation, it exports nearly all of its coffee.

MANY PEOPLE HAVE WRITTEN ABOUT THEIR EXPERIENCES GROWING COFFEE. But it was with a distinctive eloquence that the Baroness Karen Blixen told her story of coming to British East Africa from Denmark in 1914. Settling in the Ngong Hills outside Nairobi, she and her husband, Bror Blixen, placed their entire future on the coffee farm they purchased there. After struggling for many years—with both crops and marriage—they eventually had to admit defeat in both. While many of their contemporaries had found success in coffee, the Blixens had chosen the wrong location for their farm. In 1931, broken and broke, the baroness was forced to sell her farm and leave Africa.

Upon her return to Denmark, using the pen name Isak Dinesen, Blixen wrote about her life in Kenya in *Out of Africa*. She beautifully describes the immense pleasures and profound heartaches that owning a coffee farm exacts, along with the unwavering responsibility she felt for her family, her employees, and the African people. Anyone, anywhere, who has planted and grown coffee can understand the depth of her words. They are as moving today as when she wrote them:

There are times of great beauty on a coffee-farm. When the plantation flowered in the beginning of the rains, it was a radiant sight, like a cloud of chalk, in the mist of the drizzling rain, over six hundred acres of land. The coffee-blossom has a delicate slightly bitter scent, like the blackthorn blossom. When the field reddened with the ripe berries, all the women and the children, whom they call the Totos, were called out to pick the coffee off the trees, together with the men; then the waggons and carts brought it down to the factory near the river. Our machinery was never quite what it should have been, but we had planned and built the factory ourselves and thought highly of it. Once the whole factory burned down and had to be built up again. The big coffee-dryer turned and turned, rumbling the coffee in its iron belly with a sound like pebbles that are washed about on the seashore. Sometimes the coffee would be dry, and ready to take out of the dryer, in the middle of the night. That was a picturesque moment, with many hurricane lamps in the huge dark room of the factory, that was hung everywhere with cobwebs and coffee-husks, and with eager glowing dark faces, in the light of the lamps, round the dryer; the factory, you felt, hung in the great African night like a bright jewel in an Ethiope's ear. Later on the coffee was hulled, graded and sorted, by hand, and packed in sacks sewn up with a saddler's needle.

Then in the end of the early morning, while it was still dark, and I was lying in bed, I heard the waggons, loaded high up with coffee-sacks, twelve to a ton, with sixteen oxen to each waggon, starting on their way in to Nairobi railway station up the long factory hill, with much shouting and rattling, the drivers running beside the waggons. I was pleased to think that this was the only hill up, on their way, for the farm was a thousand feet higher than the town of Nairobi. In the evening I walked out to meet the procession that came back, the tired oxen hanging their heads in front of the empty waggons, with a tired little Toto leading them, and the weary drivers trailing their whips in the dust of the road. Now we had done what we could do. The coffee would be on the sea in a day or two, and we could only hope for good luck at the big auction-sales in London.

KENYAN COFFEE FIELD

Weather is a constant concern, and anyone whose livelihood depends on coffee observes it almost intuitively. When El Niño's rains drenched Kenya during its usually dry harvest season, everyone watched the skies with great apprehension. Too much rain not only made it hard to get the harvest in on time but made drying the beans almost impossible. Adding to planters' concerns, the rain threatened blossoms, already forming on some trees and essential to the next crop.

Weather was obviously on this worker's mind as she emerged from a row of trees to deposit the cherry she had just picked. Afterward, she paused a moment to glance up at the gathering rain clouds, then started back into the trees to continue harvesting. Suddenly, she stopped again and turned to face the sky above her as if in confrontation. She stared at it for a long while before disappearing back into the grove to resume her work.

BRINGING IN THE CHERRIES

Coffee is the main cash crop in the Nyeri growing district on the foothills of Mount Kenya. Two-thirds of the growers there are small, local farmers with several acres of land apiece. At harvesttime only the ripe coffee cherry is picked, and men and women labor side by side, sharing the work. The cherries are gathered at seven-day intervals until all are harvested.

The absence of a centralized communication system among the numerous small farms means that it is difficult to assess how well the overall coffee crop is maturing. This is of particular concern during times of crisis, such as drought or excessive rain. Exporters in Nairobi have little information with which to gauge the severity of problems in the field, while farmers are rarely current on the daily ups and downs of the international coffee trade. Lack of communication is also a problem when farmers are faced with specific agricultural problems; they must rely on their immediate community for advice, solutions, and materials.

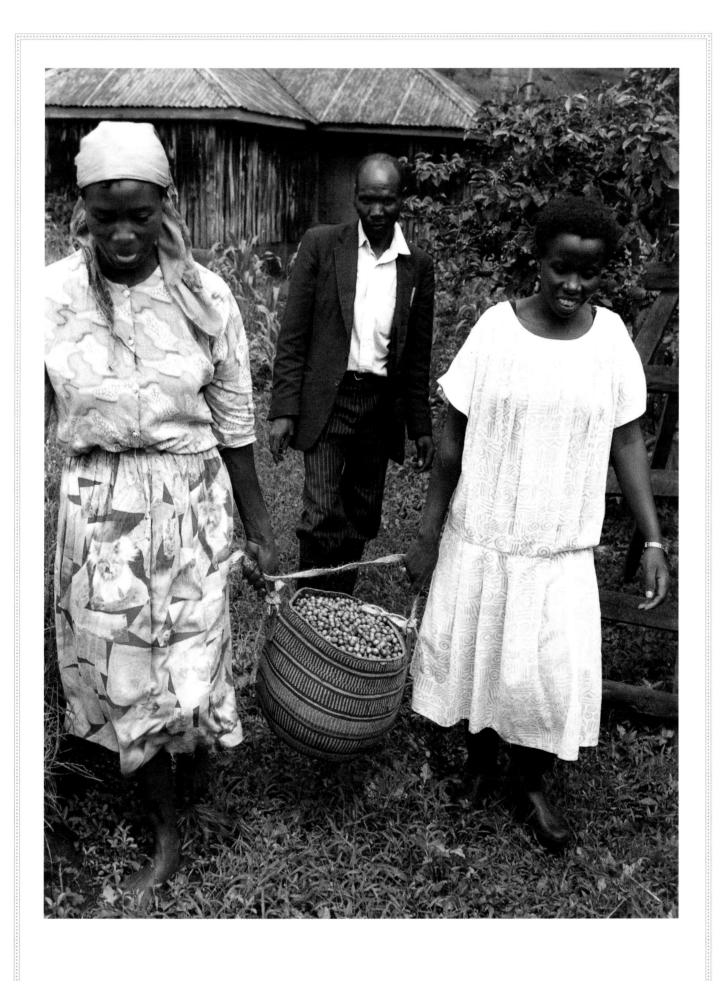

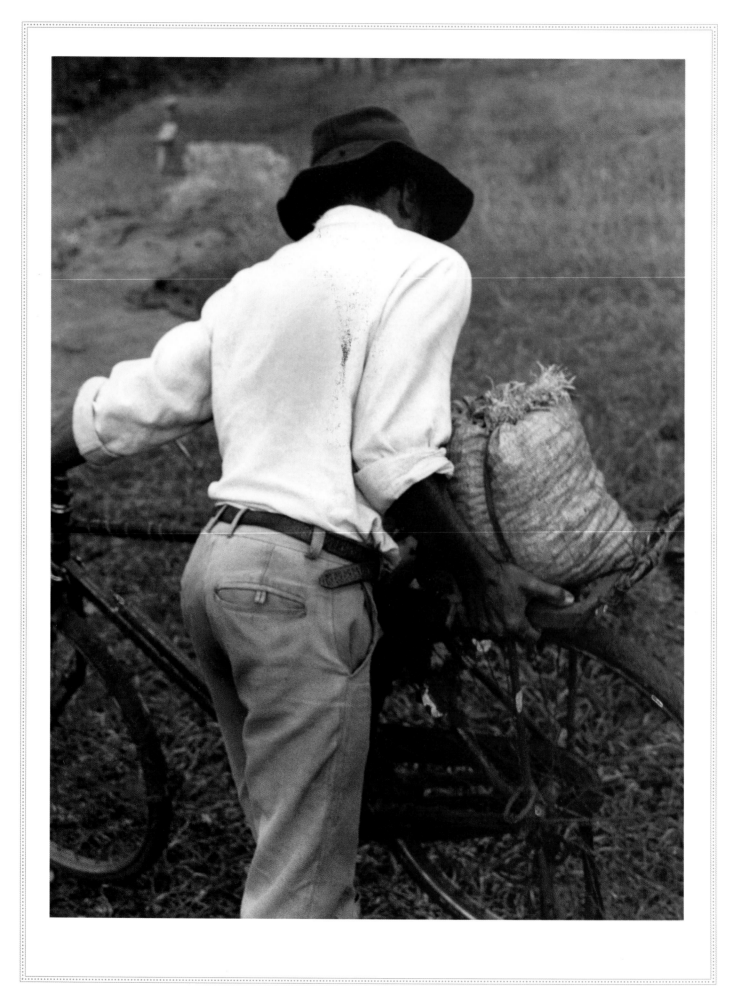

JUST ARRIVED

Coffee arrives at processing facilities in containers that come in an assortment of sizes and are carried by various modes of transportation. From out of nowhere, this man appears—though the sound of his squeaky old bicycle precedes him. As he materializes from a grove of coffee trees, he brakes to an immediate halt, hops off his bike, grabs his little bags of beans, and runs to get paid.

THE SORTER

At the end of a day of harvesting, the picking complete, workers must sort through their day's work. Whether by hand or by machine, coffee sorting takes place at every step of production.

In Kenya, as in many other countries, constant attention is given to this process to ensure high-grade coffee. More than just quality control, this vigilance is a strict code followed by every worker.

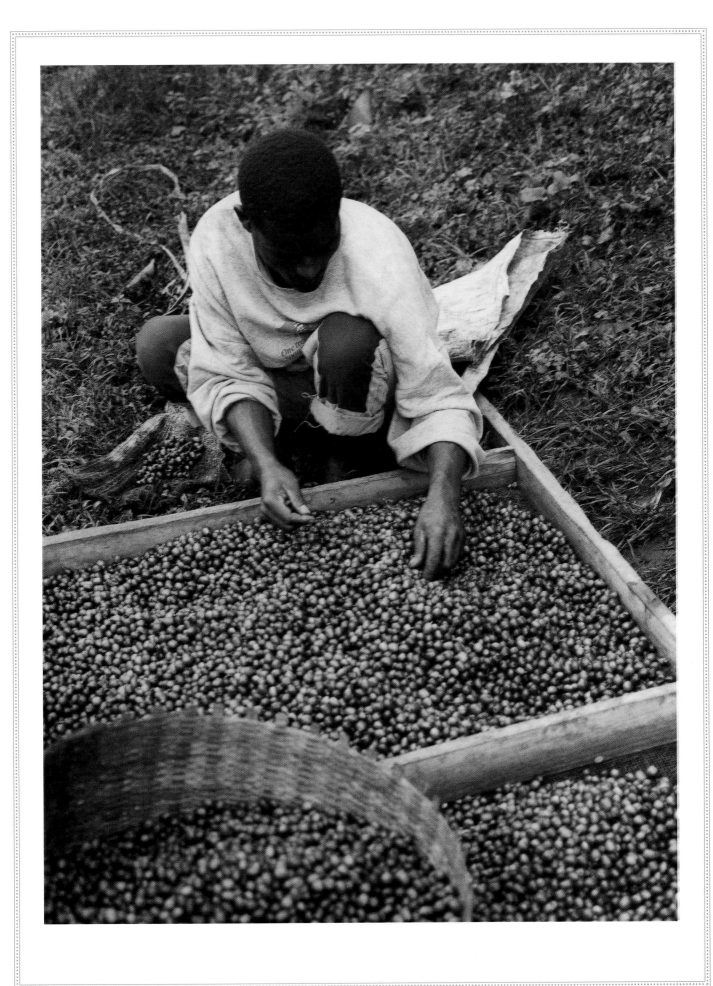

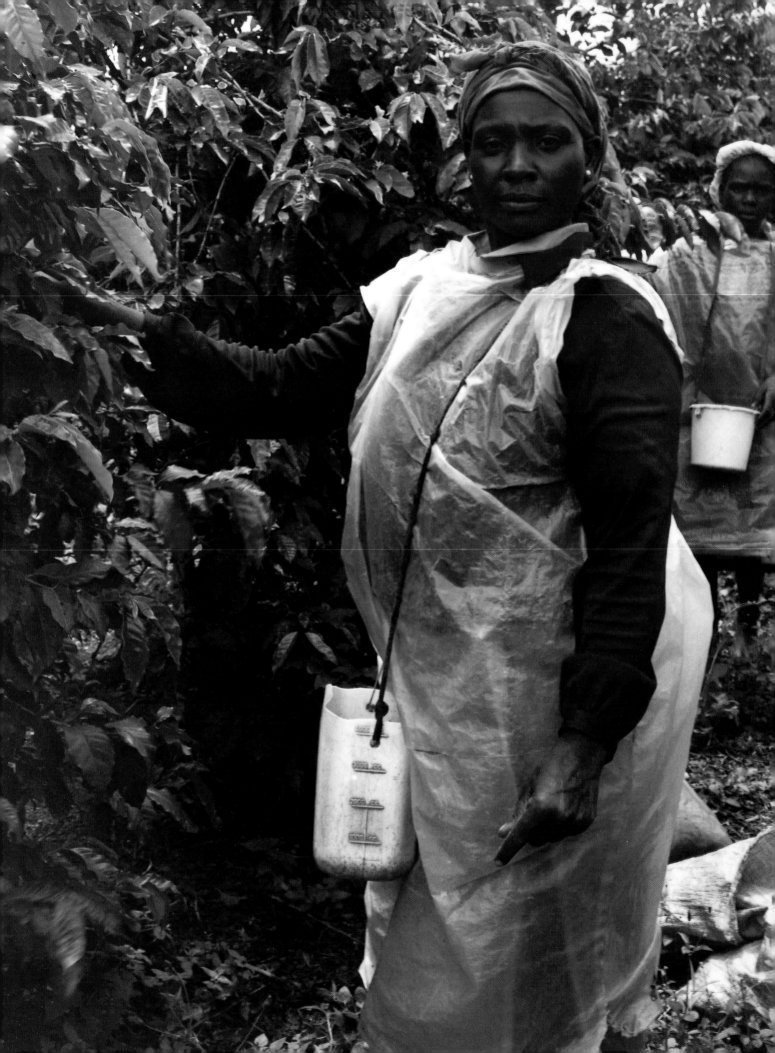

KENYAN PICKER

This strong, proud Kenyan woman captures the essence of her country in her stature. Both power and grace epitomize her movements, as she gently harvests coffee.

GETTING PAID

There is a certain cadence to the way the more than three hundred pickers on this farm complete their day. Softly talking as they sort their harvest, they fill plastic measure buckets with ripe cherry, then carry it to a receiving truck, where it is tallied and dumped. This young woman turns in a chit and all her buckets, again carefully tallied, to receive daily compensation. The rhythm of the process is softly punctuated by the soft sounds of handheld counters measuring coffee, measuring buckets.

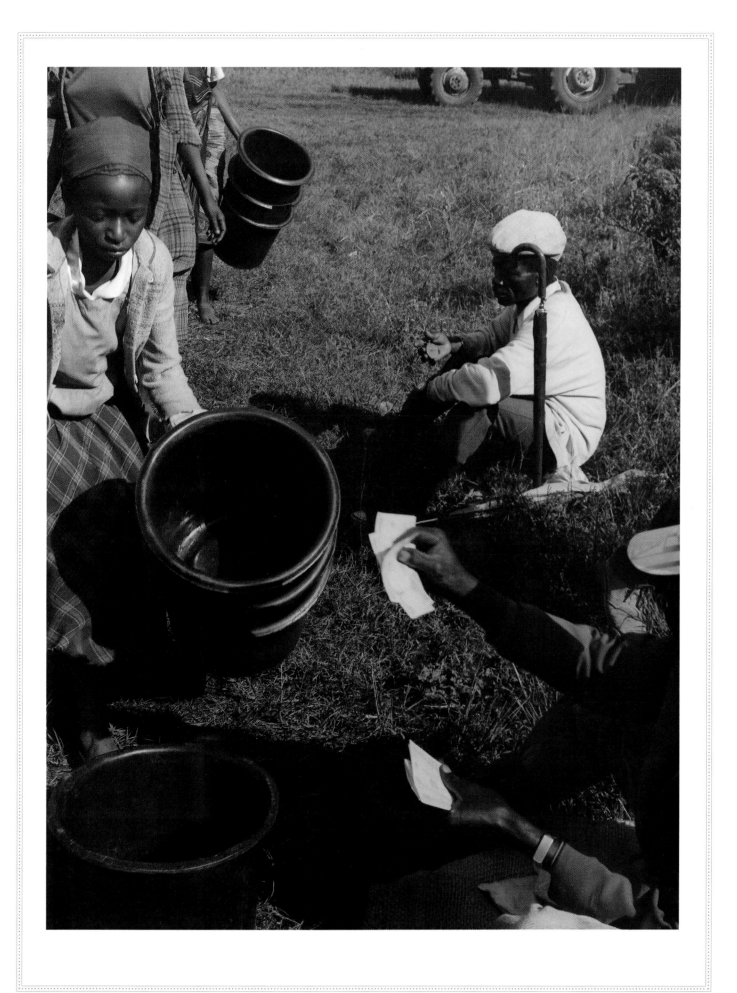

THE PUSH

Water is often used to move and separate coffee. Because ripe cherries are lighter, they float to the top and are carried through water channels. Using simple wooden tools, these workers push the "sinkers" remaining in the bottom of a long water trough into a special tank. Because this fruit did not completely ripen on the tree, the flavor in these beans will not be well-developed, making them lesser-quality beans.

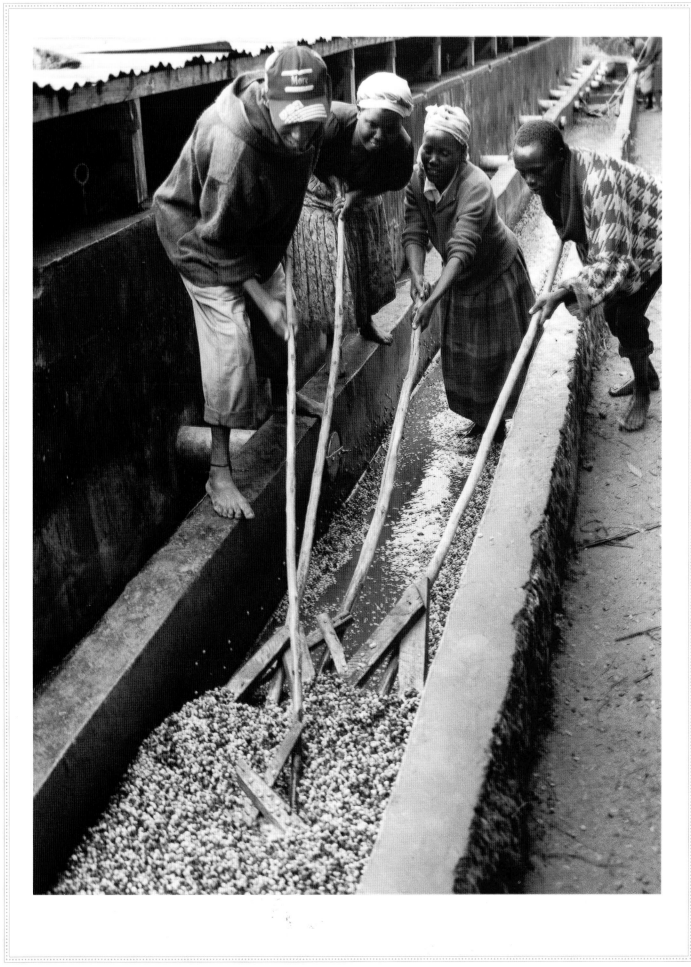

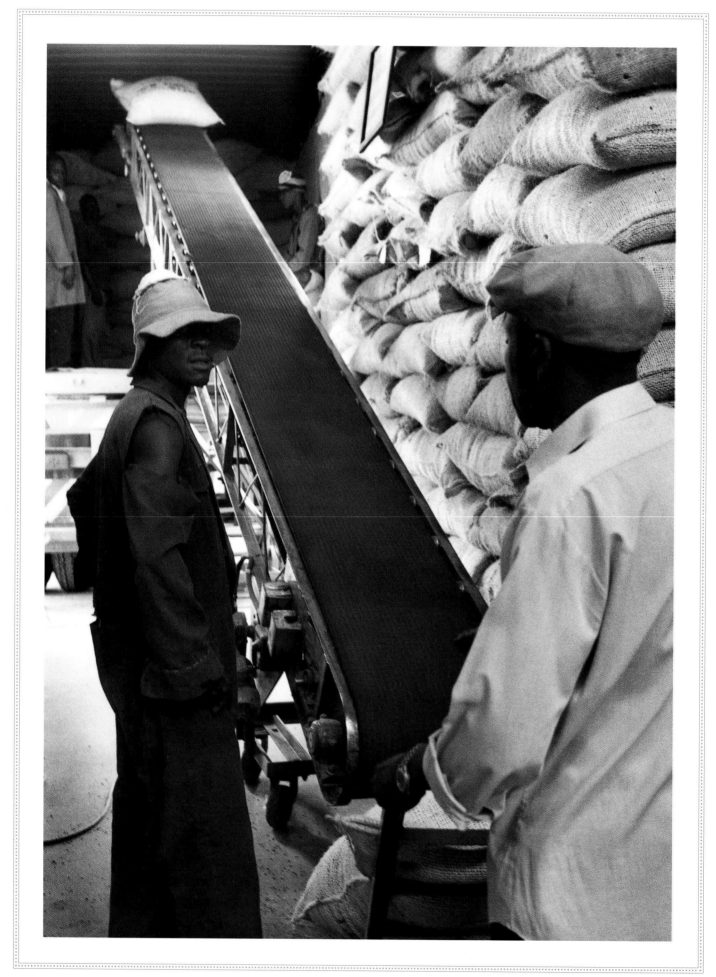

LOADING COFFEE

Again and again these beans—soon to be exported—have passed through countless Kenyan hands. Being moved one last time at this processing facility in Nairobi, bags containing sixty kilos of beans each are loaded onto a truck that will transport them to the port of Mombasa. Within weeks, they will arrive in the country of importation, where once again they will travel through many processes, past countless people, before arriving at their final destination and the ultimate goal—the preparation of a fine cup of coffee.

FROM SEED TO BEAN

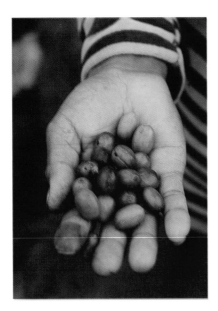

Equatorial rain
droplets nourish
coffee seed
gently planted
bursts forth
branches spreading skyward.

White flowers glisten
like fragrant snow.

New growth laden
with cherries, each
containing the seed
we call bean.

Brilliantly red
removed from
arboreal support
ripely harvested
the long voyage
begins.

Dried under
sun's warmth rays
raked, turned, sorted
 by worker
 by machine
 by hand
 by eye.

Parchment and silver
skin layers removed
quality tested categorized
by weight/color/size.

Many times.

Bagged.
Sewn.
Stacked and stored.
Opened.
Spilled & poured.
Bagged.
Sewn.
Repeatedly.

Conveyed again and again
by human strength

Crossing oceans
green bean arriving
other continents
unpacked
conveyed
packaged
repackaged
once more.

And once more.

No longer green
roasted deep shades
golden brown, chestnut
black brown perfection
of rich, dark color.

Now appreciated
anew vocabulary
body, balance, aroma
is tasted, cupped, analyzed
blended, smelled, compared.

Holding favorite
cup hot filled with
steaming beverage
morning coffee.

Small bean has completed
its journey.

—LINDA RICE LORENZETTI

INDEX

African slaves, 81–82, 86–87
arabica trees, 64, 108

Bags, coffee, 47, 100–101, 120–21
baskets, harvesting, 142–43
Brazil, 80–105
 geography and history, 80–82
brewing coffee, 32–33, 77

Celebes, 64, 77
coffee bean, defined, 11
coffee cherry, defined, 11–12
coffee farms, 106–10
coffee in parchment, 14, 124–25,
 188–89
coffee leaf rust, 64
coffee plantations, 81–85, 94–96,
 98–99
coffee trees, 11
 in Brazil, 96, 104–105
 in Colombia, 114–15, 118–19,
 126–27
 in Costa Rica, 144
 in Guatemala, 152–53, 158–59
 in Indonesia, 64
 lifespan, 118–19
 planting, 96, 126–27, 144,
 152–53
 pruning, 158–59
Colombia, 106–27
 geography and history, 106–108
Costa Rica, 128–45
 geography and history, 128–30

Drying coffee, 13
 in Brazil, 98–99
 in Ethiopia, 28–29, 30–31
 in Indonesia, 61
 on Java, 65–67
 in Yemen, 50
Dutch East India Company, 40, 62

Ethiopia, 16–37
 geology and history, 18

Fermentation, 12–13, 168

Guatemala, 146–69
 geography and history, 146–49

Harar region, 19–20
harvesting coffee cherries, 11
 baskets for, 142–43
 in Brazil, 82–83, 88–93, 102–105
 in Colombia, 112–13, 114–15
 in Costa Rica, 131–37, 140–43
 in Ethiopia, 21
 in Guatemala, 156–57, 160–61
 in Kenya, 174–77, 182–83
Huehuetenango, 149–51

Indonesia, 60–79
 geography of, 60–64

Java, 62–63, 65–69
jebena, 32–33, 36–37

Kaffa region, 19
Kalossi, 77
Kenya, 170–89
 history, 170–72

Manakhah Coffee Market,
 42–59
Mayans, 146, 148, 154–55
Meseta Central, 130
Minangkabau, 63, 71
Minas Gerais, 84–85
Minita, La, 130–32
Mocha Java, origins of, 62
Mombasa, 170–71
Monteverde, 130, 131
mucilage, 12

"Natural" processing, 12, 68–69

Out of Africa (Dinesen), 172–73
oxcarts, 145

Parchment skin, 12, 14
planting. See coffee trees
pulping fruit, 12, 68–69, 166–67

Qat, 50–51, 56–57
qishar, 48–49

Roasting coffee beans
 in Ethiopia, 34–35, 36–37
 on Sulawesi, 74–75

in Sumatra, 72–73
robusta trees, 64, 130

Sana'a, 40–41
selling coffee
 on Sulawesi, 64, 76–79
 in Yemen, 44–59
Sidamo region, 19
sorting coffee, 14
 in Colombia, 122–23
 in Ethiopia, 26–27
 in Kenya, 180–81, 186–87
strip picking, 90–91
Sulawesi, 64, 74–79
Sumatra, 63, 70–73
Suq al Milh coffee market, 42–59
sustainable agriculture, 130–33

Tarrazú, 130, 132
terraces, coffee, 39, 98–99
Torajaland, 64
transporting coffee
 in Colombia, 116–17
 in Ethiopia, 22–23
 in Guatemala, 162–63
 in Kenya, 178–79, 188–89
 in Yemen, 52–53
trumpets, 160–61

Valle Central, 130

Weighing coffee, 136–37
 in Guatemala, 164–65
 in Kenya, 184–85
 in Yemen, 46, 57
"wet" processing, 12–13
 in Ethiopia, 24
 in Guatemala, 166–67, 168–69
 in Kenya, 186–87
winnowing coffee, 50–51
wooden hand grinders, 68–69
wooden mallets, 68

Yemen, 38–59
 history of, 38
Yemeni mocha, 20
Yirgachaffe, 19

Zona Cafetera, 108–11